TRACKS ON CANVAS

The railway paintings of **PHILIP D. HAWKINS**

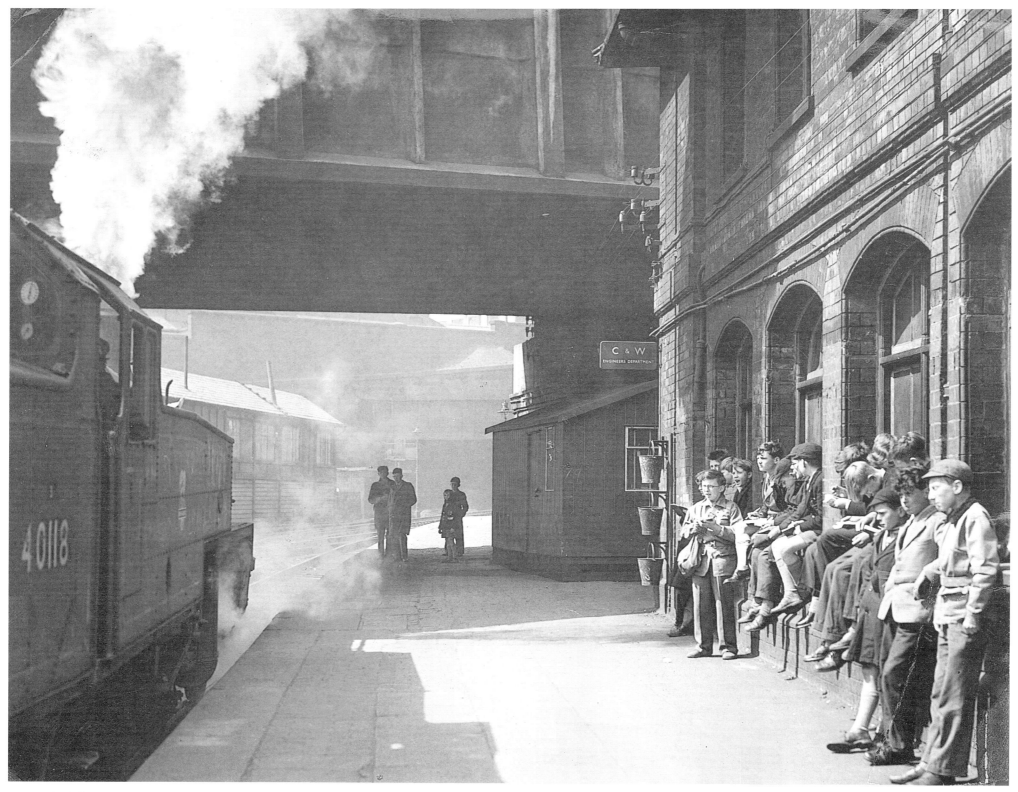

A wonderfully evocative scene at the west end of Platform 1 at New Street in April 1957 – the year that the Villa won the cup! The gallery of spotters is perched on the engineers department window sill and many are wearing their school caps. A Monument Lane tank, No. 40118, busies itself with station pilot duties and signalbox No. 5 can be seen in the background. (Author's collection)

TRACKS ON CANVAS

The railway paintings of PHILIP D. HAWKINS

(OPC)

Oxford Publishing Co.

Dedication
For Nina and Ben

A catalogue record for this book is avaiable from the British Library.

ISBN 0 86093 538 8

Oxford Publishing Co is an imprint of Ian Allan Publishing Ltd, Hersham,
Surrey, KT12 4RG

Printed by Ian Allan Printing Ltd, Hersham,
Surrey, KT12 4RG.

Acknowledgements

Thanks are due to the following who have allowed access to paintings in their collections: David Antley Esq, Bernard Apps Esq, Roy Apps Esq, Mike Armstrong Esq, David Asbury Esq, Gordon Barker Esq, Mr & Mrs D. Barrie, Ron & Freda Cass, Mrs 'Tot' Clarke, Paul Freer Esq, Andrew Harper Esq, John Hobbs Esq, Ron King Esq, Richard Martin Esq, Charles Pagett Esq, Eric Pearce Esq, John Petcher Esq, David Reynolds Esq, Bob Robson Esq, John Stockton-Wood Esq, Colin Washbourne Esq, Richard Willcox Esq.

And to the following organisations for their permission: BBC Radio Devon, Bristol United Press Ltd, Brown & Root, Booz . Allen Ltd, European Passenger Services, Midland Independent Newspapers Ltd, The Royal Mail.

Grateful thanks also to WBP of Birmingham who photographed many of the paintings for this book, Eversheds of Kingston upon Hull, Barry Everitt Associates, Simon Elvin Ltd, Quicksilver Publishing and many other organisations who have seen fit to make use of my work over the years.

Special thanks to Nigel Harris for his foreword and to Bernard Apps and Nick Pigott for their 'appreciations'.

Very special thanks to June Holloway for miraculously converting my scribble into pages of type.

The following paintings reproduced in this book are available as Fine Art prints from Quicksilver Publishing, 'The Sidings', 52 Teignmouth Road, Teignmouth, Devon, TQ14 8UT.

The Midlander, New Street 1957, On Time, Night Wolf, Waiting in the Night, Night Call, Night Freight, Island Summer, Evercreech Junction, Duchess of the Night, Firth of Forth, St Pancras Departure, East Coast Elegance, The Power and the Glory, Sunshine and Steam, The Bristolian, Unsung Hero (Ltd Edition), Twilight of the Fifties, Twilight of the Twenties, North Pole Dawn.

Contents

An Appreciation from Bernard Apps, Quicksilver Publishing

Being the Publisher of Philip's work is the culmination of a sequence of crossed paths that go right back to childhood. We were born within one year of each other in Birmingham, attended the same primary and grammar schools, but above all, our mutual love of railways was nurtured whilst trainspotting at the same place, where the former Great Western and LMS railways crossed at the bottom of our road in Handsworth. We both remember being lulled into sleep by the nocturnal sounds of the railway – sweet memories!

All of these coincidences came to light when, in my early twenties, I went into an off-licence in Solihull only to see 'railway paintings for sale'. The standard of the work amazed me. Here was an artist who actually captured the atmosphere of the railway accurately with the engines exactly as I remembered them. It was of course the early work of Philip Hawkins and I went on to purchase my first original oil painting.

I lost contact with Philip for ten years or so until we bumped into each other again, but this time I was now an experienced businessman and Philip was rapidly emerging as a leading profession[al] artist. One thing lead to another and it was a natu[ral] joining of complimentary skills which resulted in t[he] very successful Quicksilver Publishing, which [we] intend to see grow in the coming years.

Philip is a down to earth, very profession[al] artist whose work never ceases to amaze me. [He] is in my view the leading railway artist in t[he] country and the pictures in this book reflect [his] great talent. It is a privilege to have been asked [to] write this short testimony for Philip who is [a] great artist and a good friend.

An Appreciation from Nick Pigott, Editor, Railway Magazine

Tucked away in a corner of Philip Hawkins's studio is a small print depicting one of the celebrated Venetian masterpieces of J. M. W. Turner.

At first glance it seems a trifle incongruous hanging from a wall dominated by locomotive subjects. But to the owner of the studio, it is an inspiration – a constant reminder that rail art can count among its exponents one of the greatest masters who ever lived.

For Turner's *Rain, Steam and Speed*, a brilliantly impressionistic rendering of the then newly-opened Great Western Railway in 1843, helped initiate a genre whose popularity has grown dramatically in the succeeding century and a half.

Today, Philip Hawkins is one of a small body of specialised artists successfully perpetuating that genre for the benefit and pleasure of tens of thousands of railway enthusiasts.

Pleasing rail enthusiasts, however, is no simple task. A remarkably high percentage are perfectionists and wherever two or more are gathered together, a debate on railway art can be guaranteed to produce a lively and often heated exchange!

For the majority, the more esoteric aspects of painting such as surrealism, cubism and post-impressionism can safely be consigned to the realms of academia. Of far greater importance are such issues as the shade of the livery, the size of the tender logo and the shape of the driving wheels.

For locomotives whose wheels appear to be falling off the track, smokebox numberplates affixed at infuriating angles and physically impossible smoke effects are anathema to any self-respecting railfan. If just one such point has been badly executed – no matter how trivial the matter may appear to a non-enthusiast – the rest of the picture might just as well not have been painted.

The number of artists who fall foul of such criticisms is surprisingly high... yet full-time professionals such as Phil Hawkins have to please these armchair critics month in, month out if they are to earn a crust.

I first became aware of Phil's work when I was working in Fleet Street and keeping a watching brief on the enthusiast press in the late 1970s. At that time he was just in the process of turning professional and I remember making a note of his name as someone to keep an eye on in the future.

I have to admit here that where railway art is concerned, I am as pernickety and punctilious as any railway pedant and I can recall searching [in] vain for errors of detail or perspective in [his] work and, somewhat perversely, feeling cheat[ed] when I couldn't find any.

Phil's uncanny aptitude for someh[ow] combining the accuracy of a photograph with t[he] vitally-important 'look' of a painting impress[ed] me greatly and has continued to do so ever sin[ce].

Much of the reason for his success, I lat[er] discovered, is the amount of time he spen[ds] researching his subject in the most meticulo[us] and fastidious detail before brush is even allow[ed] to touch canvas. For like all good enthusias[ts] Phil himself is a perfectionist.

The results speak for themselves. Ownersh[ip] of a Hawkins original is now a symbol of stat[us] in the railway world and after undertaki[ng] hundreds of commissions, he has yet to co[me] across a dissatisfied customer.

Art is of course highly subjective and althou[gh] one man's meat is another man's poison, Phi[l] Hawkins' elevation to the Presidency of t[he] Guild of Railway Artists proves he also has t[he] hard-earned respect of his peers.

I am sure this collection of his paintings w[ill] give tremendous fascination, inspiration a[nd] happiness to his many admirers.

Foreword

I've always had great respect for those lucky folk who can take up pencil, charcoal or paintbrush and create pictures – but I'm especially impressed by those uniquely gifted individuals whose work not only convinces the eye but which stirs the soul, too.

For therein lies the difference between technical drawing and the finest art, which captivates for ever. An exaggeration? No – look in the world's art galleries and you'll find proof, for great art outlives us all. It continues to communicate for as long as it survives – and not just skills in perspective or technique either, but much more importantly, the artist's passion and appreciation for the subject.

I must take care, for I'm in danger of doing my friend Phil Hawkins a disservice, because even those of us with a satirical sense of humour run the risk of sounding pretentious when discussing art. We've all heard plummy critics (and, sometimes, even artists themselves!) spouting endless high-blown nonsense – but you certainly won't find Phil in their company, because his exceptional artistic talent is exceeded only by his healthy disregard for what he once described to me as 'arty claptrap!'

Despite Phil's talent in turning a blank canvas into memories which thousands of folk both share and relate to, he's a modest chap and tends to change the subject if you praise his work, which as this book shows is both extensive in range and of the very highest quality. He's worked hard to raise artistic standards in railway art generally and I've always admired his leadership of the Guild of Railway Artists which has played an important part in developing and improving all kinds of railway art. Phil was a founder member of the GRA and leads from the front with his steady output – so whilst I've known Phil's paintings for many years, it came as a surprise to me in this book that he's as creatively successful with a pen as he is with a paintbrush.

Just as Phil's paintings powerfully evoke 'the way it was', so his words had me chuckling along with him. For I too grew up in an industrial town of cobbled streets and small backyards and I too was a regular at the Saturday morning *Odeon* picture shows – for me, it was sixpence to get in, leaving around a 'bob' from my 1s 6d pocket money for some *Spanish Gold* confectionery

'tobacco' and a Lyons Maid *Zoom* ice lolly in the interval. Happy days! I laughed out loud at his tale of hordes of Saturday afternoon would-be Brummie 'Zorros', annoying the neighbours ("Go and play near your own house…!!") and leaping from advertising hoardings, gaberdine 'macs' buttoned around their necks as makeshift capes!

Phil powerfully evokes his childhood in early '50s Britain, when a word to your parents about you from the local 'bobby' earned you a clout first and questions later. This was the Indian Summer of the England of Enid Blyton – secondary school lads still went to school in short trousers, cars were required to 'Halt at major road ahead', AA patrolmen saluted members – and a squat glass jar of *Brylcreem* and an apprenticeship were the rites of passage into manhood!

And that's why Phil Hawkins is such a very special railway artist. He's not just a lucky chap who can draw and happens to paint trains. Phil really is 'one of us' – he's *lived* a good deal of what he paints and this is the magic ingredient alongside the burnt ochre on his pallette.

And I really do mean that Phil has lived what he paints – because the words in this book not only connect many of the locomotives and locations in his pictures with his own experience, but you'll also find the young Hawkins himself, together with members of his family, in some of the paintings. Family groups in old snapshots have been incorporated into his work to breathe a very special kind of life into his paintings. This book is a personal, very effective autobiography of a boisterous young lad of the early '50s, who doubtless sketched the spectacle before him at New Street when he wasn't 'copping' what he describes as 'the mechanical heroes strutting before him'. Wonderful stuff.

Phil is fascinated by the railway of earlier years which he wasn't privileged to see. His crimson 'Compound leaving St Pancras' (page 61) is a special favourite of mine – what amazing days they must have been and powerful pictures like this give us a taste of what it was like. There are lots more paintings I find myself returning to again and again: the country railway feel of *Evercreech Junction* (page 48) is delightful: the thrilling anticipation of *Duchess of the Night* is powerful (page 53) and the driver on the left, collar up, billy-can in hand and quite unmoved by the spectacle, is a wonderful touch. The cold

in *Western Blizzard* (the hunched, miserable shoulders of the flagman say it all!) is chillingly conveyed. This is a book to savour – repeatedly.

It's fashionable today to heap scorn on those who take an interest in railway, as being 'sad' and in need of 'a life'. I've always believed that my interest in railways was the stage on which I acted out my own formative years and learned to handle the grown-up world on my own two feet. 'Spotting' trips were my first tentative experiences away from protective parental control – and learning to 'sink or swim' in the wider world as served by the railway has stood me in very good stead. I'm glad I did it – and Phil makes the same point; that his interest in railways linked his other boyhood activities from acting out 'Zorro' to football and cricket. Each interest nourished the other to create a wealth of experience from which he now draws not just inspiration, but also 'feel', atmosphere and emotion.

And he's still hungry for new experience – where in the '50s it was New Street and Tyseley, it's now North Pole Junction and the 'East End' for Eurostar and the Docklands Light Railway – taking in Class 50s, Class 20s and Merry-go-round coal trains on the way. Truly, if it's on rails, it's likely to spring from Phil's palette – and you can be sure that the finished canvas will appeal to both eye *and* heart. It was a pleasure and a privilege to work with Phil on the *Unsung Hero* painting (page 89) produced in association with a *Steam Railway* appeal to raise the £70,000 needed to restore the National Railway Museum's Robinson Class O4 2-8-0 No. 63601, at the Great Central Railway – and Phil's involvement helped to push our final total well past our target, to more than £75,000.

As Phil Hawkins' work continues to mature, I firmly believe that he will be increasingly – and deservedly – acknowledged as Britain's finest railway artist.

But I bet you'll never find him guilty of 'arty claptrap!'

Nigel Harris,
Managing Editor;
*RAIL, Steam Railway,
Steam World, Model Rail.*
Emap Apex Railways Division,
Peterborough, Cambridgeshire.
May 1998

Introduction

For the last 20 years I have earned a living, of sorts, from my paintings which have been, with very few exceptions, of railway subjects. Practically all have been published in one form or another but never before in a book devoted entirely to my work. During the preparation I have received a great deal of advice and assistance from my editor, Peter Nicholson, editorial director Darryl Reach, and Alison Roelich, editorial department manager. My thanks are due not least for believing in my work but also for allowing my ideas and suggestions to reach fruition.

The paintings in these pages date from 1982 and cover a selection of work covering 15 years. Working drawings, sketches, pages from notebooks and photographs are included where appropriate which will, I hope, help to explain something of the thought processes which culminate in the finished article. The brief autobiography may help to explain the background and motives which drive me on, the writing of which has proved a fascinating and thought provoking exercise.

Although painting, and other art forms for that matter, tends to be a solitary process one of the delights of my career has been the help and encouragement received from many kind souls over the years. Some of these are mentioned in these pages, others such as Dick Potts, a great character and an ex Tyseley and Saltley footplateman, have been a veritable mine of information and anecdotes of real day-to-day life on Britain's railways. Their help has been invaluable and has helped lift otherwise inpenetrable black clouds on many occasions. My wife, Sonya, also a professional artist but not of railway subjects (thank goodness) has developed an effective line in backside kicking and honest, incisive critisism when apathy or despair threaten to take over. Nina and Ben, my children, now in their twenties, can also be relied upon for their veracity. Both, incidently, have appeared in my paintings, although not in recent years; Ben, for example, can be found in at least three pictures in this collection. These are salutary influences in what can sometimes be a fawning, deferential profession, and always well received but invariably accurate.

The Guild of Railway Artists has proved to be a great source of encouragement. Meeting and talking with kindred spirits, sharing problems and solutions, receiving and offering constructive critisism. To have served as President since 1988 has been a great honour. Frank Hodges, the Guild's Chief Executive and founder deservces a very large medal!

Much of my work is commissioned, both private and commercial. These range from vague requests to the most highly detailed specifications. Meeting and discussing a prospective painting with these brave souls and discovering their reasons is fascinating and results in subjects and locations that otherwise would not be considered. Sometimes a discussion will span many meetings and involve copious amounts of photographs and general reference, other times the briefest of chats will suffice. Either way I prefer quite an amount of input, particularly regarding composition, lighting and angles etc, and have declined work where I have been unable to achieve this.

Those with scant knowledge of painting and indeed art in general often imagine that it all happens as if by magic, a simple clicking of the fingers perhaps, but as with most professions, hard graft, knowledge, practice and years of experience with the odd splash of that magic are the order of the day. When work is going well I know that I'm doing the right thing, but there are days -------! Whether my work betrays any of the aforementioned attributes is for you to decide. I sincerely hope that you enjoy the following pages.

Waiting for the Road

Philip D. Hawkins
Birmingham 1998

Home thoughts

The first three years of my life were spent in a pub, just along the Warwick Road from Tyseley engine sheds in Birmingham. 'The Britannia Inn' was home for me, my parents and grandparents. Just two memories remain of the 'Brit' – the large garden which included a bowling green, and feeding grandad's chickens. He had been a publican for most of his working life and the 'gaffer' of many Birmingham 'boozers'.

In 1950 I moved, with mom and dad of course, across the city to live with great aunt Hetty in Winson Green. The house was a three-up, two-down end of terrace mansion with fading green corporation paintwork (apparently there were two choices, green or brown!). I had reached the grand old age of five when, much to my disgust, a sister arrived. When the midwife came from the bedroom to impart the glad tidings I found a tiny suitcase, packed, left the

house and waited at the bus-stop down the road – I had been looking forward to a brother. My freedom was short-lived however and I was promptly marched back into the house, up to my bedroom and introduced to Janet.

Inside the house breathing space was at a premium, but that didn't matter because the centre of my universe was our backyard which, depending on the time of year, was a football stadium or a cricket pitch with stumps carefully chalked on the back door, and a vast road network for my Dinky toy collection. The fact that this wondrous place, with an area of at least ten square yards, was an uneven collection of blue bricks, cunningly laid on a 1 in 2 slope merely added to the drama when Freddie Trueman (dad) bowled to Colin Cowdrey (me) up the slope against the chalk stumps. Five-day tests took up to an hour, unless tea was early, and the outside lavatory door and coal house were witness to a thousand boundaries.

As if all of this excitement wasn't enough, through the back-gate, across the entry (also known as the back passage) and over the railings was the eighth wonder of this small boy's world, the railway embankment – my bank! It was in fact the Soho loop line, a useful operational link from the main New Street to Wolverhampton route at Soho Junction to Perry Barr Junction on the Aston to Wolverhampton line. A former LNWR stronghold, and later LMS, but during the period in question, the London, Midland Region of British Railways held sway.

Across this stage strutted my mechanical heroes. Star turns were the Glasgow train, actually empty stock en route from Duddeston carriage sidings to New Street station, invariably hauled by a Crewe North 'Royal Scot', and 'The Midlander' which was the preserve of Bushbury's stud of well-kept 'Jubilees'. The 'Glasie' came up the bank at 10.50 am and 'The Midlander' down the bank at about 8 pm. There was a steady

The author aged 2½, with friend, on holiday at Cliftonville in 1950.

Right: *As mentioned in the text, cowboys and indians were 'in' in a big way in the 1950s. Inspired no doubt by comics, books and Saturday morning matinees at the local 'fleapit' the Regal. The author is modelling a natty cowboy suit in the front 'garden' at home in 1953, aged 5½.*

One of several school 'mug' shots. This time sporting a 'red indian' tie. Taken at Christmas 1954, aged 7.

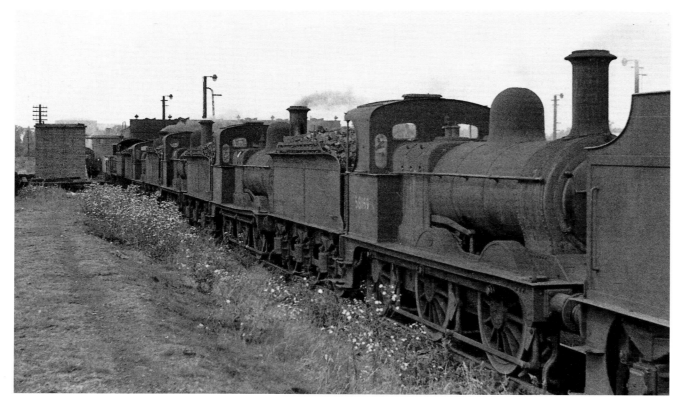

A collection of decrepit 'fivers' as mentioned in the text with No. 58169 to the fore in this Sunday scene at Bescot in the late 1950s. The shed's allocation far outstripped its covered accommodation and on Sundays engines would occupy most of the yard area. They would be in light steam in preparation for Mondays workings and this weekly spectacle was known locally as the 'Sunday Roast'. At this time some of these 'fivers' were getting on for 80 years old and looked and sounded every year of it! Designed by Samuel Johnson for the Midland Railway they were built between 1875 and 1902 and originally totalled some 875 engines. (Author's collection)

stream of goods trains which, when climbing the gradient, would usually require the assistance of a banking engine in the shape of an Ivatt Class 2 Mogul from Aston Sheds. Nos 46423 and 46492 spring to mind. Most of these trains were trip workings and often seemed to contain sludge tenders. Favourite freight engines were the ex LNWR 'Super Ds' known to us as 'Duck 8s', Fowler 4Fs were 'Duck 6s', Stanier Class 5s were 'Blackies' and 8Fs were 'Consuls', to mention but a few. A gruesome collection of decrepit ex Midland 2F 0-6-0s, usually from Bescot, also put in regular appearances and were known to one and all as 'Fivers'. Of all the locomotive types to cross 'my bank' my favourites were the 'Patriots'. Though not as glamorous as the 'Scots', their straightforward, no-nonsense demeanour topped off by that odd, pinched-in chimney appealed to me and I always think of them as 'proper' engines.

So much for the LMR line, but just a short distance down the bank these tracks crossed the Western main line from Snow Hill to Wolverhampton, consequently a few yards from my house it was possible to see both lines from a position between the bridges. During the evenings, weekends and school holidays this spot was a popular rendezvous for local spotters. The Western line was much busier with the regular expresses on the Paddington run producing 'Castles' and 'Kings' in abundance with other passenger services supplying a steady diet of all the 4-6-0 types and Moguls. Local trains were worked by large Prairie tanks and there was plenty of goods traffic too with 2-8-0s, Moguls and the occasional 4700 for good measure.

What more could a small boy wish for? Would the 'railway bug' have bitten so deeply, or even at all, had we not moved to that house by the 'bank'? I've really no idea, but I do know that trainspotting was as popular amongst boys in the 1950s as computer games are today. It was very much a common interest and high on the 'most popular hobbies' list. Many men, now in their forties and fifties will admit, some grudgingly, that they were once trainspotters. Most of them would also have had train sets.

The idea that railways were the 'be all and end all' of my younger years would be quite wrong, rather it was the thread of interest that connected

countless other pastimes that occupy small boys' heads. Cowboys and Indians were 'in', in a big way in the fifties and many budding 'Cisco Kids' had double-belt holsters with matching Colt 45s beneath a ridiculously oversize stetson. Saturday morning matinees at our local 'fleapit', the Regal, were very popular, the results of which manifested itself with swarms of would be 'Zorros' launching themselves off the tops of advertisement hoardings with school macs tied around the neck acting as a cape. Why didn't girls behave like this? We made carts from old pram wheels and a plank and hurtled through the back entries, emerging on to the main road at break-neck speed. Once, to my horror, landing at the feet of a passing policeman, who said nothing, but later the same evening came to the house for a hushed conversation with dad, who duly gave me a clout around the ear. We were chased out of neighbours' back yards (often grandly referred to as gardens) by irate women, with tea-cloths tied around their heads, who would loudly shriek, 'I know your mother', or, 'I know where you lot live'.

All of this excitement took place within sight or sound of the railway. Looking back of course, this is hardly surprising as we wouldn't have wandered far from home, although at the time it seemed like miles. Time after time I would be in trouble for not returning home at the allotted time after post-school 'playing'. Invariably I would be at a mate's house having told his mom,

Boulton Road school football team at the end of the 1957-58 season when we won the league and the cup (the feat was repeated the following season). Mr Cooper, the headmaster, is on the right and Mr Palfreyman on the left. Yours truly is in the front row on the left, aged 10.

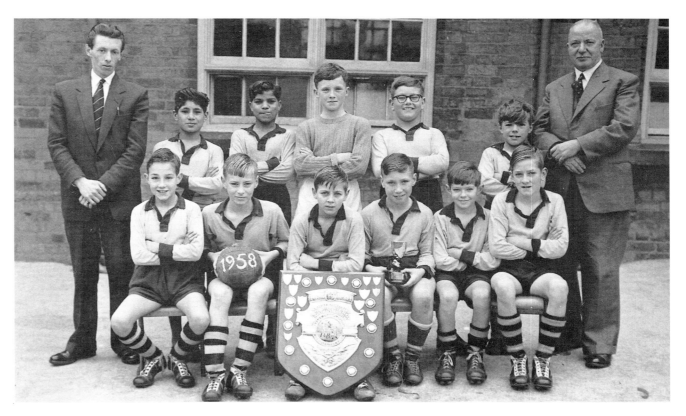

'yes, my mom knows where I am, it's OK'. Or we might be sitting by the railway noting down numbers on a scrap of paper, although what we were really doing was hatching devious plots, swapping bubble gum cards, planning the football team, or any number of things, but the railway was the excuse for these misdemeanours.

Highlights of the year were Christmas and summer holidays. I was very lucky with the latter and usually had two; a week or two with mom, dad and my sister, and a fortnight with my grandparents. We didn't have a car and, like most folk in the fifties, we went by train, sending our luggage, in a huge metal trunk, in advance. In 1956, and the following two years, we stayed in a caravan at Blue Anchor Bay in Somerset. The site was bisected by the Taunton to Minehead line, now the preserved West Somerset Railway. Apart from this the only memorable things about these holidays was one year when my sister was launched from the caravan door when a particularly fierce gust of wind caught the door as she was holding the handle. She described a graceful parabola and landed several yards away in a heap of tears. I can still feel the ringing in my ears after receiving a 'smack' from mom for laughing. Also, whilst enjoying a day out with friends in their sit-up-and-beg Ford Popular, it stalled on Porlock Hill and treated us to a hair-raising ride against the traffic flow before eventually finding an escape road. The fact that there were eight of us on board may not have helped!

Grandad liked the Isle of Wight and the Marine Hotel at Ryde welcomed us many times. Sometimes we would travel to Portsmouth by car, a family friend providing the service, and sometimes by train. I have vague memories of seeing Bulleid Pacifics long before underlining any in my ABC. The first year that I can remember taking any real notice of the railway whilst on holiday was in 1959. We stayed in a chalet at Dawlish Warren in Devon and the entire fortnight was spent deserting the family on the beach and watching trains on the sea-wall. This was the first year that the 'Warship' diesels were in regular service but 90 per cent of trains were still steam hauled. The following year was spent at Exmouth and it was infuriating to see the procession of trains passing through Starcross, in the distance across the River Exe, and being unable to see the numbers. More about holidays later...

My education began in 1952, at Boulton Road Junior and Infants School, ten minutes walk from home. From the main playground, as if by divine intervention, one could see both of the aforementioned railway lines in the middle distance. I was reminded recently that morning 'playtime' coincided with the passage of the Glasgow train and mom would religiously make a note of the engine number. This would be my first question when I eventually came home, although the 'Scot' or sometimes a rebuilt 'Patriot' would most likely have been seen many times before.

I enjoyed my time at Boulton Road, especially the hundred-a-side football matches played with every conceivable type of ball, except a proper football. Many boys served their time being tended by nurse Bonner after being struck in a delicate place with a lethal sorbo rubber ball. Football was as important as trains and dad took me regularly to Villa Park. When the Villa were playing 'away' we would go to the Hawthorns or occasionally Fellows Park. During the last two years at junior school I was a regular member of the football team and Saturdays or Sundays and spring evenings saw us traipsing across our side of the city to play 'away' games. Perry Hall Park was a regular venue, where, as luck would have it, Sunday diversions from the West Coast Main Line passed by in a shallow cutting. Some of these matches would continue well over time because of the mass exodus from the pitch each time a train went by. The sight of a 'Semi' or a 'Princess' was not to be missed!

Meanwhile I found school lessons a bit of a 'doddle', only doing what I had to do, which

resulted in reports unanimous in their opinion that 'Philip doesn't try' and 'scatterbrain'. However I always tried when it came to art and was encouraged by one or two teachers and the headmaster Mr Cooper, to produce 'special' pictures for school plays and displays etc. It's a good feeling, when 9 or 10 years old, to be asked to do something 'special', although I don't recall feeling grateful at the time because it sometimes meant missing out on playtime or staying after school. The praise was enjoyable though. Other lessons claimed barely adequate attention, enough to get me by. Nevertheless, when the time came, I passed the 11+ examination and duly went to Lordswood Boys' Technical School in September 1959. This necessitated a short bus ride and very often an aunt would be the conductress and I wouldn't have to pay.

Just before Christmas 1959 I arrived home from school as usual and was surprised to find grandad chatting in an animated way with mom and dad. Now this was really out of the ordinary because grandad was not known for his visits. We would always visit him and did so regularly. I had a terrible feeling that something was wrong. It should be said at this stage that grandad (I only knew one) and I were as thick as thieves. He took me on holiday, bought me great Christmas presents and spoilt me in general. Back to this 'royal' visit. A couple of years previously he had semi-retired as a publican and bought an off-licence and general stores in Acocks Green. Apparently, I discovered later, things were getting on top of him and he was here in an attempt to persuade us to go and live with him so that mom and dad could run the shops. Great, I thought, his new place was much bigger than ours and had a huge garden with a stream running through it. Mom wasn't keen on the idea to say the least, but

A trio of 'Black 5s' at Saltley at 7th March 1965 with No. 45202 on the turntable. After 'bunking' this shed we would often sit beside the line at the back of the yard to savour the action on the New Street to Derby line and the antics of the banking engines on the Camp Hill route. (David K. Morris)

a few weeks after Christmas we moved and left behind 'my bank' forever!

Discovering sheds

Throughout my childhood, several members of my family occasionally mentioned in passing, that my great-grandfather Allen had been an engine driver. One would have thought that such a snippet of information given to a railway mad kid would have made him sit up and take notice, but it hardly made any impression at all and I honestly can't remember the subject surfacing again until in my late twenties when mom, who had been sorting through some family 'junk', gave me a faded newspaper cutting from the *Birmingham Evening Mail* celebrating great-grandfather's retirement after a railway career of 50 years. Apparently, he had been an engine driver at Monument Lane sheds in Birmingham when the London & North Western Railway and later the London, Midland & Scottish were in control. He began his career as an engine cleaner at Vauxhall and soon moved to Monument Lane eventually becoming a driver. According to the newspaper tribute: 'There had been memorable occasions when Royal personages had been entrusted to his care. He has driven troop trains, race trains and in fact every sort of train one could mention!'. There was no date attached to the cutting but I would calculate that his career spanned the years 1880 until 1930.

Perhaps because of this distant family association Monument Lane became the first shed that I actually visited. It was, I believe, in 1958 when dad had the brilliant idea that I would enjoy such a visit. To witness at close quarters from ground level the very same engines that had become old friends on 'my bank' was a magical experience. Suddenly they were seen in an entirely new light with such powerful presence, not to mention the almost human noises that emanated from various parts of their anatomy. Here were the fire-breathing monsters in their lair being tended, fed and watered before venturing forth into the world of mere mortals. My favourite 4F was there, No. 44444, and I was allowed on to the footplate where a patient

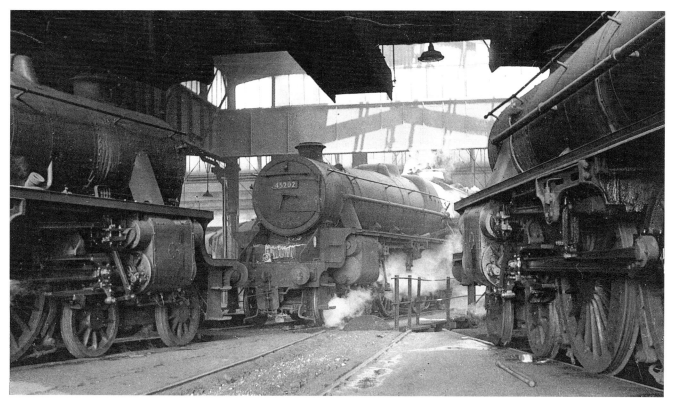

The newspaper cutting commemorating my great-grandfather's retirement from the footplate. Taken from the Birmingham Evening Mail, *c1930, this was passed to me by my mother who found it while sifting through family 'junk' in the 1970s.*

engineman explained what made it tick. I'm sure that dad had no idea what he had started but after this experience, just watching trains pass by and at stations was no longer quite enough and during the next seven or eight years most engine sheds, or to use the proper terminology, motive power depots, in England, Scotland and Wales were visited, usually unofficially.

By this time, usually in the company of two or three friends, I had begun to spread my wings after the Monument Lane episode had whetted my appetite for more sheds. Maybe, at just 10 or 11 years old we shouldn't have been gallivanting about on trains, on the pretext of 'playing' at a friend's house and mom would surely have gone raving mad, and sometimes did, but the urge was strong.

The first 'far away' shed discovered was Wolverhampton Stafford Road. We soon realised that by catching a train from our local station, Handsworth & Smethwick, to Wolverhampton Low Level and then a local train to the next stop at Dunstall Park, that access to the shed yard was easy to gain from the platform. At once, 'Castles', 'Kings' and 'Halls', most of which had

already been seen at the bottom of my road, were paraded before us and as a bonus the LMR line from the High Level station to Stafford and Crewe ran across the shed yard on a series of bridges. The turntable and coaling stage were some distance from the shed and we would often sit eating sandwiches and swigging Tizer watching the procession of engines being coaled and turned. Stafford Road must have been the tattiest, most filthy shed on the Western. Sometimes the whole of the shed yard was covered in piles of ash and clinker and on windy days this was blended with smoke and steam to create a layer of gritty fog up to chimney level across the entire complex. Today's 'health and safety at work' officials would have it closed down in an instant, as they surely would with many railway installations. Often we would then walk along the canal towpath to Oxley shed which I will always associate with the dreadful smell, especially on hot days, from the pig farm which was adjacent to the pathway leading to the shed yard. This was a busy freight depot and there were usually two or three of the lovely 47XX 2-8-0s which would have escaped our attention at home because they invariably worked during the night.

The local sheds at Tyseley, Saltley and Aston were soon added to the list and little by little the area of operation widened. In 1959 I was lucky enough to travel on a special train to Doncaster Works and shed hauled by Midland Compound No. 1000. Apart from a brief visit to King's Cross station earlier the same year and seeing the odd B1 4-6-0 at New Street, this was the first time that I had been confronted with so many Eastern Region engines and also my first

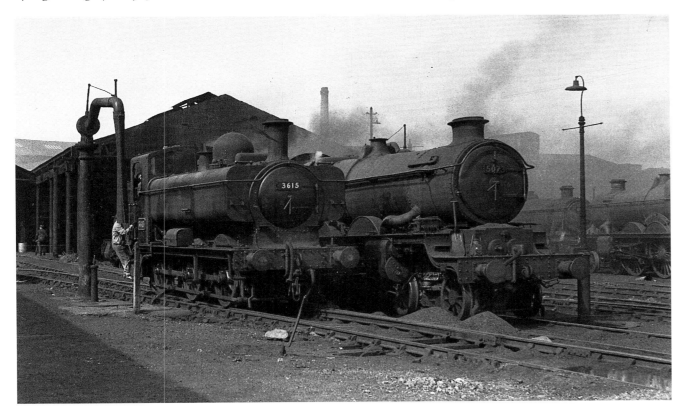

The second shed visited by the author. Wolverhampton Stafford Road c1960 displays the piles of ash and general debris lying in wait to create the fondly remembered 'foggy grit' when the wind got up. Pannier tank No. 3615 and a double-chimney 'Castle' No. 5073 Blenheim *take centre stage with another 'Castle', No. 4092* Dunraven Castle *in the background. (Author's collection)*

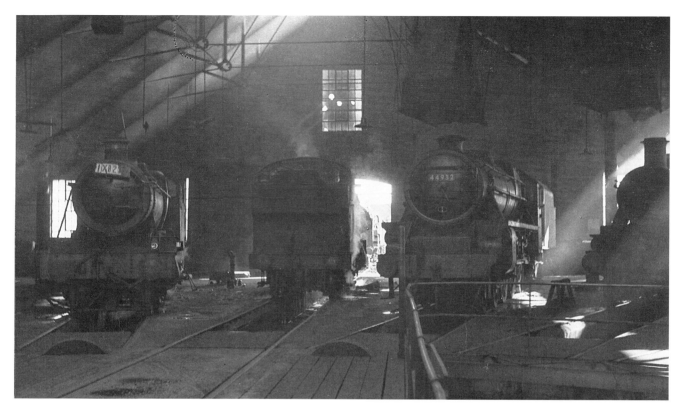

experience of a locomotive works, the first of many.

Early in 1960, soon after starting my senior school education, I joined the Birmingham Locospotters Club and immediately began travelling the length and breadth of the country, mainly by coach, on Sunday shed-bashing trips. These were interspersed with self-planned outings with friends which often involved a midnight departure from New Street to such places as Leeds, Liverpool, Manchester and Carlisle which gave us the whole of Sunday in which to follow Ian Allan's shed directory to 'bunk' as many depots as possible in these cities, often returning home just in time to grab a few hours sleep before school on Monday. Such outings were far more enjoyable to me than the organised club trips, involving, as they often did, some convoluted train and bus connections in an attempt to complete our planned itinerary which added to the excitement and sense of achievement. However, travelling with the club was excellent value for money and usually cost far less than our own efforts.

It must have been around this time that mom and dad resigned themselves to the fact that their son was rarely at home and stopped including me in family arrangements. Even when trains weren't on the agenda, football was! Dad would occasionally have his Sunday night relaxation interrupted, having been working in the off-licence until 10 pm, by a 'phone call explaining that my money had run out and, was there any chance of a lift? Usually the plea would be made from somewhere fairly local but I remember one rescue mission to Crewe and another to Rugby. Whatever his faults he could always be relied upon in an emergency.

Local sheds were regular haunts, particularly during school-day evenings, when we would regularly cycle to Tyseley, Saltley and Aston, in that order, to see if any foreigners were on shed. Aston was sometimes difficult to 'bunk' and was also home to a homicidal maniac engineman who would take great delight in hurling 'ovoids' of coal which would ricochet along the flanks of rows of engines making a thunderous din as we desperately tried to escape. At Saltley, after checking out the shed, we would sometimes settle down by the neck of the yard and watch

trains on the New Street to Derby line and were occasionally treated to the sight of an Eastern engine which had worked into Birmingham and would retire to Saltley for servicing. These were usually B1s but I remember a couple of V2s and a K1. Heavy freight trains for the Bristol route would also stop near here to take on banking assistance, provided by a Saltley 3F or 4F for the steep climb up to Camp Hill.

One of the most exciting trips was to Scotland in the spring of 1962. During a memorable week I 'finished off' my 'Semis', 'Prinnies' and 'Scots' – Nos 46223 *Princess Alice* and 46121 *Highland Light Infantry, City of Glasgow Regiment* at Polmadie (66A) and 46201 *Princess Elizabeth* at Carlisle Kingmoor (12A). Quite an army of ex Caledonian veterans were still intact with many still working but the highlight was seeing the 'rare' 'Jubilees' at Corkerhill (67A) and to a lesser extent at Kingmoor. Most 'Brummie' spotters had similar gaps in their 'Jubilee' collection and to see the likes of *Neptune, Agamemnon, Lord Rutherford of Nelson, Valiant, Keppel,* and many more was an ambition fulfilled. Sadly, some were in store never to turn a wheel again, but I only became aware of this later.

Trains Illustrated magazine was discovered in 1960 and the monthly ritual of entering reallocations and withdrawals into my shed 'ref' provided up to date information of where everything was and added a further element to planning trips.

Locomotive works were something else again. Here it was possible to see engines, sometimes old favourites, being cut up while others would be immaculate, fresh from the paint shop. On occasions, these two extremes would involve

Almost the end of steam at Old Oak Common, on 17th January 1965, with a handful of pannier tanks still hanging on to their empty stock duties into and out of Paddington. A Brush Type 4, later Class 47, defiantly represents the new order. The classic trappings of a steam shed make a fascinating frame as a father and son 'mooch' around. (Author)

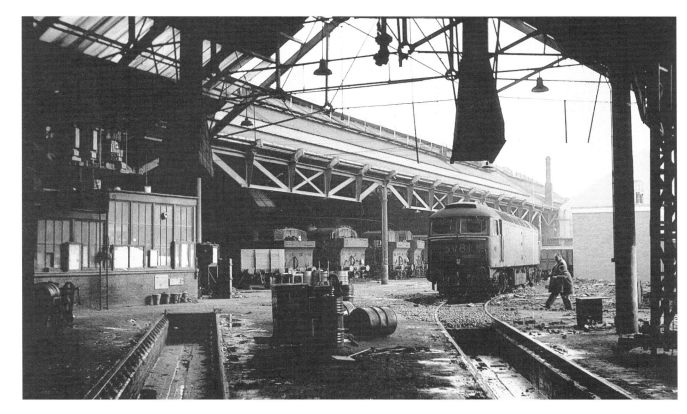

engines of the same class. Ex LNWR 'Super Ds' at Crewe and 'Castles' at Swindon for example, and there were many more. I managed to successfully negotiate the works at Crewe, Swindon, Doncaster and Eastleigh without a permit, usually by tagging on to an organised party and making myself invisible, although on one occasion at Swindon I did manage to talk my way in and had a private tour complete with guide. An oft-cited problem of works visits was trying to figure out which dismembered parts of an engine constituted a 'cop'. I seem to remember that we had to see the cabside number and the corresponding smokebox before it counted and that Western Region engines had their number stamped on the coupling rods, over each axle.

Travelling became a way of life and I loved it. Initially the object of the exercise was to 'cop' as many new engine numbers as possible with the ultimate aim to see them all, but in retrospect there was so much more to it than that. Over a few short years I become acquainted with many of the less fashionable districts of our big cities. Near the entrance to the large freight shed at Speke Junction, about eight miles out of Liverpool, there was a corner shop with a metal grille protecting the window. 'What sort of people live around here?' I wondered in my innocence. It was a fact that most city engine sheds were situated in the less glamorous districts. More affluent areas would never have tolerated the dirt and noise. Or was it that they were able to move elsewhere when the railway moved in? A combination of both I suspect, but it did provide a partial insight into how things

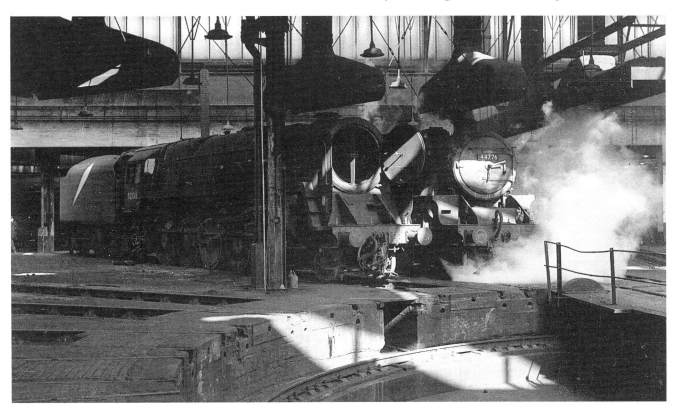

A typical scene inside Saltley shed on 7th March 1965 with 9F No. 92138 receiving attention alongside 'Black 5' No. 44776. The authorities here seemed to tolerate the ever-present nuisance of train-spotters more than most sheds which was surprising considering how busy it was at most times of the day. (David K. Morris)

really were and extended my education beyond the classroom. I became quite adept at finding my way around London's Underground system and bus routes in an attempt to visit all of the Capital's engine sheds in one day. Football excursions were an inexpensive way to travel and we would even see the match if it promised to be good. We were fortunate in Birmingham in that in the early sixties all of the local teams, Aston Villa, West Bromwich Albion and Birmingham City, as well as Wolverhampton Wanderers, were in the 1st or 2nd divisions and provided away matches at regular intervals at Liverpool, Manchester, Sheffield and Leeds giving us a good choice of cheap rail travel throughout the season.

These trainspotting pilgrimages continued with a vengeance until about 1964 when my enthusiasm, for a variety of reasons, waned. One of these was the very obvious rundown of steam power which resulted in such unedifying sights as the remaining Western 4-6-0s running around minus their nameplates leaving three ugly brackets protruding from the splasher. Dirty locomotives were one thing but this was too much and just one of the many manifestations of the almost total lack of care shown by British Railways towards the objects of my affection. One of the rapidly decreasing bright spots was on the Southern Region where Bulleid Pacifics in decent 'nick', were still on top link work out of Waterloo on the ex LSWR main line. Basingstoke became a favourite haunt along with other points west to Weymouth. Even these trips became less frequent as other teenage interests took precedence.

From the age of 10 until 16, thousands of miles were covered, mainly by train, from the north of Scotland to Cornwall. Dozens of notebooks were filled with the spoils of these adventures and I still have most of them from 1961 onwards. Occasionally they will provide inspiration for a painting or solve a problem of reference, but the most important aspect was the experience of travelling and of trudging round engine sheds, often in foul weather ankle deep in ash and oil, breathing in the unmistakable aroma of the steam railway. There was always

something special to see, to discuss and argue about. A regular travelling companion was a school friend, Dave Morris, who could always be relied upon to provide moments of light relief. Hardly a shed visit went by without him disappearing into an inspection pit, walking into point levers or treading in an oil puddle unaware that it was concealing an uncovered man-hole. Many are the times that I turned to chat only to find him gone. A few seconds later a groan, a moan, some choice language and an oil-covered hand slowly rising, excalibur-like, from the pit would confirm that he had done it again. I still see Dave from time to time and remind him of his shed-stuntman days. He denies that it happened with anything like the regularity that I recall – but I'm not so sure.

Maybe British Railways missed out on a substantial source of revenue during the fifties and sixties by not cashing in on the insatiable desire of enthusiasts to go 'shedbashing'. Imagine it – the larger sheds could have set up box offices, open on Sundays only perhaps, with uniformed guides, catalogues, roster lists, footplate rides, photographs, demonstration boiler wash-outs, turntable demonstrations, details of engines away at works or out on loan, the list could go on and on. What a day out that would have been, and infinitely preferable to some of the dubious offerings at today's adventure parks. Perhaps if steam and enthusiasts had lasted into the ultra cost-conscious nineties there would be hoards of anoraks festooned with camera gear queuing outside Crewe North, Old Oak Common, Carlisle Kingmoor, Doncaster, etc, etc

A page from the author's notebook in August 1962 when full use was made of a Cornish railrover ticket with several trips along the Cornish main line to Plymouth. This was the last year of steam in Cornwall and 'Warships' were to the fore. Nevertheless there was a mouth-watering selection of 'Castles', 'Counties' and 'Granges' with a sprinkling of Prairie tanks for good measure. (Author)

on Sunday mornings. Perish the thought! Surely part of the 'buzz' of furtively tip-toeing between rows of engines was the certain knowledge that we shouldn't have been there.

Holidays and trains

As the fifties progressed so it slowly but surely dawned that many of the locomotives that paraded through my local hunting ground were seen again and again. Such things as shedplates and depot allocations entered the equation. Until the spring of 1959 I had to make do with copies of the single volume Ian Allan ABCs, those for the Western and London, Midland regions. The cost of a combined volume at 10s 6d was way out of my reach. Consequently the mysteries of the Southern and Eastern regions gradually unravelled after looking through the combined volumes of more affluent friends. What on earth were these pages full of numbers beginning with '3' and '6'?

It was my good fortune that summer holidays came my way twice a year. Why little notice was taken of these distant railways is a mystery to me now. Perhaps there was just so much else to occupy my time. A fortnight at Dawlish Warren, Devon in 1959 proved to be the breakthrough when hitherto unseen 'Castles', 'Halls,' and many others were added to my collection. It was also the first time that I had been armed with a combined volume 'ref', bought a couple of months earlier at Snow Hill station and taken home with reverence. I couldn't wait to underline Southern and Eastern numbers.

The holiday definitely started well. Tickets were bought well in advance for an excursion train to Devon that departed from Birmingham Moor Street at around midnight on Friday. My memory of the journey is remarkably clear, starting with me wandering off to the front of the train to get the number of 'our' 'Castle', and incurring much parental wrath in the process. It turned out to be No. 4037 *The South Wales Borderers*, a Newton Abbot engine at the time I have since discovered. The entire journey to Bristol was spent hanging from the carriage window amongst luggage piled high along the length of the corridor, in a vain attempt to see anything that passed by. On arrival at Temple Meads some time was spent waiting in the station and a brisk balancing act to the front of the train produced the spectacle of Bath Road sheds illuminated beneath the yard lights. Amongst the expected 'Castles' and 'Halls' were two 'Britannias', one of them, I remember, was No. 70029 *Shooting Star*. That would impress my mates! After what seemed an eternity we reached Exeter in the early hours of Saturday morning and had to change trains for a local to Dawlish Warren. Disembarking at St Davids I could hardly believe my eyes. There, amidst the confusion of passengers, station staff and luggage trollies, lurking in the shadows, was the unmistakable outline of a Southern 'Pacific'. Once again, for the umpteenth time since leaving Birmingham mom and dad were left to worry as I set off on my quest for a number beginning with '3'. It turned out to be 'Battle of Britain'

No. 34079 *141 Squadron* and it looked magnificent to this 11 year old. Another vivid memory of the next few minutes is of straining my eyes through the side of the footbridge as a 'Warship' enveloped the entire station with vibration and noise as it roared past on the down through road.

Eventually we caught the connection and were deposited at Dawlish Warren. The ensuing two weeks were spent watching trains on the sea-wall and persuading mom and dad to take me to Exeter so that I could spend some time at Central station. How many times it worked I can't remember, but it was several. Sitting on the platforms watching Pacifics, Moguls, T9s, Z class tanks and many more was far better than a matinee at the Regal! *Cunard White Star* was the first 'Merchant Navy' I saw and can remember running my fingers along the huge, gun-metal nameplate, perhaps to make sure that I was really there.

Back on the sea-wall all of the earlier D600 'Warships' were underlined as were most of the D800 series up to No. D809 *Champion*. Several 'Counties' were added to my list and I was surprised, and delighted to see one or two Southern light Pacifics working on the Western. Subsequently this mystery was solved when it was discovered that this was regular practice to allow SR drivers to learn the route to Plymouth just as Western crews did on the SR route.

What a great holiday, and an important summer in other ways because I had left junior school and would start at Lordswood Boys in September. At least I would be armed with some impressive Southern 'cops'.

The following year, 1960, could have been a bit of a let-down holiday-wise because we headed for a fortnight at Exmouth, just across the River Exe from the previous year but too far away to see engine numbers on the sea-wall. To counteract this nondescript railway resort I had taken the precaution of writing to British Railways to apply for permits to visit Laira and Exmouth Junction sheds, in dad's name of course. What the 'powers that be' thought of his handwriting I don't know, but amazingly the

required permits duly arrived just prior to our holiday. They were for a particular date and time and for twelve persons! Recollection of the train journey from Birmingham escapes me except the trip from Exeter Central to Exmouth behind a Standard Class 3 tank. An experience repeated several times during the ensuing two weeks.

We never did make it to Exmouth Junction shed; dad couldn't find it, so he said! Laira, however, was different. Dad and I set out from Exmouth arriving at Exeter Central very early where we caught a train to St Davids. The prospect of a journey along the coast road through Newton Abbot to Plymouth was mouth-watering and the promise of a perfect day began when No. 1024 *County of Pembroke* slid into St Davids with our train. Approaching Plymouth, after running alongside the River Plym, Laira shed yard was in full view and packed with engines. I recall a very smug feeling knowing that shortly we would be paying an official visit. At North Road station we found out which bus to catch for the long ride back out to Laira. On arrival in the shed foreman's office dad did some nifty talking to explain the missing ten persons in our party and eventually an elderly railwayman arrived who was appointed to be our guide. Sadly my notebook no longer exists but I remember several 'Castles', 'Counties', 'Halls' and 'Granges' not seen before and a myriad of tank engines including the tiny saddle tank, No. 1363. Having exhausted every nook and cranny we reported back to the foreman who kindly stamped my 'ref' with the official Laira rubber stamp. He also suggested that we might pay a visit to Friary shed, which we duly did before returning to North Road where, as if to order, 'West Country' No. 34104 *Bere Alston* was waiting to take us back to Exeter.

1961 was a bad year. We went to Folkestone and, apart from one day when I managed to escape on my own to Ashford sheds, a trickle of Southern electrics was the only fare. Later that year dad passed his driving test and at last we had a car. During the war he had been a driver and found himself behind the wheel of anything from Jeeps and staff cars to tank transporters

and I could never understand why he had to take a driving test. Be that as it may, he was now the proud owner of a brand new Austin A40 in Sutherland green, an odd looking vehicle, a cross between a saloon and an estate. The bilious colour didn't help either! At the time of writing a near neighbour has one, now a collector's item, and I occasionally gaze inside and wonder how four of us, complete with tons of luggage, managed on our journey to Cornwall in the summer of 1962. This holiday began with a near disaster while searching for our hotel on the outskirts of Newquay. Coming off a steep uphill junction on to a main road our trusty A40 started to tip backwards, too much luggage in the back perhaps! As the bonnet began to rise dad and I, sitting in the front seats, bounced madly up and down in an effort to reach terra-firma. We slid slowly backwards and watched, with great relief, as the bonnet resumed its accustomed position. A unanimous decision was made to avoid that particular junction during the next fortnight.

This was to be the last holiday that we spent together as a family. In subsequent years either mom or dad had to stay behind to look after the shops which were becoming busier. In retrospect I'm very grateful that I took full advantage of the opportunity and bought a rover ticket that allowed unlimited travel in Cornwall. All the main sheds were visited with a trip to Wadebridge, to see the last of the Beattie well tanks, thrown in for good measure. Thankfully I still have the relevant notebook and can confirm that Laira was 'bunked' three times during the fortnight. Other sheds receiving the same treatment were Penzance, St Blazey, Plymouth Friary, Wadebridge and Newton Abbot, although the latter wasn't included in my rover ticket. For some reason Truro was missed, perhaps I was thrown out. 'Warships' were in charge of practically all the top link passenger services in Cornwall by this time with the mediocre, drab looking D6300s on secondary duties although I did see a few 'Counties' and 'Granges' filling in and several steam/diesel combinations. In later years I learnt that 1962

was the official end of steam in the county and, indeed, Penzance lost its allocation at the end of the summer timetable. The first 'Western' class diesels had recently entered traffic and a few were seen at Plymouth where, as a matter of coincidence Nos D1004 *Western Crusader* and 1004 *County of Somerset* were seen together at North Road station. One of the highlights of my wanderings was to ride across the Royal Albert bridge several times, an ambition since Cuneo's marvellous poster featuring Brunel's masterpiece had demanded my attention on many station platforms during the previous year or two.

Unfortunately the box Brownie had remained with the family on the beach at Newquay, and as a result, I have absolutely no photographic record of this most enjoyable fortnight. The notes are some compensation though, parts of which are reproduced here. This was to be my last holiday where trains took priority and 1965 found me staying with three buddies, in a holiday camp at Douglas on the Isle of Man – freedom had arrived along with the mixed delights of wine, women and song. Railways only occasionally claimed my full attention.

The reader may be questioning the relevance of holidays to my present work, with some justification perhaps. In mitigation I would have to say that these recollections, and many others that serve to fuel my imagination, are priceless, as is the very fact of 'being there', the thrill of seeing a rare engine, of walking around Laira sheds surrounded on all sides by the smells and sounds of everyday working steam, the kindness of the foreman, but most of all the excitement and anticipation of setting out on these adventures. Perhaps my enthusiasm could have been directed more usefully elsewhere to other interests but it was the railway that fired my imagination and I was eager to drink in all I possibly could. Now, when confronted with a blank canvas I can draw on these experiences, savour the aroma and hear the sounds. Maybe its the difference between an adequate railway painting and a convincing one. Who knows, but I'm sure of one thing – I wouldn't have missed it for the world!

Palaces of delight – New Street and Snow Hill

During the last 15 years or so New Street and Snow Hill stations have figured in at least a dozen of my paintings of which more than half have been commissioned. City railway stations such as these became an intrinsic part of people's lives, particularly until the late fifties when almost everyone used them at least once a year for their summer holidays and many thousands used them daily as commuters. My father, for example, used the train regularly when we lived in Winson Green to travel to his job as a coach-trimmer at the James motorcycle company in Small Heath, catching the Prairie-hauled local at Soho & Winson Green and travelling across the city through Snow Hill. Such stations were considered with deep affection by countless citizens, others of course could take them or leave them, but not many I think. the deep emotions felt for Snow Hill surfaced in the late sixties with the unbelievable announcement from British Railways that it was to close. How could such a once-crucial part of the city disappear? Anyone who knew about such things was aware that New Street could barely function smoothly at the best of times, let alone with the extra traffic generated by the closure of its once-great rival.

The death of Snow Hill was slow and undignified, main line services ceased in 1967 and local trains gradually disappeared until the last one, a single unit railcar operating all stations to Wolverhampton, ran for the last time in 1972. The full realisation of the station's impending demise finally dawned for many Brummies late in 1969 and early 1970 when the once-impressive façade and Great Western hotel were reduced to rubble and the gap between the platforms was filled in to form a car park. The unthinkable had happened and the folly of closure was realised too late to save the old station.

A new Snow Hill was built and opened to passengers in 1988 on the same site with none of the former grandeur, but at least trains are running through the tunnel again.

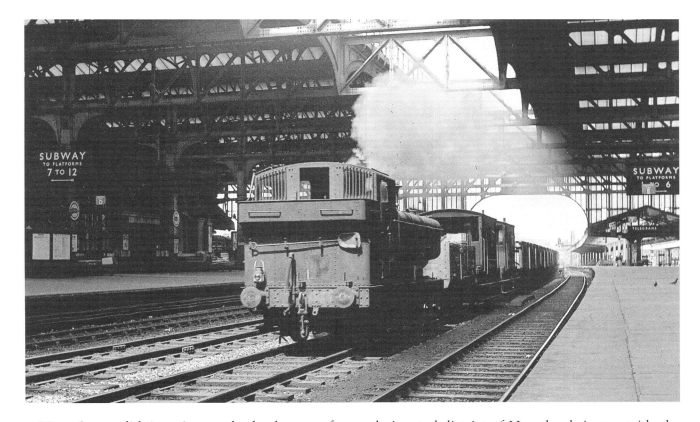

Although taken as late as 24th July 1965 this picture epitomises the quieter moments at Snow Hill with a pannier tank, No. 9608, trundling a trip freight along the up through line passing a couple of pigeons. The view also gives a good impression of the light and airy atmosphere of this much-loved and lamented station. (David K. Morris)

Train mad kids in Birmingham were fortunate in that both stations presented examples of almost every locomotive type from the London, Midland and Western regions. The only notable types missing were 'Duchesses' and 'Princesses' and even these could be seen on Sundays when West Coast traffic was diverted, and although New Street was by-passed, a short train ride to Aston or Stechford was all that was required to see them. Also, when diesels took over many West Coast Pacific duties in the early sixties 'Duchesses' were then sometimes used on Wolverhampton to Euston trains which ran through New Street.

When exactly I first discovered these two palaces of delight in the centre of Birmingham is lost in the mists of time but it almost certainly

New Street didn't quite reach the hearts of Brummies in the same way as Snow Hill, perhaps because it was bigger, busier, dirtier, more confusing and not as attractive, but in a way it was much more a part of the city. A public way, Queens Drive, divided the North Western and Midland platforms and busy city roads surrounded the entire station. Complete rebuilding, begun in 1964 and completed in 1967, almost obliterated the station that I knew as a kid and created an underground concrete tomb with a corresponding character. At the time of writing there is talk of building a new inter-city station for Birmingham in the newly

designated district of Heartlands just outside the city centre. This would leave New Street to cater for local traffic only.

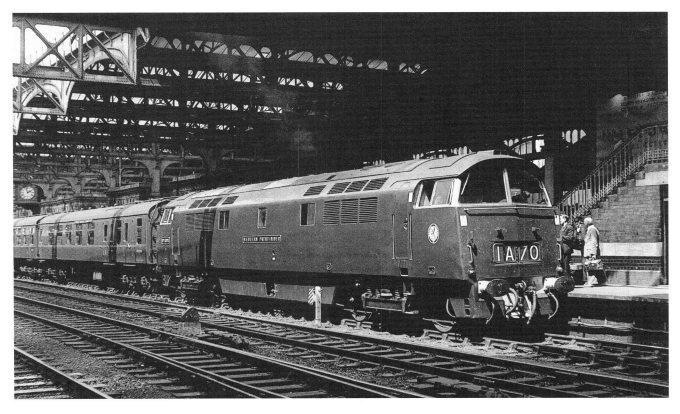

It is late in 1962 and the 'Western' diesel-hydraulics have recently ousted the mighty 'Kings' on Paddington expresses. No. D1001 Western Pathfinder, *resplendent in maroon livery, stands bathed in sunlight at Platform 7 in charge of a Paddington train. I was always fond of these engines and photographed them extensively in the early 1970s. (Author's Collection)*

involved family holidays. Snow Hill was the first I came to know well. Our school football team would often meet for away matches outside the main entrance and to kill time, waiting for late-comers, we would wander around the grand concourse, with boots dangling around our necks, peering into the large glass display cases that contained the wares of local companies. It wasn't long after this that entire days were spent on the platforms. My lasting impression of Snow Hill is of a very well ordered, light and airy station. A vantage point at either end would allow everything to be seen with the added attraction at the up end of the spectacle of trains erupting from the long tunnel from Moor Street. During quieter periods there was plenty to occupy our inquisitive minds, including putting pennies into a bright red machine which would stamp out our names, and other less choice phrases, on a metal strip. One of the bay platforms at the north end was the scene of my first footplate ride, together with a couple of mates. It may have been just a few yards but the illicit journey aboard Prairie tank No. 4175 made us feel like we'd won the pools!

There was a steady flow of Paddington expresses which included the 'Inter-City' and the 'Cambrian Coast Express', almost exclusively hauled by 'Kings' and 'Castles' with 'Halls', 'Granges' and the odd 'Manor' and Mogul on secondary services. The 'Cornishman' made up a trio of named trains seen here. Prairie tanks fussed in and out with local trains until about 1958 when DMUs began to take over. A Great Western railcar regularly worked the 'Dudley dodger'. The through tracks were often occupied by freight trains waiting for the road and pannier tanks scurried through with great regularity. 'Counties' were the most scarce passenger types and were usually greeted with shrieks of delight by the waiting rabble. On the other hand, many 'Castles' and 'Kings' were seen so often that they were booed and slandered as 'crates'. The 'King' with the bell, No. 6000 *King George V*, better known to us as 'King Ding', was subject to this humiliation countless times.

There is no doubt that Snow Hill was a fine

station but as soon as I got to know New Street, in all its polluted glory, there was no contest for my affections, what a place this was and the exact opposite of Snow Hill. It was much noisier, dirtier, busier, far more chaotic and, to this kid at least, it had atmosphere, loads and loads of atmosphere. To me it was everything a large station should be and I found the locomotives more interesting too. It seemed that the only local main line engines seen there were the Bushbury 'Jubes', everything else came from – well, everywhere. Crewe North, Camden, Holbeck, Derby, Trafford Park, Bristol Barrow Road and many more depots contributed to the never-ending variety to delight youthful connoisseurs of motive power at New Street.

The layout of the station, with its two distinct sections, made it necessary to choose a vantage point carefully so as not to miss anything – heaven forbid. My favourite pitch was at the east end of Platform 6 adjacent to signalbox No. 1 where, in a siding, were usually one or two open wagons loaded with the station's refuse. The smell from this, particularly on a hot summer day, was powerful and combined with the ever present scent of fish permeating through from the Midland side made a potent cocktail. Smoke and steam paled into insignificance by comparison. 'Scots', 'Jubes' and 'Black 5s' could always be seen in the North Western platforms and the latter two types were also common over on the Midland where Bristol's three 'Patriots', Nos 45504, 45506 and 45519, were also regulars, the latter, *Lady Godiva* becoming a firm favourite. Standard designs were represented by regular visits from Class 4 and Class 5 4-6-0s and, to a lesser extent, 'Britannias'. As with the GWR Prairie tanks over at Snow Hill, Stanier 2-6-2 and 2-6-4 tanks and Fowler 2-6-4Ts did the fussing at New Street. The period in question here is 1958 until 1963, and I can just remember 2P 4-4-0s and Compounds but they had almost gone in my heyday apart from Nos 40936 and 41168 which lingered on in store at Monument Lane sheds until late in 1961.

Unlike Snow Hill, New Street was an 'open'

station and as such you didn't require a platform ticket to set foot into the grandstand. This had the added advantage to us kids in that we could come and go as we pleased, particularly useful when told to scram by station staff, only to reappear a few minutes later as if nothing had happened. There was rarely a dull moment at New Street, even if only passing by on the top deck of a bus. When I had to travel to school from Acocks Green to Bearwood I would sometimes travel via the city centre and well remember 'copping' a Holbeck 'Scot', No. 46109 *Royal Engineer*, one morning in 1960.

Named trains using the station were the 'Pines Express', the 'Devonian' and the 'Midlander'. The latter has been mentioned before in these pages and will be familiar to readers by now. The 'Devonian' was invariably worked by one of Bristol Barrow Road's 'Jubes', not always in the best of condition, externally at least. As with 'King Ding' over at Snow Hill, the likes of *Shovell, Trafalgar, Leander, Kempenfelt, Barfleur, Rooke* and *Galatea*, were loudly booed by the gallery during their frequent visits. Derby 'Jubes' were also used on this train ensuring visits from *Seychelles, Wemyss, Basutoland* and others. Oddly enough, I only remember seeing my namesake, No. 45649, in New Street a handful of times even though it was a Derby engine.

The panorama from the east end of Platform 6 provided a good view of arrivals and departures from both the North Western and Midland sides and also offered a superb broadside angle of Euston departures and so forth from Platform 3. Memories of 'Scots' waiting for take-off come flooding back, occasionally they would have been double-headed with a 'Black 5' or 'Jube'. I distinctly remember Nos 45709 *Implacable* and 46153 *The Royal Dragoon* in this very situation sometime in 1961, and actually took a photograph with my plastic camera. Unfortunately there was only room for the 'Scot, and just the tender of the 'Jube'. I swear that there was plenty of scope in the viewfinder for the complete engine.

During the fifties main line diesels in the shape

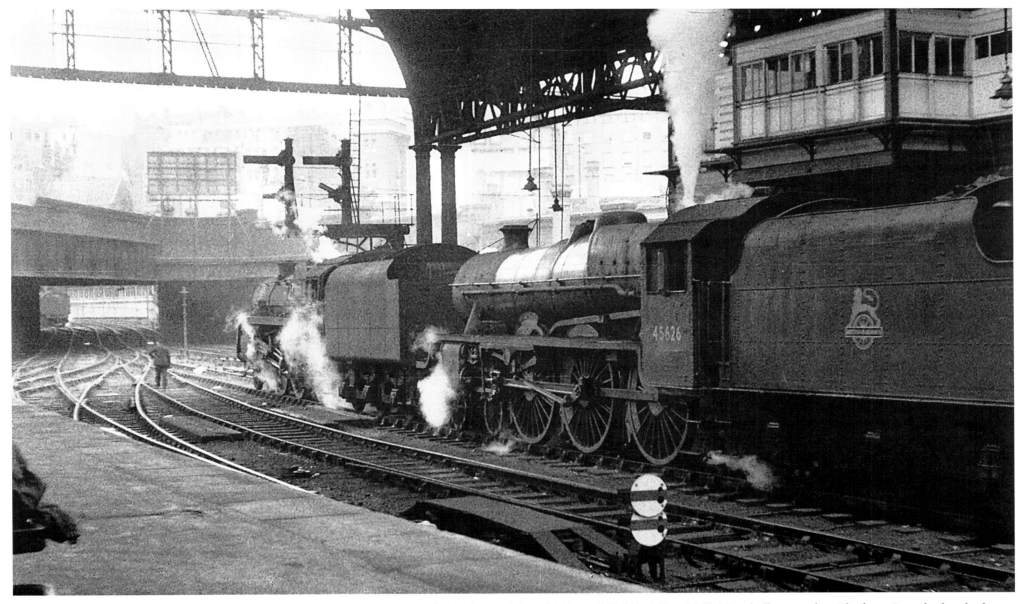

Double-headed trains were a common sight at New Street. Here, a Standard Class 5, No. 73141, and 'Jubilee' No. 45626 Seychelles *stand at Platform 9 at the head of a Bristol train. This is the old Midland Railway side with signalbox No. 4 on the right and box No. 5 visible in the background through the bridge. (Author's collection)*

of the ex LMS Co-Cos Nos 10000 and 10001 and the ex Southern trio, Nos 10201–10203 had become familiar to me, but the year 1958 saw other more portentous main line arrivals in the form of Sulzer Bo-Bos of the D5000 series, later to become Class 24s. Early examples could be seen in New Street, often with trains to Rugby and Peterborough, and were thought of as a brief aberration. How could these puny looking machines compete with Staniers 4-6-0s? Little did we know, in our youthful innocence, that this

was the beginning of the end, and by 1960, some of the Bristol line trains were in the hands of the more impressive looking 'Peaks' while English Electric Type 4s, later known as Class 40s, were seen regularly on North Western line trains. During the following two or three years these two types had practically ousted steam from passenger services. At Snow Hill similar changes were happening and by the end of 1962, 'Western' class diesels had sent the mighty 'Kings' to their doom. It all happened so quickly

and yet I don't recall recognising the signs until it was too late.

Maybe I have given the impression that my preference was for New Street and that would be correct, although if a time-travel ticket came my way with the proviso that only Snow Hill was on the agenda, then I would go back like a shot. I'm glad that both of them become so familiar to me, but for sheer spectacle and atmosphere New Street won hands down.

Earlier I mentioned that the only main line

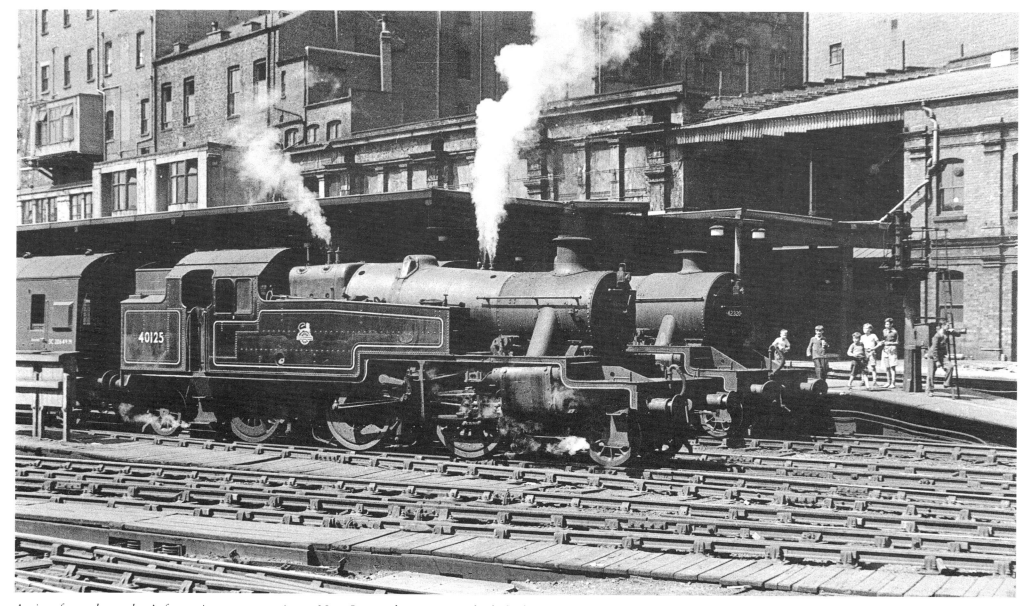

A view from the author's favourite vantage point at New Street, the eastern end of Platform 6, with a brace of local trains preparing to leave, watched by a small gallery of young 'Brummies'. A Fowler 2-6-4 tank, No. 42320, is at Platform 3 and Stanier 2-6-2 tank No. 40125 at Platform 4. This is the old London & North Western side where the overall roof was removed after the war following bomb damage. (Author's collection)

passenger engines not to frequent New Street were 'Duchesses' and 'Princesses'. Since becoming the proud owner of a Hornby-Dublo *Duchess of Montrose* when the model was first introduced in 1953, I longed to see those magnificent machines in the flesh. My wish came true during the course of a school day trip by train to Southport in 1958. As our special train passed slowly through Crewe station there it

was, probably ex-works and shining like a new pin – No. 46232 *Duchess of Montrose*. 'Sir, sir, I've got that one!', I yelled. Whether or not 'sir' knew about trains, I've no idea, but I recall that he showed some interest before telling me to calm down and to stop hanging out of the window before I got my head knocked off! The sight of 'my' 'Duchess' made me determined to see more and by 1959 we were 'clued up' enough

about their workings to plan a summer Saturday trip to the West Coast Main Line. My companions were a couple of school friends. We made our way to New Street, caught a DMU to Lichfield City and walked to Trent Valley station. We were impatient and the walk seemed to take forever. I've since discovered that the distance is just over one mile. On arrival we spied the main gallery, just off the south end of

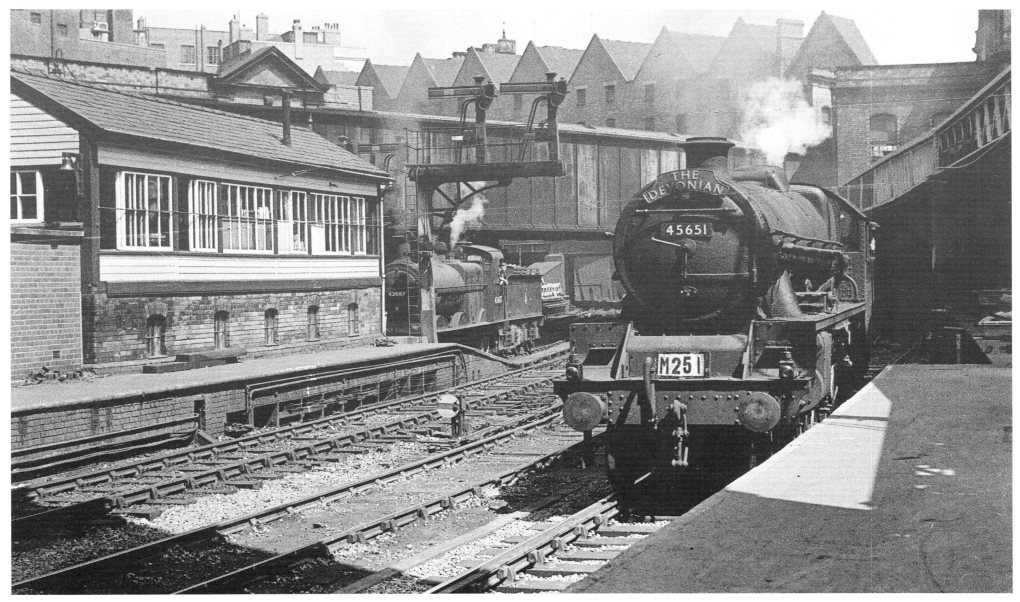

The southbound 'Devonian' running into Platform 10 behind Bristol 'Jubilee' No. 45651 Shovell. This particular engine seemed to be in and out of New Street several times a day and must surely have carried the most unglamorous but appropriate name ever given to a steam locomotive. In the background, an ex Midland 0-6-0, No. 43687, rests against signalbox No. 2 between station pilot duties while just visible behind its tender is the fence at the end of Platform 6 upon which the author and countless other kids perched to witness the New Street comings and goings. (Author's collection)

the platforms on the down side, and rushed to join the madding throng. Just then a red blur hurtled by at terrific speed. I realised that it was a 'Princess', but couldn't make out the number. We joined the rabble and discovered that it was No. 46207 *Princess Arthur of Connaught* (strange name for a princess), my first 'Prinnie'. What a great day it turned out to be, we saw

about 15 'Semies', another three or four 'Prinnies' and lots of 'Jubes', 'Scots' and 'Patriots'. Many of these appeared later in the day on return workings.

We soon learnt to identify the numbers even though the average speed must have been 80 to 90 mph. The terms 'peg on the clanger' and 'peg on the main' became part of our vocabulary and

could also be used at Tamworth, a location explored shortly after this trip. Here, the New Street to Derby main line crossed the West Coast tracks and produced 'Jubes' and 'Black 5s' in abundance on a summer Saturday. Mean-hearted firemen of southbound engines on the Midland line would sometimes infuriate us by dangling their cotton-waste rag over the last digits of the

cabside number making it impossible to read. If it was a 'namer' and clean then this was no problem but otherwise we just hoped that someone on the high level platforms had the answer.

Nuneaton and Rugby soon entered the West Coast equation. Rugby in particular was a marvellous location, in addition to the Great Central line crossing over our heads on the famous bird-cage bridge, there was the engine shed and the test plant. Double-headed 9Fs rattling loudly across the bridge on the 'Windcutter' freights remain a vivid memory as does my first sight of a North Eastern B16. Engines would constantly potter along to the turntable close to the bridge and liven up the few quieter moments, and there was always the sheds to 'bunk'.

The reader must bear in mind that these are memories from over 30 years ago, and we all know that some things improve with age. A year to a child seems like a lifetime, hours and hours spent watching trains at Birmingham's premier stations and loitering with intent by the West Coast Main Line seemed the most natural way to spend our time. Judging by the armies of balaclava-clad kids seen on Saturdays noisily occupying platform ends and grassy banks, it was a common conclusion. Hopefully these brief recollections will give some idea of what inspires my work. Photographs, of course, are invaluable images to refresh our memories and without the efforts of those who were willing, able and aware enough to record those exciting days on film for posterity, where would artists such as myself be? – but the most important element from my point of view are the personal memories. Elusive elements such as sounds, smells and the feeling of anticipation and excitement rarely emerge from a photograph and these ephemeral qualities are what I attempt to portray through my paintings.

Muck, grime and decline

It is often said that nostalgia is dishonest and judging by many artistic offerings depicting days gone by, when every Christmas was white and June was always flaming, then perhaps this statement is correct. Railway art is probably more susceptible than most to perpetuating this myth. As an artist I am occasionally torn between a client's rose-tinted recollections and my own preference for 'telling it like it was', to coin a phrase, or at least how I think it was.

Anyone of my vintage or older who has any knowledge at all of railways whether as a railwayman, passenger, enthusiast or even someone who happened to live by or near the railway will know from experience that steam railways were inherently filthy, very filthy indeed. Remember finding a seat in a compartment carriage, sitting down and disappearing in a cloud of smoky dust from the jazzy patterned, moquette-covered seat or experiencing a sauna bath in winter when the steam heating leaked beneath the seat enshrouding everything in sight with steam? Wearing your best gear was not recommended when travelling by train in the days of steam.

Maintaining locomotives, rolling stock, stations, engine sheds and other installations in anything like a presentable condition required far more attention and resources than British Railways could muster. Consequently, from the beginning of the Second World War, through the fifties until the end of steam in 1968, a clean engine was, more often than not, an indication that it was recently out of the paint shop rather than being well cared for. Low wages on the railway were not conducive to attracting workers who could find better paid jobs with more pleasant working conditions in most other industries. After the war until the sixties there was virtually full employment in Great Britain and workers could afford to be choosy to a certain extent. Certainly, motive power depots in the larger cities and towns found it practically impossible to recruit cleaning staff. Even so, passenger locomotives, particularly from the top

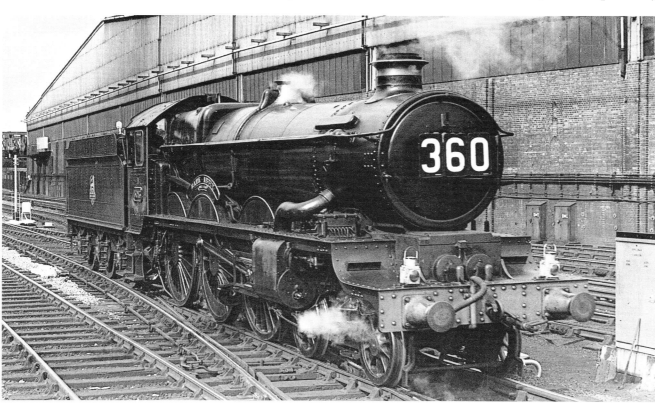

Worcester shed enjoyed a reputation for keeping its 'Castles' clean, exemplified here by No. 5083 Bath Abbey *seen backing out of Paddington after bringing in an express in the mid 1950s. (Author's collection)*

This picture illustrates the difficulty that we had deciphering the cast numberplates on grubby Western engines. Although a fairly close-up view of a Churchward 2-8-0 in typical condition, trundling through Gloucester Central in the early '50s, its number, 2835, is barely readable. (Author's collection)

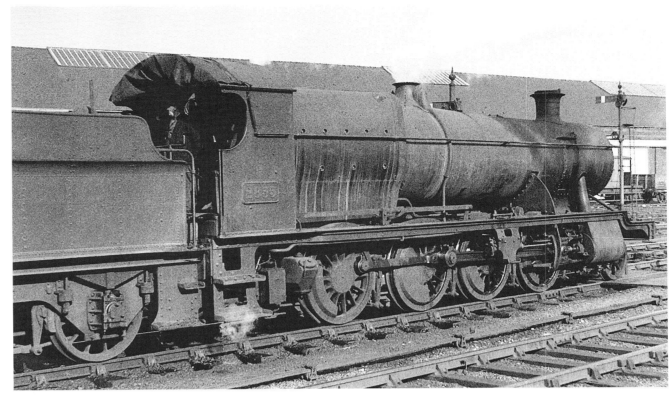

links, were generally turned out in a presentable condition, indeed several depots earned quite a reputation, against all odds, for the immaculate turn-out of their star inmates.

Bushbury 'Jubilees' for example, most of which I saw day after day during the fifties, were invariably 'spick and span' and carried some most evocative names into the bargain. *Meteor, Samson, Atlas,* and *Polyphemus,* spring readily to mind and were to me amongst man's most glamorous creations. When they proudly carried the 'Midlander' headboard the vision seemed complete. Worcester shed too could always be relied upon to look after its 'Castles' for the Paddington expresses. Similar examples of pride in the job could be found at other sheds throughout the country, often through the

ceaseless efforts of individual shed-masters, but they were swimming against the tide.

Hindsight is an alarmingly precise science and

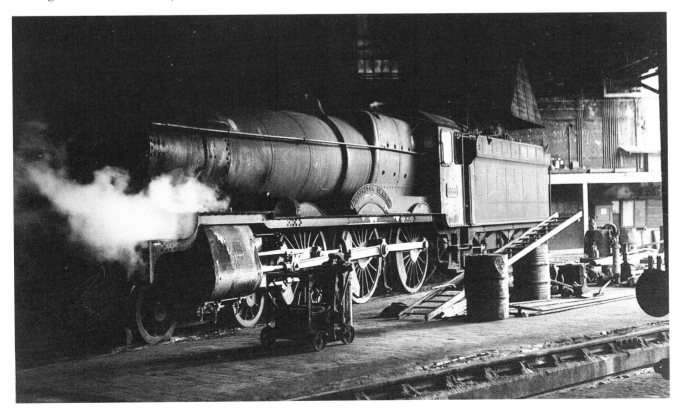

we now realise that Britain's steam railway was rapidly entering its death throes. Kids of the period simply saw what they saw and there was little to indicate that the end of a glorious era was but a few years away. After all, brand new Standard locomotives were still being built and this was confirmed by our Ian Allan ABCs by the reassuring phrase beneath whole classes, 'Engines of this class are still being delivered'. We knew that steam engines had a long shelf life, an average of at least 30 years, so what could possibly happen to annihilate them before say – 1990? The rest, as they say, is history!

Little had changed since the turn of the century, steam reigned supreme, semaphore signals guarded the tracks, there were thousands of signalboxes, hundreds of engine sheds and the ambition of many small boys was still to be

This 'Grange', No. 6848 Toddington Grange, is unusual in that it retains its name and numberplates at this late stage of Western steam, although its condition is typical. A scene at Old Oak Common on 17th January 1965. (Author)

engine drivers, so perhaps we could be forgiven for thinking that things would be all right for the next 20 or 30 years at least. Small clues to the contrary came our way. Occasionally a brand new Sulzer Type 3 diesel (later Class 33) would shyly emerge from the nearby Birmingham Railway Carriage & Wagon works and scuttle past en route for duty on the Southern Region. Grandad presented me with a Hornby-Dublo Bo-Bo diesel, No. D8000 by request, for Christmas 1958, or was it '59? 'You've waited for it, and its worth it' ran the blurb in *Meccano Magazine* – how could I resist? Diesel multiple units were taking over local services from Prairie tanks on the Western and during my 1959 holiday in Devon, 'Warship' diesels were wearing 'Torbay Express' and 'Cornish Riviera Express' headboards, once the property of 'Castles' and 'Kings'.

Maybe the one event that made me wonder about the future of steam was when the 'Westerns' craftily usurped the 'Kings' on Paddington expresses during the second half of 1962. At this time I would often sit on my bike on Tyseley bridge during the evenings watching trains. One by one the 'Kings' disappeared and the 'Westerns', some green, some maroon and one in that strange 'desert sand' livery, slowly but surely muscled their way in. My notebooks reveal that a visit to Stafford Road sheds in September confirmed my fears – there, lying cold and dead, some with sacks over the chimney, were no less than nine 'Kings'. Old friends snatched away without a word.

I digress, back to muck and grime. Collecting numbers was often infuriating where really dirty engines were concerned, particularly on the Western lines. Many panniers, Moguls and 2-8-0s passed by without fear of being identified. The small, cast number plates were so well camouflaged by layers of dirt that some escaped our notebooks. Often, one of our number would be posted actually on the embankment close to the line in an effort to decipher the front number plate. Fortunately the freight trains hauled by these engines were not famous for their speed exploits and between us there was usually

enough time to figure out if the engine was a 'cop' or not. 'Kings' and 'Castles' on this line were a mixed bunch when it came to cleanliness but I seem to remember that many appeared to be in good nick. It's a strange thing but to this kid engines on the Western always gave the impression of being smaller and fussier, with their copper-capped chimneys and brass adornments, than the Midland 'Scots' and 'Jubes' for example. Even 9Fs and WDs looked smaller when seen on the Western!

Many readers will consider the following remark as sacrilege – but I soon tired of the 'Kings' as I had seen them all by about 1956 with the exception of No. 6014 *King Henry VII*, a Stafford Road engine, which somehow escaped my attention until 1959. How this happened I've no idea, but according to my notes it did! 'Castles', on the other hand, were always welcomed, especially those with the aircraft names which seemed particularly glamorous with that little bit extra beneath the nameplate which read 'Castle Class'. Why didn't the 'Earls' have this?

'Halls', 'Granges' and 'Manors' were often as filthy as the purely freight engines and were sometimes difficult to identify which was annoying because we knew that many came from far-flung sheds and would surely have been 'cops'. My favourites on the Western were the 'Counties', due partly no doubt to their rarity value but also because they looked so different to the company's other passenger engines with their straight nameplates and hunched-up appearance when fitted with double chimneys. Also it was difficult to see the entire class with many allocated to Cornish and Welsh sheds. Perhaps this added to their special aura.

Back on the Midland line 'Scots' that appeared on the Glasgow train always seemed to be clean with many also having the added embellishment of a regimental badge atop the impressive nameplate. What wonderful machines and how powerful they seemed. Strangely enough 'Patriots' that happened along 'my line' were in the usual disreputable condition and I can well remember seeing No. 45501 several times before

realising that it was a 'namer', so insignifican and covered in grime was its *St. Dunstan* nameplate as to render it virtually invisible.

Apart from leaning from a carriage windo catching red hot 'smuts' in the eye the place *pa excellence* to enjoy railway filth was the engin shed. This grubby environment was, of cours perfect for small, grubby boys and could hav been made for them. Our parents were rarely i any doubt as to what we'd been up to and ou arrival home must have been akin to welcomin a steam locomotive into the living room. Station weren't the cleanest places on Earth either. W spent many hours waiting for trains and ofte entire nights at such beauty spots as Carlisl Citadel and Crewe, with the occasional carton c cold milk, from those vending machines tha made a resounding 'thud', for sustenance. Wha a marvellous place Citadel was and what a grea name for a station. The small hours produced constant procession of sleeping car, parcels, ma and newspaper trains, many with top-lin motive power, 'Duchesses', 'Scots', 'Jubes' an after 1963, 'Britannias'. 'Jinties' would fus about as engines were changed and station sta would be busy loading and unloading parcel and mail. A few hours at such a place woul permeate our clothes with an intoxicatin sulphurous, sooty smell. I'm surprised that on of the famous perfume houses has not markete an aerosol version of this.

Watching freight trains pass by presente other hazards, particularly on windy days. Cattl trains, coal trains, ore trains and so forth woul leave their own distinctive aromas waftin around in the breeze, not to mention dust, lon after their noisy passage.

The thought of freight trains brings fort many memories. My bedroom in Winson Gree was directly opposite the railway embankmen which, as mentioned previously was mainly goods line. The sound of clanking buffers an juddering brake levers accompanied my lapse i to the land of nod most nights.

Regular visits to steam centres for referenc are an important part of my work and places lik the Severn Valley Railway and the Great Centra

Railway have a marvellous working atmosphere. The National Railway Museum at York is also an invaluable venue, although it would be marvellous if one of the turntables and its occupants could be allowed to 'weather' into a real working roundhouse to create the real feel of steam. Perhaps visitors could sign an indemnity form to relieve the museum of all liability for damage to clothes from oil and grease. It is interesting to note that some steam centres have recently allowed their engines and stock to become work-stained, realising perhaps that many of us prefer it that way. A greasy clean locomotive is far more convincing than one that has been cleaned to the point where it could be an ornament.

Adventures with cameras

As with many readers I suspect, one of my biggest regrets is not having a camera of any description during my younger years. Apart from the occasional holiday snap taken with the family box Brownie, which I always took charge of, the first time my trigger finger made the acquaintance of a shutter button was in 1961 when my grandad handed me a camera which he had scrounged from a rep' in his shop. The maker's name escapes me, but it was a nasty little plastic job, with matching lens, that used 620 film. We lived in Acocks Green at the time and at the first opportunity I was prowling around Tyseley sheds clicking away at everything in

sight. On the way home the film was handed into the local chemist and after the longest week, the results were collected with trepidation. Carefully taking the photographs from the neatly presented wallet must rate as one of the low points of my life. What greeted me was a set of grey, fuzzy, small square images which, on much closer inspection, were my carefully taken Tyseley shots. Certainly they were nothing at all like the Treacyesque pictures that were expected. It slowly dawned that my new camera was only remotely happy in bright sunlight with stationary objects and even then the definition was awful. Conditions at Tyseley had been quite beyond its capabilities.

There was no way that my paltry funds could afford a better camera and so for the next two years I persevered with the plastic job and consequently managed to produce just a handful of half reasonable pictures. Fate stepped in by depriving me of one grandmother, when my grandma Evans sadly died in 1963 and left each

of her grandchildren £15. This was a small fortune in those days and I knew exactly what to spend it on. During the two years of frustration with my awful camera I had got to know the local chemist, whose shop was partly devoted to camera equipment and accessories. He had been kind enough to teach me a thing or two about photography and now had a good idea of what I wanted. Many of my contemporaries were using Halina viewfinder cameras but, being naturally contrary my unexpected windfall was spent on a Voigtlander Vitoret, a fairly straightforward viewfinder camera with a top shutter speed of 1/125 of a second, a damned sight better than the 1/30 of a second that I had judged the old one to have, and a much better lens.

Tyseley once again was the first target where, it so happened that the following day promised to be, literally, quite special. A special train was due from Leeds and a 'Clan' Pacific was the planned motive power. So, on 26th March 1963, my brand new camera braced itself to record

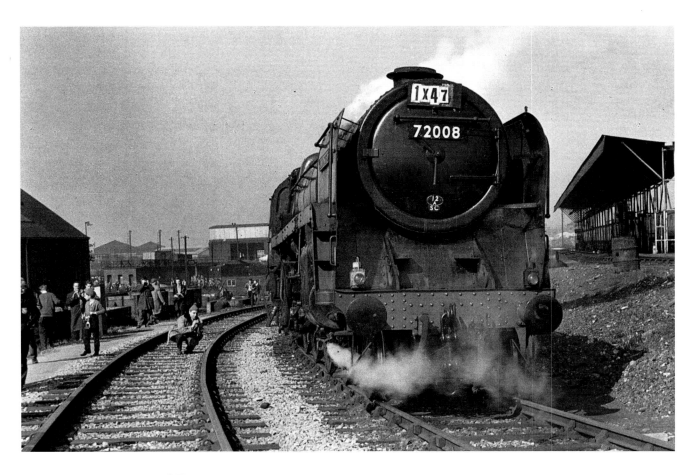

A shot taken the day after buying a new camera, a Voigtlander Vitoret. This was about the fourth exposure on the first film and shows a rare visit by a 'Clan' Pacific to the Birmingham area when No. 72008 Clan Macleod *called at Tyseley on 26th March 1963 with a special train from Leeds. It later headed north with No. 7929* Wyke Hall *attached to the front as pilot. Other like-minded, camera toting characters can be seen plying their trade. The re-fuelling bays for DMUs are on the right and the shed yard and coaling plant on the left. (Author)*

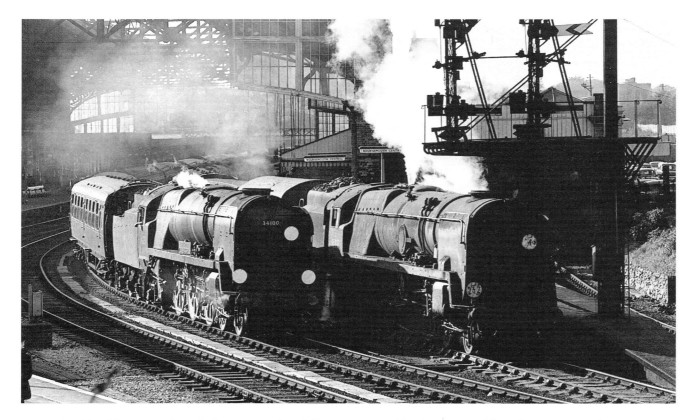

No. 72008 *Clan MacLeod* for posterity. The results were much more encouraging, the sun had shone for one thing, and these were the first of many that this camera was to take all over the country. Although, as with most of us it seems, the photographs were almost entirely locomotive portraits with the exclusion of practically every other facet of the railway. Such wasted opportunities which I'm probably still trying to make up for.

It soon became apparent that my new camera could not cope with fast moving trains, but again, lack of funds precluded any advancement in the technical department, although I did buy a second-hand enlarger and began to produce my own prints in a makeshift darkroom in the bathroom at first, much to mom's delight. Eventually, by 1966 I had saved enough money to afford a second-hand Pentax and a 135 mm lens. Unfortunately this coincided with my declining interest in railways, but the camera did accompany me to Scotland and several trips to the Southern Region where I enjoyed aiming the big lens at Bulleid Pacifics which seemed to lend themselves to the telephoto treatment. At the time I felt that the compression of perspective achieved by using this lens made these already puissant engines appear even more so. This particular piece of hardware became a firm favourite and in retrospect I probably used it far more than was necessary, or even sensible, and did so for many years. It still lurks in my camera case and occasionally comes out to play.

Photography in general became an important part of life throughout my college education and later led directly to landing a job as staff photographer with a local newspaper in 1970.

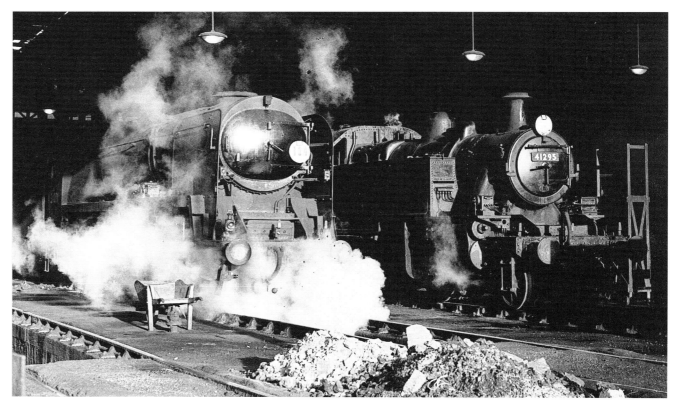

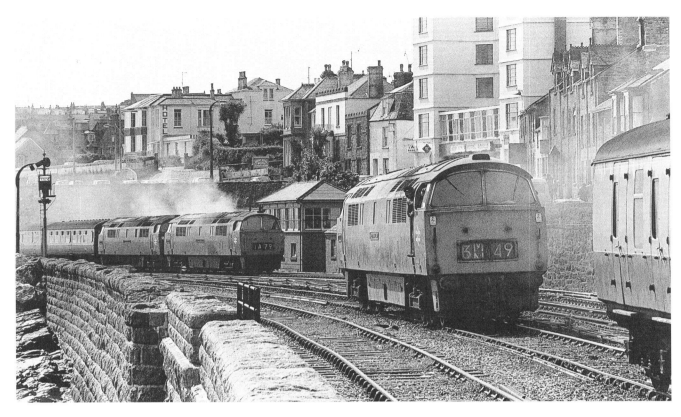

For some time the *Solihull News* had been using my sports pictures which I would shoot at weekends and deliver on Monday mornings. During one of these visits the editor invited me into his office and offered the position there and then. Apparently their regular photographer was away on long term sick leave and they were stuck. So began an interesting and enjoyable time shooting every sort of incident you could imagine. I soon learnt how to doctor the diary to make more of the work that interested me, such as fashion and sport, and less of the mundane presentations, openings and interminable civic functions involving the Mayor, whom I must have photographed hundreds of times. One memorable job involved a demonstration drive around the Rover cross-country test track in the newly introduced Range Rovers and another to cover a visit by Grace Kelly to open a fashion show.

In 1971 I became a freelance photographer for a while undertaking work for several newspapers and magazines, again specialising in sport, mainly football and rugby. Shortly afterwards marriage came along and the problem of where to live was solved with a job as an off-licence manager in Solihull which included living accommodation. The camera took a back seat for a while, only emerging to take family pictures. Railways hardly appeared in the viewfinder at all.

Cornwall was a regular holiday haunt and on our way to St Ives very early on a summer Saturday in 1973, we were stuck in the

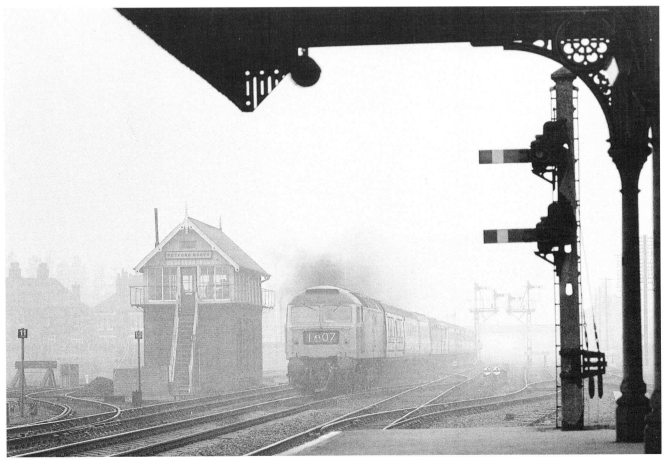

I often find adverse weather conditions far more exciting than bright sunshine and much more of a challenge. This shot of a Class 47 heading an up East Coast express was taken at Retford on a foggy day in 1974. (Author)

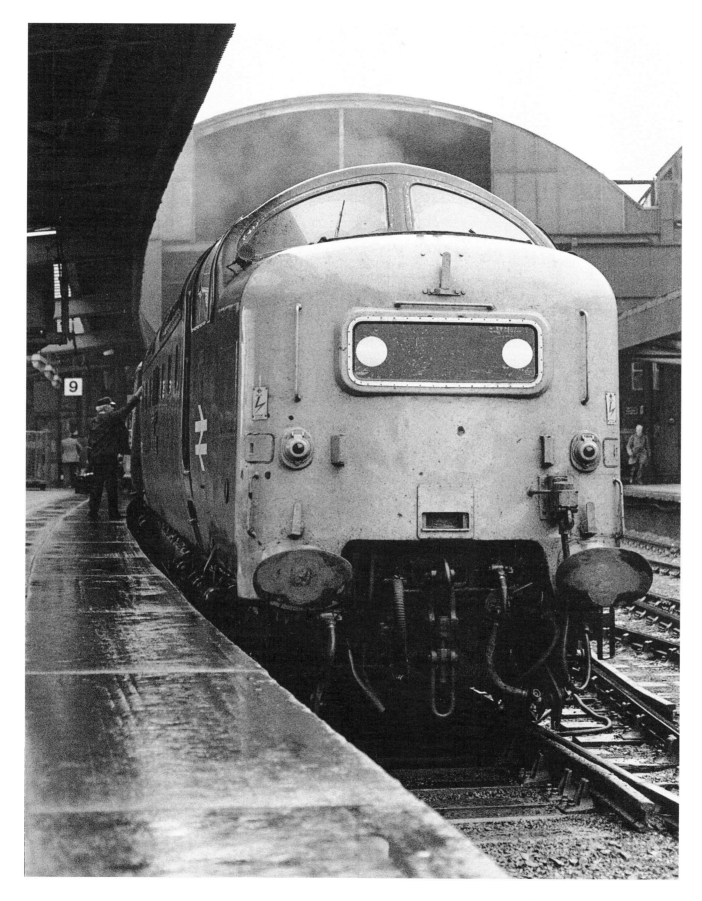

A foul day at Newcastle Central in September 1976 surrounds the powerful image of 'Deltic' Class 55 No. 55022 Royal Scots Grey *at rest after bringing in an express from King's Cross. Just prior to taking this photograph I had bent my car somewhat when I hit a concrete bollard in torrential rain by the railway at Gateshead. (Author)*

traditional traffic jam on the A30 through Hayle – a by-pass has since been built. Nothing had moved for some considerable time and I found myself staring in a resigned way at the impressive viaduct leading into Hayle station when a train from Penzance came into view headed by No. 1073 *Western Bulwark*. Immediately my mind raced back to Tyseley bridge in 1962 when the 'Westerns' first appeared on the scene and I was quite taken aback to find them still intact – it now seemed such a long time ago. The following two weeks were spent taking photographs along the Plymouth to Penzance main line.

Thereafter, for the next three or four years, I made a point of getting out once a week whenever possible to photograph the current railway scene, soon getting into the swing of things again. Expeditions were planned with regard to weather, light and motive power, although this time my plan was to record more than just locomotives. My output was quite prolific for a time and regular batches of prints were submitted to Ian Allan Ltd and appeared, in some quantity in their publications, particularly *Modern Railways* where a couple of my photo-features were used – 'Brummy Freight' and 'Birmingham, Inter City Crossroads'. Regular visits were made to various locations on the East Coast Main Line to shoot the 'Deltics', and 'Westerns' suffered a similar fate, wherever they went.

I developed a style which tended towards low-key pictures which were often deliberately grainy. The mood and atmosphere of such offerings satisfied my sensibilities at the time and were the very opposite of the perfectly lit, pin-sharp record shots preferred by many enthusiasts with the result that a few derogatory letters came my way via the offices of Ian Allan Ltd. This only

served to convince me that I must be doing something right!

The simple fact that I actually took all of those photographs, including those taken with my plastic camera, has proved to be a godsend to my work as an artist. Concerns about lighting conditions, angles and choosing a location are all to be considered when planning a painting, quite apart from their value as a straightforward record of course. It is vitally important to be aware of just what is involved when taking a photograph prior to using the information for a painting. Mistakes and misrepresentations are all too easy to make when data is translated onto canvas by the ill-informed artist. The effect of lenses of different focal lengths must be understood thoroughly. An image taken through a telephoto, for example, when transferred to the foreground of a painting will appear to be 'wrong'. Conversely an image through a wide-angle lens used in the background will also appear to be out of place. Only once have I used all the elements of a photograph in a painting and in this case it was a combination of two exposures.

I have mentioned before that photographs are a vital ingredient to any artist depicting the steam age and when working on a canvas I am usually surrounded by dozens of them, not all totally relevant to the work in hand, but which may have a flavour of my intentions. The camera is an important part of my armoury even when dealing with contemporary subjects and is a convenient way to gather reference material quickly and as a back-up to any drawings and sketches that may be made at the same time. Many artists tend to become secretive when questioned about the use of photographs, feeling perhaps that the employment of such things would be considered as cheating by somehow short-cutting the perceived traditional artistic process. Long before the invention of the camera many of the great masters used a form of epidiascope to record complex scenes. Giovanni Canaletto for example, achieved his remarkable views of Venice in the 18th century by using such a system to establish the basic drawing and to ascertain the effect of shadows and so forth.

An awful lot of nonsense is spoken when the relative merits of photography and paintings as artforms are discussed. Both produce pictures but a snapshot is a world apart from a skilfully executed and well considered photograph taken by an artistic cameraman. A picture is a picture whatever method is used to create it and surely the viewer can decide whether it is art or not.

Since the end of steam on British Railways in 1968 only a handful of photographs of steam specials have emerged from my cameras. The whole carnival that surrounds these trains is the exact antithesis of what I enjoy about railways. The day in day out aspect of the railway, locomotives working, simply doing their job, hauling passengers and freight in all conditions is what appeals to me, not a highly polished one-off event surrounded by thousands of camera-clad individuals fighting for the best view. This may sound uncharitable to the efforts of preservation societies, but it is most certainly not intended to be. Many preserved lines are terrific and some are mentioned elsewhere in these pages.

Making a living

My interest in art increased during my time at Lordswood Technical School and was encouraged by two teachers, Mr Rankin and the appropriately named Mr Hart. Another subject which intrigued me was technical drawing. I enjoyed using pens, pencils, brushes, clay and so forth to create something from nothing whereas some other subjects, particularly chemistry, filled me with dread. Each time I crossed the threshold of the chemistry laboratory it was as though a portcullis dropped around my brain allowing no sensible thought to escape. By comparison, the freedom of the artroom seemed like heaven.

During a parents' evening in my fourth year my parents were told by the art teachers that perhaps teaching, particularly art, could be my forte and the T.D. teacher, Mr Harrington, informed them that I was excellent design draughtsman material. Both of these careers obviously appealed to them with mom being particularly smitten by the former idea. Unfortunately I had other plans. The only thing in my mind was to go to art college at the earliest opportunity, but this desire was kept under wraps until the last minute when the time came for them to sign the necessary forms. They were a little disappointed perhaps, particularly mom, but gave their consent willingly.

The course chosen at Birmingham College of Art & Design was a pre-diploma one-year stretch which was designed to give students a taste of each of the diploma subjects which could be pursued full-time for the remaining three years. These included fine art, graphic design, industrial design, dress design, photography and so forth. Fine art was my choice from the beginning but it quickly became apparent that any tendency towards representational work was frowned upon. Apart from life drawing classes very little else made sense. Being given a number of straight lines and filling space meaningfully with them was not exactly what I had in mind. Had I been a little older and more mature my reaction may have been very different but in my rush to get to art college I had left school after taking 'O' levels whereas most of the other students had stayed on for their 'A' levels. Nevertheless I persevered and recall vividly a particular tutor's reactions when a group of us returned from a drawing session in the city centre. On seeing my drawing of New Street station in the early stages of reconstruction he wasted no time in informing one and all that this is exactly what we should *not* be doing, preferring instead, other more esoteric offerings. Disillusioned but undaunted I completed the year only to discover that I was too young to begin a diploma course and would have to repeat the exercise or apply for a vocational course. The thought of another year with unsympathetic tutors held absolutely no appeal and so I enquired about the alternatives. The only course that seemed vaguely to suit my needs was technical illustration, and in September 1965 I embarked on three years of training to produce elaborate perspective drawings, discover the

The author with Standard tank armrest at the Severn Valley Railway, 1998. (Ben Hawkins)

During a visit in 1971 I discovered that there was a regular open air exhibition of paintings in the winter gardens, where, for a nominal fee, it was possible to rent a few square feet of hanging space. A few watercolours and drawings were quickly produced and sold. Although the prices were extremely modest I enjoyed the feeling.

One incident from this venue sticks in my mind. A local gentleman had spent a long time gazing at my work and eventually asked if I had ever painted the 'Bournemouth Belle' in Bournemouth Central station. 'Funny you should ask that', I replied, 'the picture you describe is back at my studio and I could bring it tomorrow for you to see!' This was not strictly true of course, but as usual I was in need of funds and returned quickly to my parents' home, gathered together a few materials and reference, and worked through the night on the 'Bournemouth Belle'. A frame and mount were taken from another picture and next morning, bright and breezy, I appeared at the winter gardens, having the brand new watercolour complete with a 'reserve' ticket and sat back in the sunshine feeling pleased with myself. My would-be patron duly turned up, was delighted with the picture and bought it there and then. The exact price escapes me but it would have been between £25 and £40 for the modestly proportioned painting.

Highly unethical perhaps but extremely satisfying, and my first commission. I haven't seen the painting in question from that day to this and would no doubt be horrified if I did, but I was delighted with it at the time and definitely enjoyed the experience. In fact, this incident probably hardened my resolve to earn a living from painting.

At this time I was earning a crust from freelance photography and selling the odd painting, although my income from the latter

delights of annotations, cut-away sections, exploded views, lettering and airbrush. Not really what I had intended to do but my fellow students were great company and some remain good friends to this day.

At this time students were virtually guaranteed a good job at the end of the course and I was offered a position at Metro-Cammell, Washwood Heath, not far from home. The fact that this company was well known, and still are, for producing railway locomotives and rolling stock amongst other things, was quite coincidental as was the fact that dad had been a coach-trimmer there before and after the war. As the company had never employed a technical illustrator before there was some uncertainty about my role. This suited me fine and I was able to create needs which they had never realised existed and produced artist's impressions of

locomotives for Malawi and Pakistan and of proposed London Underground stock, oil tankers and containers amongst other things, working from blue-prints supplied by the army of draughtsmen. After a year or so of this enjoyable employment design and production of new rolling stock began to slow down, consequently the need for my artist's impressions subsided likewise and I found myself having to produce technical illustrations almost exclusively. This aspect of the work was less appealing and, having no commitments at this time, I handed in my notice and became a freelance photographer. Throughout my stay at Metro-Cammell I produced a few paintings, mainly water colour, some of railway subjects and managed to sell most of them.

In the summer of 1970 my parents moved to Bournemouth and I visited them quite often.

was minute. Nevertheless the desire to paint full-time was strong. For as long as I could remember paintings of all types had fascinated me. Cuneo's pictures on BR posters and model railway catalogues, amongst other things, grabbed my attention and during 1969, give or take a year or two, there was an exhibition of the man's railway work in the foyer of the *Birmingham Post & Mail* building in the city centre and many hours were spent pouring over them. Likewise a small exhibition of the wonderful work of J. M. W. Turner at the Birmingham City Art Gallery found me gazing in awe. One painting in particular, 'Coniston Water', encompassed everything that I felt a work of art should be, it was lyrical, vital, dripping in mood and atmosphere and so beautifully executed. Some time was spent considering the best way to remove it from the gallery without being noticed. These experiences and countless others determined my desire to play a part in the world of art, however small.

Meanwhile, real life took over. As previously mentioned, marriage came along in November 1971 and the problem of somewhere to live was solved by taking a job as an off-licence manager for Mitchells & Butlers in Solihull. In spite of the unsociable hours, Cath and I coped easily with the task, leaving time to devote to painting. From about 1975 customers were treated to a display of four or five paintings, mainly of railway subjects, and for the first time I was struck by how many were interested in trains; all types of people. Amongst those who showed an interest was Bernard Apps, now my Quicksilver Publishing partner.

At this time my paintings were framed at a small gallery in nearby Dorridge, called Garrett Fine Arts. The owner John Letts, a well-known Midlands' sculptor, kindly offered to organise an exhibition of my work during the spring of 1977. This comprised a dozen or so paintings and drawings and there was some useful local press coverage and public reaction was very encouraging resulting in most of the work being sold.

Later the same year we moved to a private house complete with mortgage. The move was far from straightforward because of the nature of my job although this was resolved when I negotiated a new position in the display department of the same brewery. Unfortunately, shortly after moving, this new job fell through, as apparently the director who had authorised my appointment had had a disagreement with the company and left under a cloud. So, we had a new house, a new mortgage and a new son Ben, but no 'proper' employment. Christmas was approaching fast and I became a milkman for a while, which of course included the financial boost of festive tips. I'm afraid I found the job loathsome and couldn't wait to complete my round each day. The soul purpose of the work seemed to revolve around getting back to the depot and then home as quickly as possible. My resignation was handed in a week into the new year, so ending the shortest career in the milk delivery business.

Perhaps the move to become a full-time painter should have been made much earlier but I was always mindful of my family's opinions and the advice of others who had continually warned of the possible pitfalls of trying to earn a living in this way. Also they were definitely of the opinion that painting was not a 'proper job'. Nevertheless the thought of reaching old age and wondering what might have happened had I taken the plunge was beginning to haunt me and the feeling that I could make a go of it was strong. Consequently, during the summer of 1978, much to the dismay of family and friends I entered the precarious world of the self-employed artist.

The problem of where to work was solved quite by chance when I called to see John Letts at his new studio in Shirley, Solihull. Not long before, he had moved into a group of garages which had been knocked into one and converted into offices. John was using these premises as a modelling studio and workshop but had a couple of rooms doing very little. He immediately offered the use of these rooms for a nominal rent and I moved in. Part of one room was partitioned off to form a darkroom and another

became my studio. This was to be my workplace for the next six years and most congenial it was too. John is one of the kindest, most generous people it has been my good fortune to meet and, amongst other things, kept me supplied with cigarettes and newspapers. The only thing I could afford to give in return were my old brushes which were employed to fill awkward corners of rubber moulds used to produce his limited edition sculptures.

Making any sort of living proved to be extremely difficult and the dire warnings of the doubters came back to haunt me on many occasions and still do, but occasionally things went well enough to bolster my spirits. To enable us to function as a family – eat, pay the bills and keep the building society happy – Cath took some lousy jobs to supplement my meagre earnings. Sadly, we are no longer together but her help and encouragement during those difficult years are remembered with deep gratitude.

From the start I specialised in railway paintings simply because that was what I knew and loved, but never thinking that sufficient work would come my way to remain in this field until the present time. Occasionally I would paint other subjects but as more railway work was undertaken I began to realise what a vast subject this was. Some commissions opened new doors, particularly historic and foreign subjects, enabling me to research hitherto unknown areas.

In 1984 we decided to convert the loft at home into a studio so ending my 'garage' period. Once again a prerequisite was that there should be a darkroom and with some canny planning this was organised across the landing from my new studio. Much has happened since then but at the time of writing it is still my base.

Today, 75 per cent of my output is to commission but in the early days it was a case of selling paintings wherever and however I could. Galleries proved to be very hit and miss, seldom buying work outright and sometimes very reluctant to pay promptly after selling work left on a sale or return basis. Another annoying aspect was that they rarely kept a promise to

inform me of the whereabouts of any pictures sold, with the result that I have effectively lost contact with them for future reference. For a few years John Letts and I staged regular exhibitions at the Solihull library gallery, usually during November and December. This proved to be an effective combination with John's sculptures occupying the floor space whilst my work hung on the walls. Several commissions came my way from these occasions and slowly but surely patrons of my particular art materialised to the extent that now I have some two year's commissioned work ahead.

Some people may be upset by the following remark, but painting for a living is much the same as any other business. Unless prospective clients see the work of an artist then they will never know that it exists. With painting the obvious solution to this problem is publishing in its many and varied forms. We are surrounded in our day to day life with printed images of all types, many of them derived from paintings, on anything from tablemats to advertisement hoardings and every conceivable item in between. Whatever an artist's speciality there is usually a commercial outlet to suit and with railway art these are probably more clearly defined than with some other subjects.

The urgency to see one's work in print can easily cloud considered judgement when discussing and considering publishing deals, resulting in the artist signing over all-time, worldwide copyright for very little financial return thereby handing the publisher carte blanche to use the work in any way they think fit, and make a profit into the bargain. In 1979, I was approached by a major London fine art publisher who was keen to reproduce a painting as a fine art print. Obviously this was very flattering and I duly signed an agreement without taking much

notice of the small print, which I later discovered signed over all my rights to the picture. My reproduction fee, the going rate for the time, was for use of the painting as a fine art print, or so I thought. Over the next two or three years it appeared as a jigsaw and a gift token card with no further fee forthcoming. Great care has been

taken when signing agreements and contracts since, but no doubt mistakes will always be made. At about the same time one or two less than ideal publishing arrangements were entered into with the resultant prints not living up to expectations by a mile. . . Still, we live and learn and gradually, by trial and error, listening to good advice and bitter experience I became more aware of how to guard against such spurious deals and I'm still learning!

To date my work has been used for greetings cards, collectors' plates, calendars, fine art prints and in books, newspapers and magazines. One of

the most constant and rewarding associations has been with Eversheds the well-known calendar and diary publishers. Jim Wilson, then a director of the company, approached me in 1984 with a view to producing a set of six pictures for use in the 1986 advertising calendar to be known as *Footplate*. I've no idea how he got to know my work but he obviously liked what he saw and so began a happy relationship that continues to this day, in fact recently, the pictures for the 1999 *Footplate* calendar were delivered. This will be the 14th year, making a total of 84 paintings!

It is often said that a creative temperament is not compatible with sound business sense and, although I've muddled along fairly well, I have always found the selling side of things distasteful. Perhaps I cope better nowadays but can still become quite embarrassed when showered with praise, particularly when offered in a patronising manner. Genuine criticism I enjoy and can handle much better. Perhaps we all need someone who has opposing business attributes and that someone came my way in the shape of Bernard Apps, a long-time acquaintance and now good friend and publishing partner. Together, we are Quicksilver Publishing, a business formed in 1988 to publish, promote and sell fine art prints of my paintings. We have long term plans to publish the works of other artists, not only those specialising in railways. The only proviso being that the work has to be excellent. Bernard, a self-confessed Philistine, is rapidly learning the finer points of art appreciation. Whether I am doing likewise with the business aspects of things is debatable!

The thrill of seeing my work in print never wanes and the fact that many more people can see, enjoy and own copies of my paintings in this way gives me great pleasure.

Philip Hawkins

The Paintings

Thornbury Castle

Wolverhampton Stafford Road sheds have been mentioned earlier and '**Thornbury Castle**', commissioned by Pete Waterman for the Waterman Railways Heritage Trust, was a great excuse to put memories into practice. Pete had been a boiler fitters apprentice at 84A in the late 1950s and remembers the place, warts and all, with much affection. Additionally, he had recently acquired No. 7027, which had languished at Tyseley for many years and plans to restore the engine to working order – no mean feat! Consequently there was absolutely no question over the location for the picture. The year is 1959 and No. 7027 was allocated to Old Oak Common and would have worked into Wolverhampton Low Level with a train from Paddington before adjourning to Stafford Road for servicing. This was a truly filthy place with many of the ancient buildings in a dangerous, dilapidated state. The 'Castle' is in a condition that I often refer to as 'greasy clean', not perfect but pretty damned good. This makes a pointed contrast with the squalid location, and a 'Modified Hall' buffered up to 7027 is in a condition known locally as 'Stafford Road green'. When the completed work was delivered to Pete at the Crewe Heritage Centre he showed me around the loco which was being dismantled. Parts stamped with the numbers of several other

Another "Castle"

'Castles' were amongst those already removed – fascinating eh!

A clear childhood memory is seeing the first double-chimney 'Castle', No. 7018 *Drysllwyn Castle*, or 'Drizzling Castle' as we called it! The year was 1956 and it was in spanking condition with the number clearly visible from my 'pitch' between the bridges. At last, I thought, the Western was catching up with the lovely chimneys seen every day on the London, Midland 'Scots'. To me the 'Castles' looked fine with this carbuncle, as described by many. An overabundance of perfection can be a little tedious and these chimneys gave, what was already one of my favourite classes, an edge over the ordinary members. What No. 7018, a Bristol Bath Road engine at the time, was doing in this neck of the woods I do not know, but it hung around for several days and became a firm favourite. Possibly it was running trials. In more recent years it has been strange to see the preserved No. 5051 running with *Drysllwyn Castle* nameplates, quite properly of course. At that time we knew this engine as *Earl Bathurst* and in fact, No. 7018 was the third wearer of the plates. The other had been No. 5076, which they graced from 1937 until 1941.

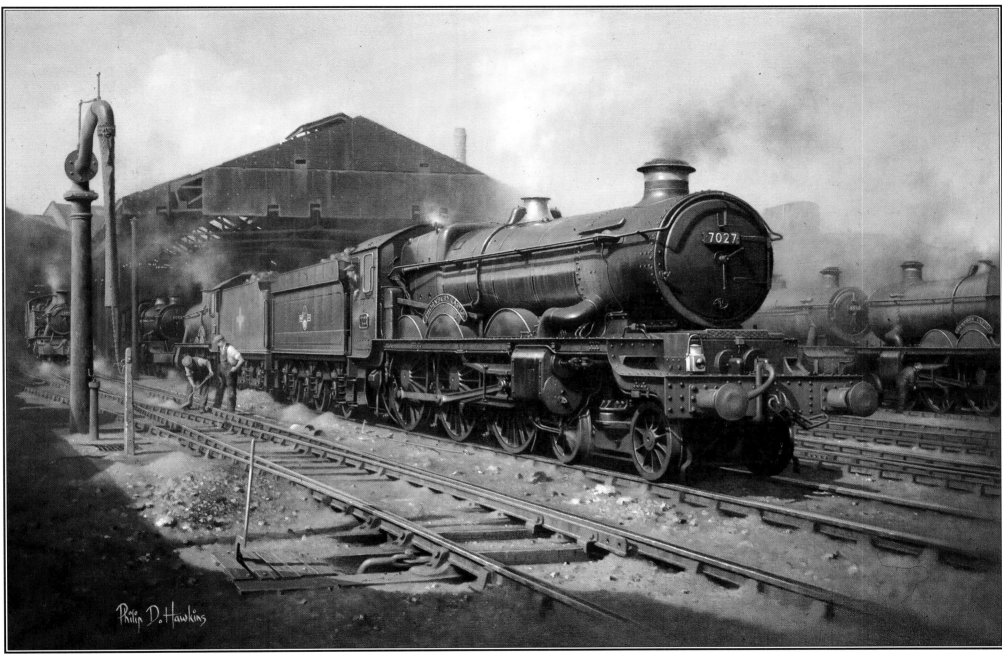

Thornbury Castle (1996)
Oil on Canvas 30" x 20"

Birmingham New Street/The Midlander

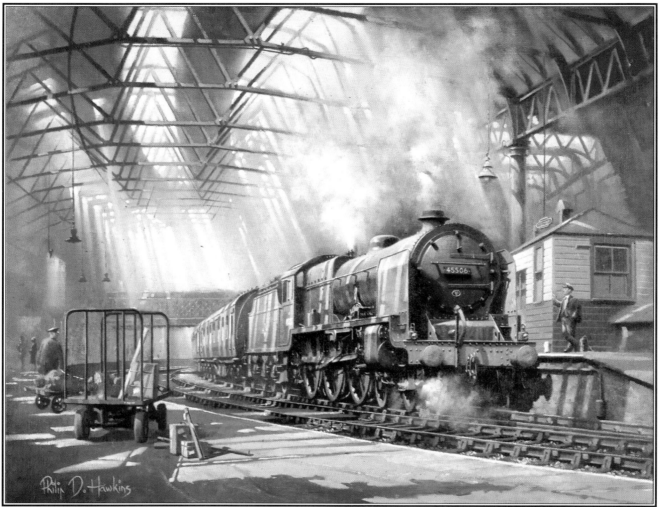

Birmingham New Street (1985)
Oil on Canvas 20" x 16"

In '**Birmingham New Street**' I have attempted to portray the atmosphere of my 'second home'. The engine is 'Patriot' 4-6-0 No. 45506 *The Royal Pioneer Corps* which is standing at Platform 7 with a train from its home city of Bristol which will be going on to Sheffield, York or Newcastle. It is 1959/60 and the time is soon after midday with shafts of sunlight forcing a way through the smoke and steam to create the sort of 'light cocktail' that today's photographers of preserved steam would kill for. The painting is now in a private collection in the USA.

'**The Midlander**' is a view of New Street from near my 'spot' on Platform 6 and features a 'Jubilee' 4-6-0, No. 45688 *Polyphemus*, running in from Euston in the mid '50s. The train is composed of ex LMS stock but painted in BR's 'blood & custard' livery. In the background, at Platform 3, a Fowler 2-6-4 tank is waiting to leave with a local train, perhaps for Lichfield, while a 'Black 5' has its thirst quenched at Platform 1. I must have seen *Polyphemus* hundreds of times. Throughout most of the '50s it was one of Bushbury's stud of 'Jubilees' and never wandered far from the Wolverhampton, Birmingham and Euston route. The 'Midlander' headboard seemed to be a permanent fixture. This painting was commissioned by Mr Andrew Harper, another 'Brummie' who also has the same fond memories of his favourite station as I. Interestingly the retaining wall, behind the engine, and some of the red brick buildings still remain to confine the present day concrete New Street. The Rotunda now dominates the centre background and the distinctive Worcester Street buildings above the signalbox disappeared during the rebuilding in 1964. With a generous helping of imagination it is just possible to picture this scene today, if you can ignore the plethora of overhead catenary equipment.

The sulphurous confines of New Street station were divided into two distinct sections, the London & North Western side and the Midland Railway side. This historical division was perpetuated by the LMS with ex LNWR and MR engines rarely straying over the 'fence'. When I became intimately involved with the place in the fifties, this apartheid was a little less pronounced but nevertheless the distinctive character remained. Trainspotters of the period would gather at two particular vantage points to be sure of seeing everything that slipped into and out of every platform. The east (London) end of Platform 6 was the favourite spot. There was rarely a dull moment and always the possibility that something 'rare' would show up. The old Midland side still retained its, by then, dilapidated overall roof and always seemed to smell of fish.

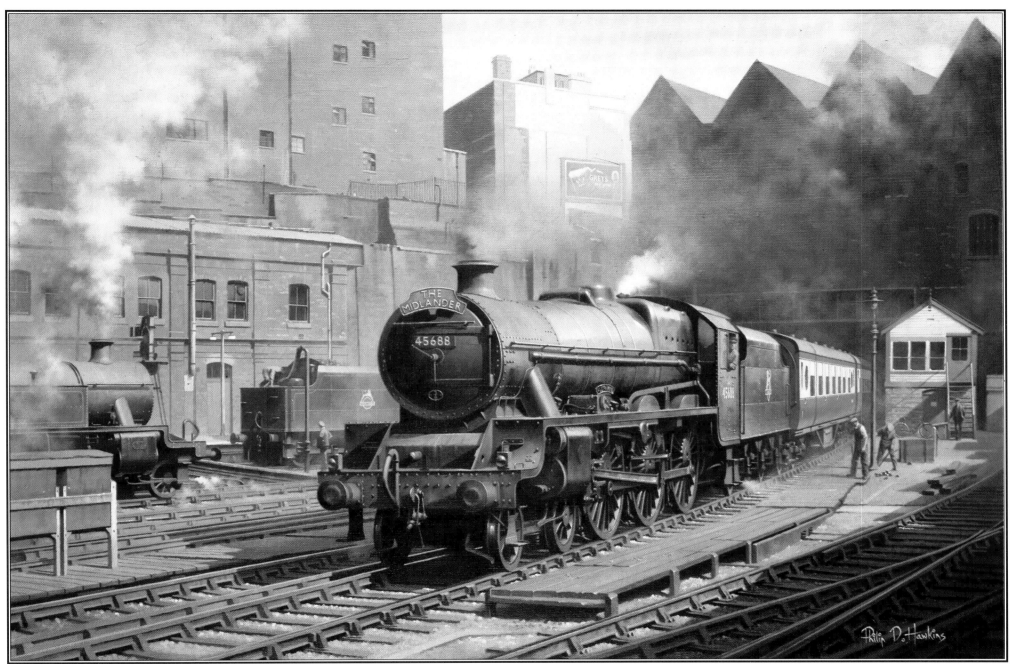

The Midlander (1992)
Oil on Canvas 30" x 20"

New Street 1957

Following the success of 'On Time' in 1985, the *Birmingham Post & Mail* decided to commission another painting the following year, again with a view to offering fine art prints to their many readers. The obvious choice was, of course, New Street station as a companion to Snow Hill.

Detail of roof structure & pillar.

odd planks missing

lamps, notices, etc supported thus

Being aware that in the popularity stakes New Street trailed behind its Great Western competitor by about 2 to 1, I clearly saw the task as having to produce something which would have at least as much appeal to the *Post & Mail* readers as 'On Time'. Early on, the period decided upon was to be the 1950s and that it had to be the old Midland Railway side of the station because I loved the dilapidated grandeur of that crumbling roof and the curves of the platforms. Also, I knew that there was no better time to be there than on a Bank Holiday when there always seemed to be trains queuing to get in and out.

So, the scene was set in my mind's eye, there just remained the rather daunting task of gathering the appropriate reference material. Here, the newspaper's photo library proved to be a gold mine of wonderfully evocative pictures, even of holiday crowds. Little by little, information was gathered. The locomotives were to be a 'Patriot', No. 45509 *The Derbyshire Yeomanry*, a Derby engine at this time and one frequently seen at New Street, and a 'Jubilee', No. 45682 *Trafalgar*, a Bristol Barrow Road engine and a 'crate' if ever there was one during my childhood. The roof, if anything, looks far grander than it actually was and if I were to repeat the exercise the 'dad and son' in the foreground would be sent back along the platform to concentrate the eye more on the locomotives and to emphasise their size. The composition is similar to 'The Bristolian', reproduced later in the book, and which had

Group for platform 10.

Light

Red tie

Show sharp creases with plenty of material.

Grey

turn-ups.

many of the same problems.

A mistake was made in the caption on the print of this painting by stating that it was August Bank holiday 1957 and I duly received a letter, a long letter, from a diligent gentleman who had made complete records of all workings on the Derby–Birmingham–Bristol route during the '50s. He was absolutely certain that the two engines would not have been seen together at New Street on this particular day, although they were both working on this line. Oh well! You can please some of the people etc, etc. The print did sell as anticipated – half as well as 'On Time'!

Grandma complete with luggage - on platform 9

Blue

Cream

Standing in front of loco 45682.

Basket with flask in view

Blue

Smarties

Brown

9th July '86

Green shirt

Grey flannel

right foreground, perhaps with suitcase.

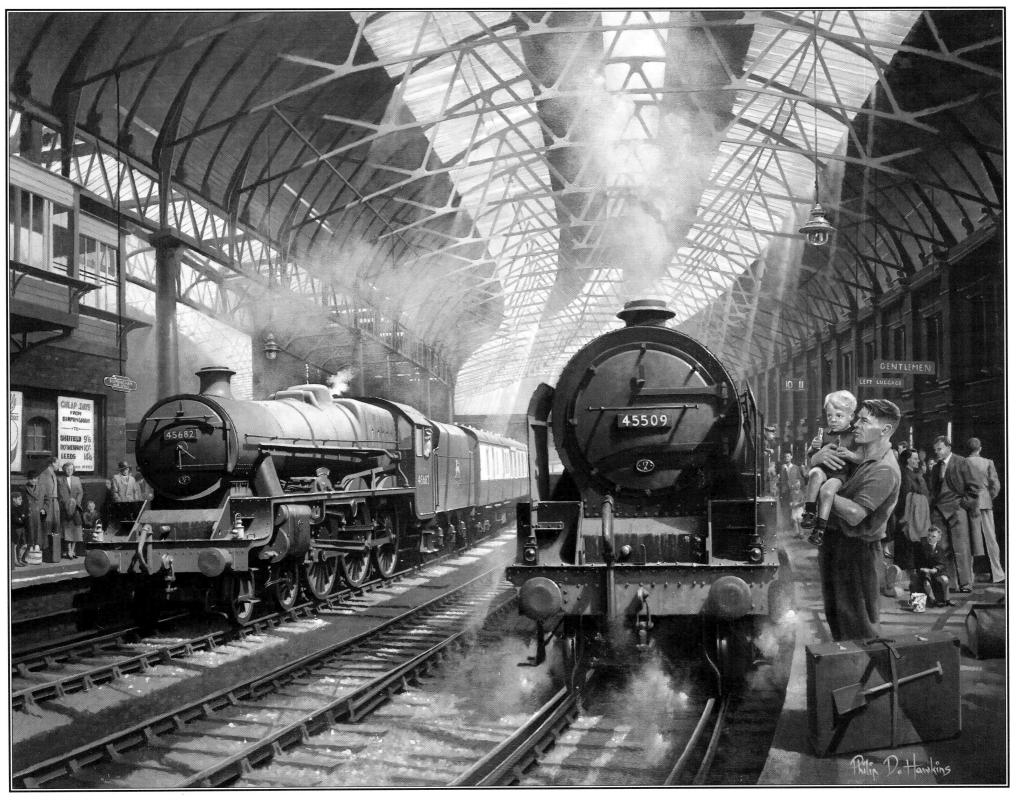

Collection: *Midland Independent Newspapers Ltd.*

New Street 1957 (1986)
Oil on Canvas 30" x 24"

41

On Time

The 150th anniversary of the Great Western Railway stimulated the *Birmingham Post & Mail* to commission a painting to commemorate the event in 1985. For obvious reasons a picture with very apparent local interest was required in order to whet the appetite of readers when the time came to promote fine art prints of the painting. There was really no contest – it just had to be Snow Hill station. That was the easy part, the rest was up to me. After considering various periods, locomotive types and trains, not to mention such things as viewpoints and angles, I decided upon the year 1947, the last before Nationalisation. The viewpoint had to be one that, although immediately recognisable, hadn't been 'done to death' in the railway press, particularly in fine art print form. After travelling in my time-machine around every nook and cranny of the station on which so much time had been spent as a kid, I settled on a view that would prominently feature one of the famous clocks. Now, as one of these was overlooking the concourse it had to be the one on Platform 7, the London side. It was only after making these seemingly logical decisions that I discovered that practically no photographs had been taken from anything

"Station Master
Mr Arthur Hammond Elsden"

like this angle and so the whole had to be worked out from scratch. Eventually the basic drawing was made featuring a 'King', No. 6008 *King James II*, on the midday Paddington train. The view chosen gave prominence to the initials GW on the tender and this, together with the clock and general impression of the station gave no doubt as to what and where it was. My son Ben is the lad seated on the suitcase and I was able to include an impression of the then stationmaster, Arthur Hammond Emsden, to add to the period atmosphere – he was quite a character I understand. Local railway historian Derek Harrison provided some useful reference for this work.

All in all a rather complicated picture to bring together but the effort was well rewarded when the first print run sold out within two months of the newspaper promotion. It was ultimately reprinted twice and has since been republished by Quicksilver Publishing. This picture involved me in a most unusual 'print signing' session when, on the occasion of the re-opening of Snow Hill Tunnel, I was asked by the *Post & Mail* to

sign copies for 'tunnel walkers' when they emerged into the new station after walking in the darkness from Moor Street. This one-off event was organised by the *Evening Mail* with donations from the £1 'walker's fee' going to local charities. An amazing 14,057 people made the walk on 12th September 1987 and I was signing prints constantly for the entire day. Tracks were laid through the tunnel and the station opened in the spring of 1988.

'Young fireman taking a breather'

'Ben' 8/8/85
include in left foreground

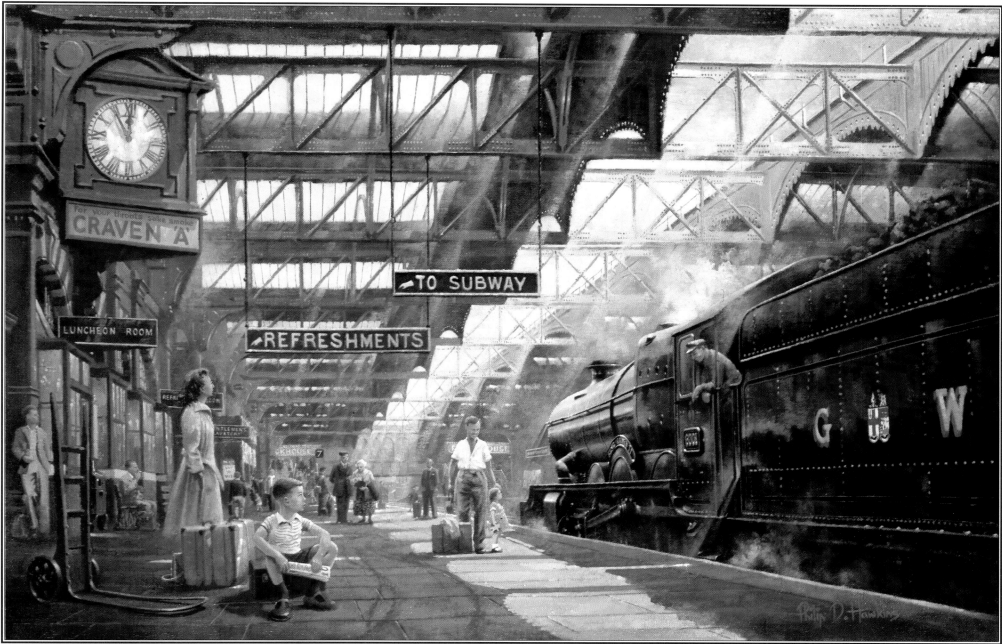

Collection: *Midland Independent Newspapers Ltd.*

On Time (1985)
Oil on Canvas 30" x 20"

Night Wolf/Flying Fox – Flying/Pacific Parade

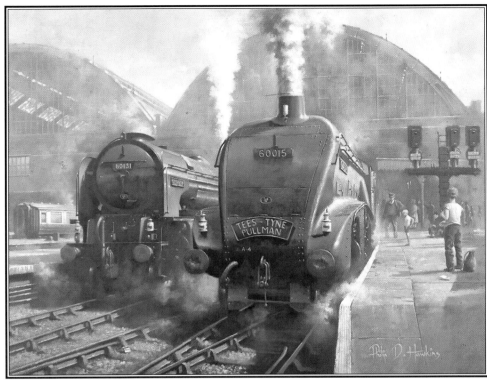

Pacific Parade (1984)
Oil on Canvas 20" x 16"

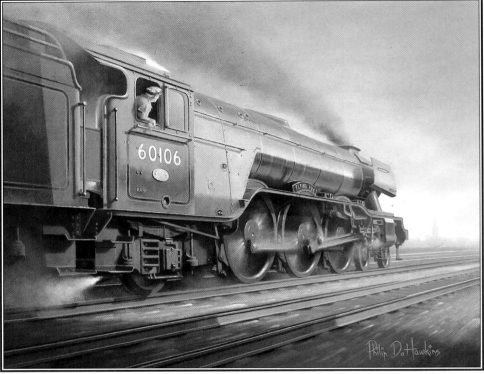

Flying Fox – Flying (1997)
Oil on Panel 15" x 12"

'Night Wolf' is a moody portrait of one of Edward Thompson's A2/2 Pacifics near the end of its days at New England shed, Peterborough. These engines were rebuilt by Thompson from Nigel Gresley's impressive P2 2-8-2s, a deed which has been covered at great length by many commentators, mostly in a derogatory vein. I took an immediate liking to these monstrous machines on seeing a photograph in a friend's ABC when still quite young. I recall seeing three of them at Doncaster in 1959, but as far as I can recollect the only one seen in steam was No. 60506 *Wolf of Badenoch* at New England late in 1960 not long before withdrawal in April 1961. Its condition in the painting is as I remember and was the only one never to have beading added to its stove-pipe chimney. What a wonderful name for a steam locomotive!

Am I alone in being quite partial to A3s in their final form with double chimneys and German type deflectors? These appendages gave an otherwise beautifully balanced, finely proportioned machine a slightly front-heavy appearance resulting in a rather odd look, which I quite liked. In recent years it has been a treat to see *Flying Scotsman* in this guise. My intentions in '**Flying Fox – Flying**' were quite straightforward, simply to show off the graceful lines whilst speeding along the East Coast Main Line – just as Sir Nigel intended. No. 60106 was not withdrawn until December 1964 and attained the highest mileage of its class.

As already mentioned, my first sight of an A4 Pacific, in the flesh, was at King's Cross station after persuading dad to make a detour on our way to the Motor Show at Earl's Court, an annual treat. The year must have been 1958 or maybe 1959. '**Pacific Parade**' depicts the period just prior to this before the A4s were fitted with double chimneys, apart from the four so built of course. The country end of Platform 10 was a mecca for train watchers from nine to 90 with generation after generation gathering to witness spectacles such as this, all for free! A4 No. 60015 *Quicksilver* is taking off with the 'Tees-Tyne Pullman' whilst a Peppercorn A1 Pacific, No. 60131 *Osprey*, waits impatiently to follow on with an express for Leeds and Bradford. At the time of writing, work is well underway to construct one of these handsome engines from the original blueprints. It is to be No. 60163 *Tornado.*

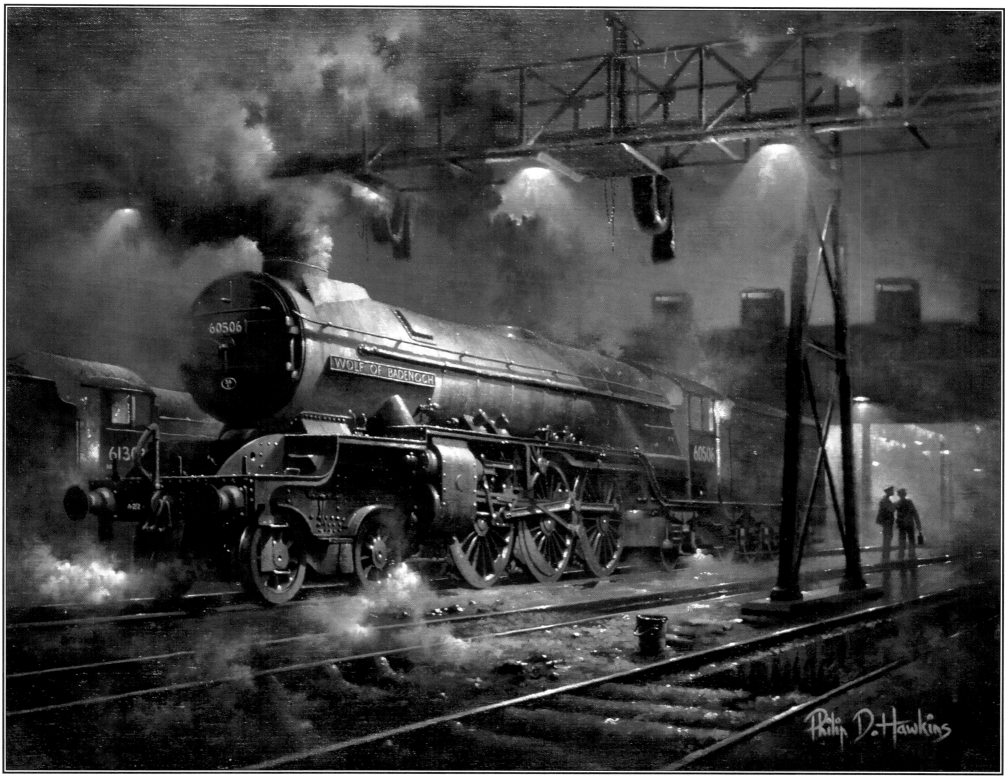

Collection: *Eric Pearce Esq.*

Night Wolf (1986)
Oil on Canvas 20" x 16"

Waiting in the Night/Night Call/Night Freight

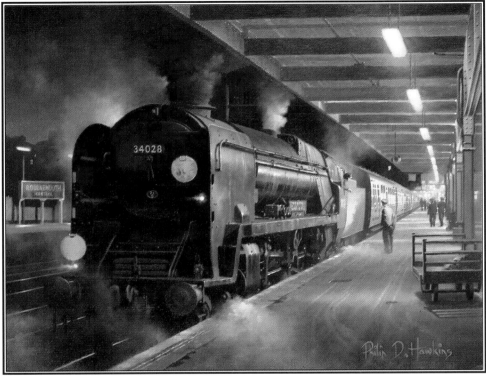

Collection: *David Asbury Esq.*

Night Call (1993)
Oil on Board 12" x 10"

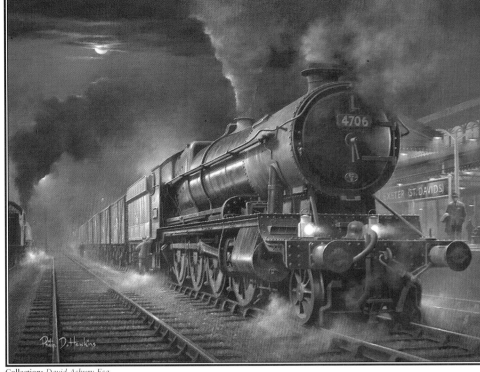

Collection: *David Asbury Esq.*

Night Freight (1994)
Oil on Canvas 20" x 16"

There is something quite intoxicating about the railway at night and this feeling is intensified where steam locomotives are involved. When very young I would lie in bed watching the orange firebox glow and leaping sparks passing to and fro the bedroom window, the crew silhouetted against the glare from the footplate, the fireman hard at work with the shovel, coaxing their steed to the top of the bank. From an artistic viewpoint I am sure that several 'old masters' would have had a field day with this most evocative of subjects.

'Waiting in the Night' portrays a Stanier 8F 2-8-0, No. 48197, waiting for the road in Washwood Heath yards, Birmingham not long before the end of steam working in this area. It was always a wonder how the little engineman's hut remained upright on each subsequent visit as a few more bricks seemed to have disappeared!

Throughout my career there have been periods when I would concentrate on specific themes, trains in snow leaps to mind, but I return time and again to the nocturnal scene, never trains flashing through the countryside, although that is a thought, but rather the locomotive in repose, simmering quietly to itself and emitting all manner of bronchial sounds, or like a coiled spring impatient to be on the move. 'Night Call' falls into the latter category. A rebuilt 'West Country' Pacific, No. 34028 *Eddystone*, waits impatiently at Bournemouth Central station while station staff go about their business before the train continues its journey to Weymouth. This picture is based on a photograph taken by myself in 1964. It was a time exposure and as I had no tripod at the time various items of luggage were carefully stacked onto a luggage trolley to fashion a suitable resting place for my camera. The result still suffered from camera shake! Bournemouth Central became quite well

known to me during the first half of the 1960s, often hopping off the train, 'bunking' the shed, then back on to the next departure to Weymouth or Eastleigh, depending on my itinerary.

In 'Night Freight' a low viewpoint was deliberately chosen to emphasis the massive proportions of these imposing engines. No. 4706, allocated to Bristol St Philip's Marsh, waits noisily on the goods avoiding lines at Exeter St Davids with a down fitted freight, c1960. I particularly enjoy 'low key' pictures and try to take advantage of the situation to use points of light and highlights to take the eye for a wander around the scene. It is important for me to create a sense of being able to walk around the back of the train to discover what may be there and to summon an air of mystery as the train disappears into the distance, a mixture of smoke, steam and the night.

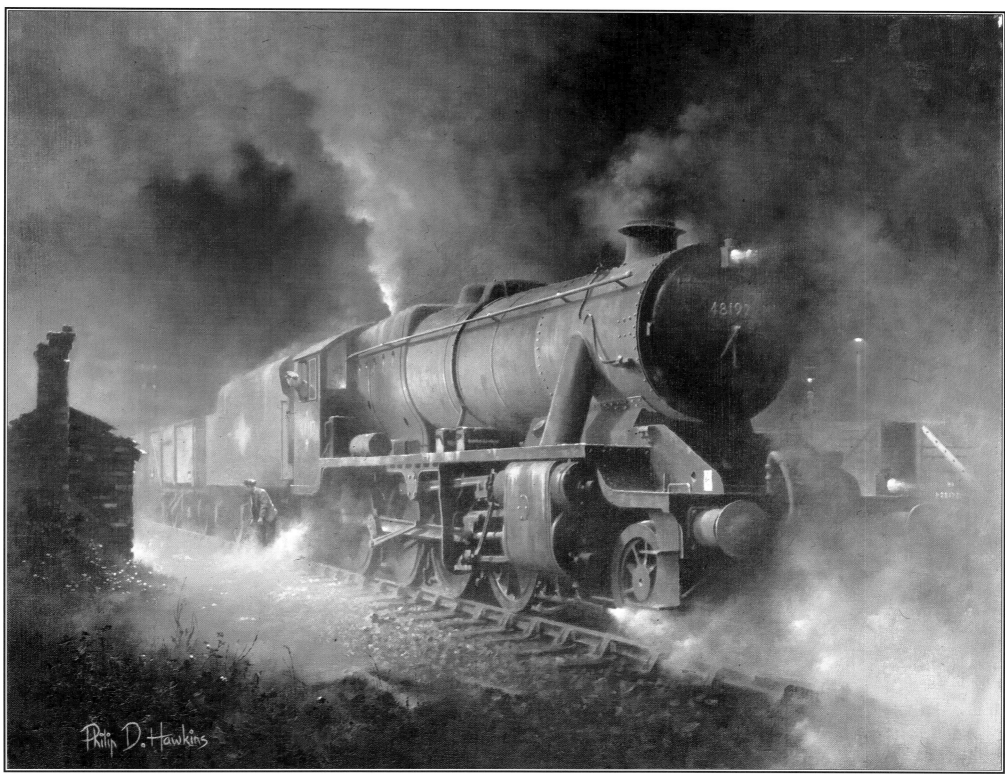

Collection: *David Asbury Esq.*

Waiting in the Night (1989)
Oil on Canvas 20" x 16"

Island Summer/Evercreech Junction

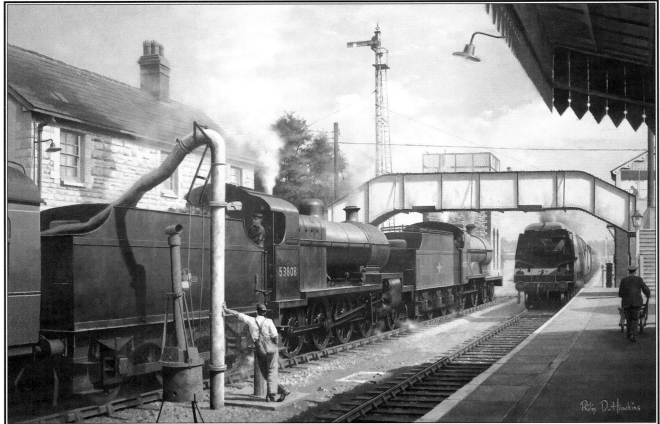

Collection: *Private.*

Evercreech Junction (1989)
Oil on Canvas 30" x 20"

Although my prime interest has veered towards busy city railways and main line engines I do appreciate the quieter charms of country branch lines and by-ways and, of course, the locomotives, rolling stock and architecture often have a character that is food and drink to an artist. There is certainly enormous enthusiasm for such lines, witness the number of books on individual branch lines that have been published in recent years, often written by enthusiasts who have spent a lifetime researching their subject. To many, the branch line is the epitome of a British railway, conjuring up, as it does, the rural idyll to which many of us seemingly aspire.

'Island Summer' was painted for purely selfish reasons. During the mid 1950s, for three or four years on the trot, I holidayed with my grandparents at Ryde on the Isle of Wight. We stayed at the Marine Hotel which happened to be directly opposite Ryde pier. How grandad could afford the luxury of a fortnight at such a palace was a mystery. Nothing else, at this time, approached the grandeur of this summer holiday! Our room and the dining room overlooked a constant procession of O2-hauled trains packed to overflowing with holiday-makers. To a small boy used to a steady diet of 'Scots' and 'Jubes' the tiny tank engines made quite an impression, particularly when working bunker first back to Ryde. During these holidays I don't ever remember actually travelling by train but rectified this in the early '60s, making several visits and in the process discovered Ventnor station. What an amazing place this was. The approach, through a barely adequate tunnel, opened out into a neat station surrounded by chalk cliffs dotted with caves. One of the two platforms was isolated from the 'Way Out' by running tracks and required a 'bridge' to be manhandled into position between these platforms to allow the eager throngs loose into Ventnor town. The engine, incidentally, is No. 24 *Calbourne*.

Summer Saturday traffic was the lifeblood of **'Evercreech Junction'** and the Somerset & Dorset railway in general, particularly in the 1950s. Indeed, mass motor car ownership was probably the main reason for the line's eventual demise in 1966 with dwindling returns on passenger receipts overtaking the line's *raison d'etre*.

Thanks to the marvellous photographs and wonderfully evocative cine film taken by the late Ivo Peters, the delights of the S&D are known and loved far and wide. My own recollections are of several visits to Bath engine shed and a couple of trips along the line, once behind a Saltley 'Black 5' throughout from Birmingham New Street to Bath and then a Standard Class 5 on to Bournemouth, in 1964 I think.

The S&D's 2-8-0s were fascinating engines and, to my eyes, quite unlike anything else. The fact that they were regularly employed on passenger trains only added to their appeal. For my painting I chose to feature one of the preserved engines, No. 53808, with one of the line's 4-4-0s, No. 40700. Approaching is an unrebuilt 'West Country', No. 34043 *Combe Martin* with a train load of returning holiday-makers. The year is 1960 and in just a few years the line and the station would be gone for ever. Incidentally, the engineman leaning against the water crane is from a drawing made on the Severn Valley Railway some years ago. They all come in handy, sooner or later!

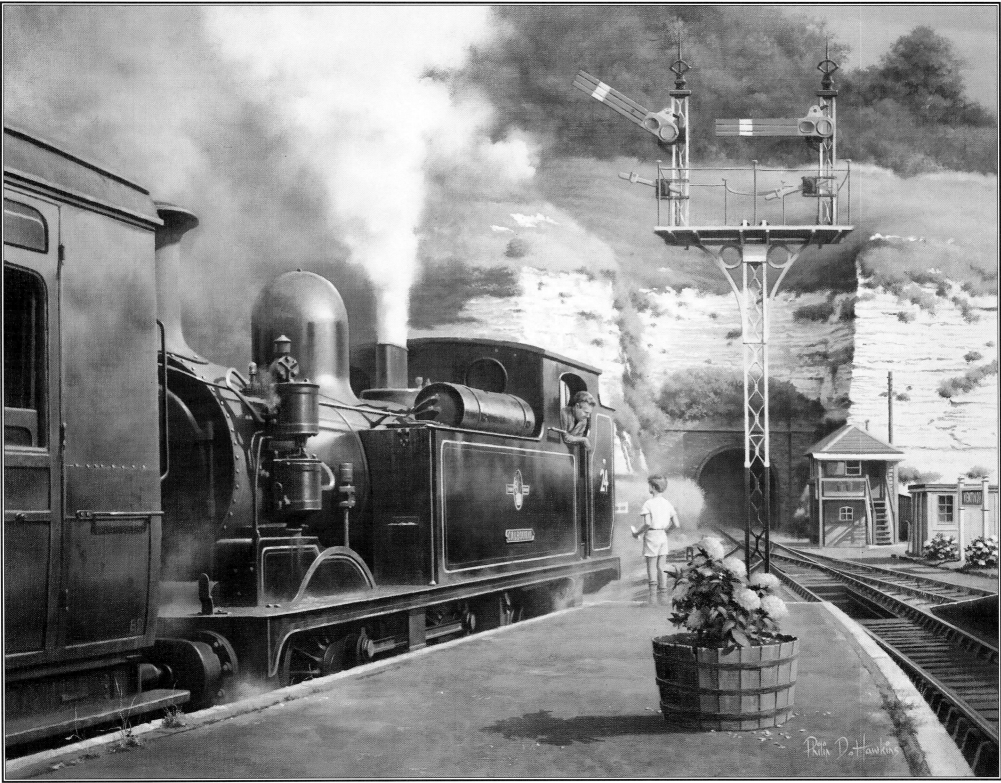

Island Summer (1991)
Oil on Canvas 20" x 16"

Bordesley Morning/Rush Hour at Rubery

'**Rush Hour at Rubery**' evoked similar memories for John Clarke of Birmingham who commissioned this painting based on a photograph by the late Peter Shoesmith. John had spent most of his working life at the Austin factory at Longbridge and remembered the workman's special trains that ran from here to Halesowen. The year is 1947 and pannier No. 7402, another Tyseley inmate, is running through Rubery with one of these trains. The ex Midland Railway Class 2F 0-6-0 in the distance is a reminder that the line was a joint MR and GWR venture.

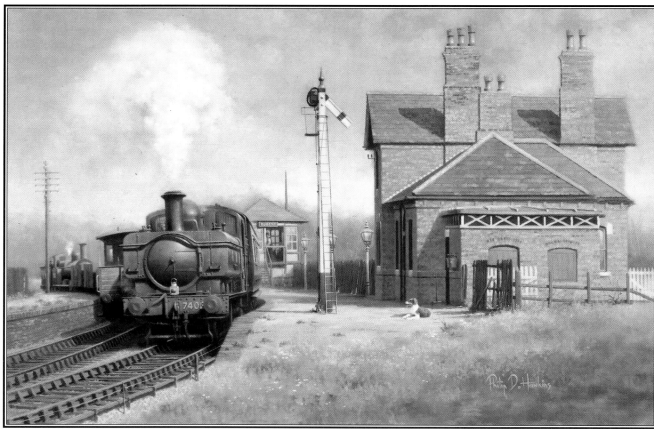

Collection: *Mrs 'Tot' Clarke.*

Rush Hour at Rubery (1982)
Oil on Canvas 30" x 20"

The everyday comings and goings of local freight trains and shunting engines was so commonplace that very few of us even bothered to take a glance, and of all the locomotive types of my childhood, Great Western pannier tanks, or 'matchboxes' as we irreverantly called them, were the most common bar none and could be seen scurrying by at any time of day at the bottom of my road. Most of the local ones were based at Tyseley sheds. No. 4648 in '**Bordesley Morning**' is no exception and is seen here approaching Bordesley station along the down main line in charge of a northbound transfer freight, probably bound for Hockley yards just north of Birmingham Snow Hill. Bordesley was the first stop out of Snow Hill heading south along the GW main line to Paddington. The bridge in the background carries the Midland Railway Camp Hill freight line which enabled trains on the Bristol to Derby line, heading north also to avoid the bottleneck of New Street station. This scene, apart from a few missing tracks and signals is remarkably intact even today, including the Great Western warehouse seen in the right background.

" RUSH HOUR AT RUBERY "

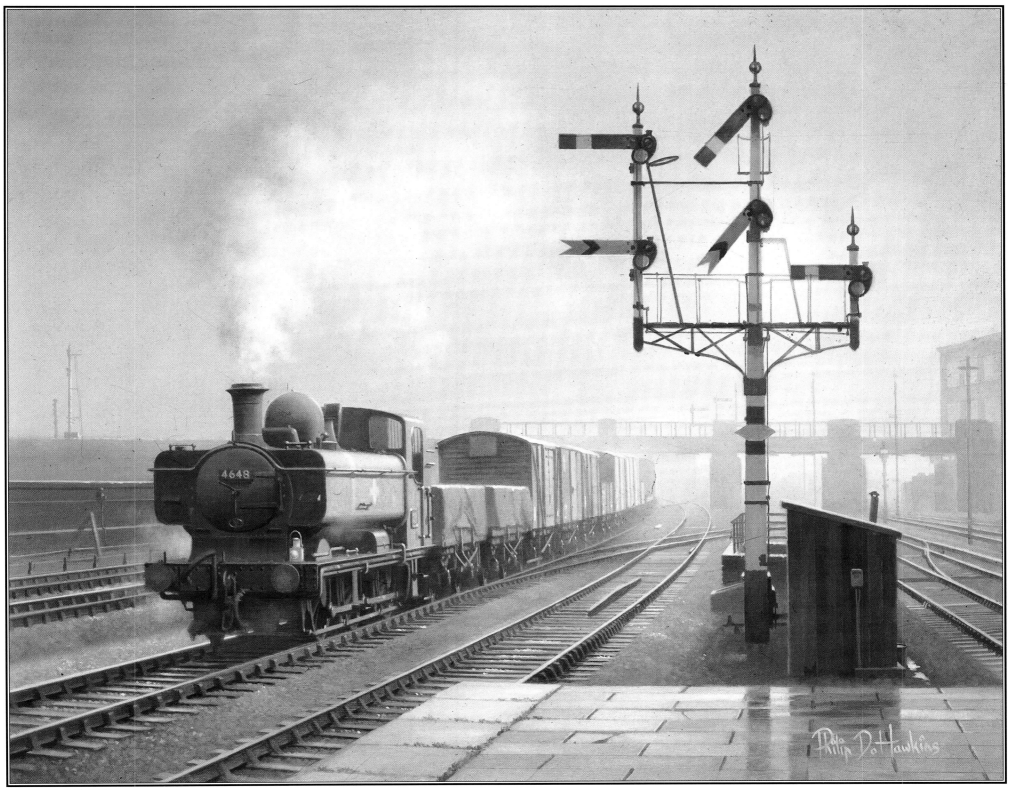

Bordesley Morning (1997)
Oil on Panel 15" x 12"

Duchess of the Night/Rushing Through Rugeley

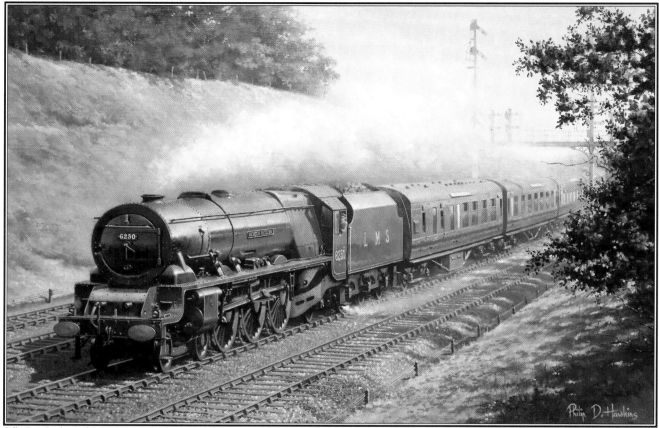

Collection: *Gordon Barker Esq.*

Rushing Through Rugeley (1985)
Oil on Canvas 30" x 20"

These paintings show William Stanier's magnificent 'Princess Coronation' Pacifics at opposite ends of their careers. **'Duchess of the Night'** features No. 46228 *Duchess of Rutland* awaiting the rightaway from Rugby Midland station on a murky, smokey winter evening with a Wolverhampton–Birmingham New Street–London Euston train in 1963. After a lifetime working crack expresses up and down the West Coast Main Line these fabulous engines were usurped from 1959/60 by the English Electric Type 4s (later Class 40s) and found themselves relegated to lesser duties such as that shown here, much to the delight of 'Brummie' spotters who hitherto had to rely upon Sunday diversions through the city to see the 'Semies'. No. 46228 was built at Crewe in 1938 as a streamliner, defrocked in 1947 and withdrawn from service in September 1964. Hardly a long life but a glorious one!

In **'Rushing Through Rugeley'** No. 6230 *Duchess of Buccleuch* is seen in the first flush of youth roaring along the West Coast Main Line approaching Rugeley Trent Valley with a Euston–Glasgow express just prior to the Second World War. This engine was the first of the class to be built non-streamlined and is portrayed as originally built in June 1938 with a single chimney. As a resident of Polmadie depot, Glasgow throughout the 1950s until withdrawal in November 1963, No. 46230 as I knew it, was a rarity to us kids in Birmingham although I did see it at Crewe during 1960. In the form shown here the 'Duchesses' were considered by many observers to be the epitomy of British steam locomotive design, both in appearance and performance. They were certainly handsome machines.

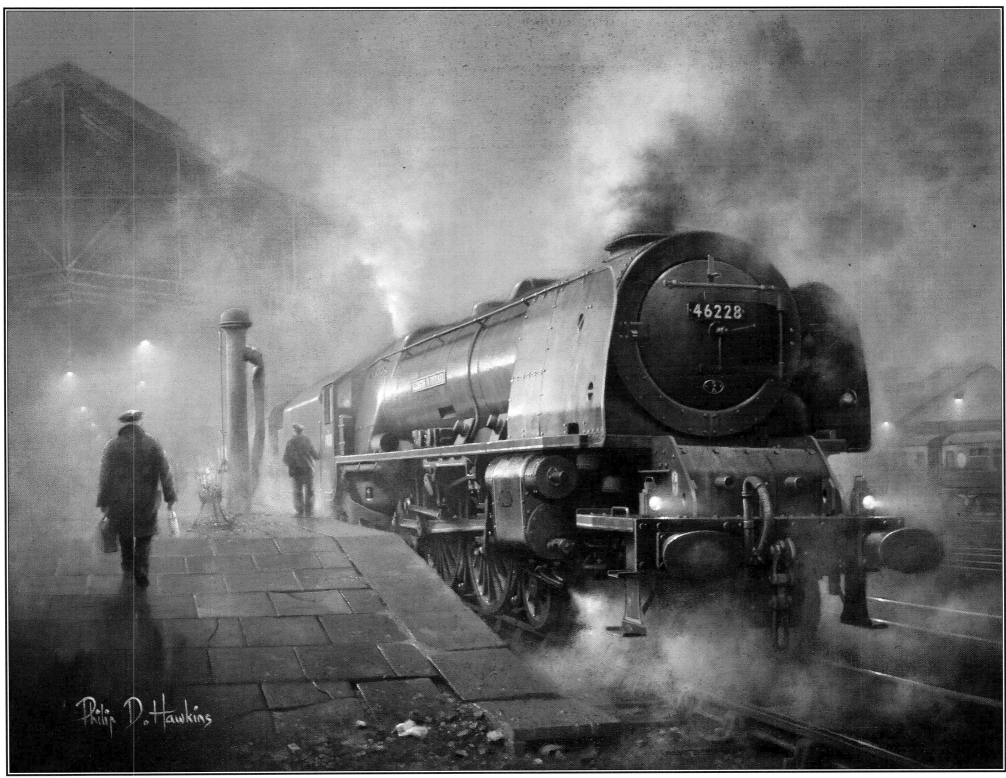

Collection: *Bernard Apps Esq.*

Duchess of the Night (1996)
Oil on Canvas 20" x 16"

Southern Freeze/Southern Sunset

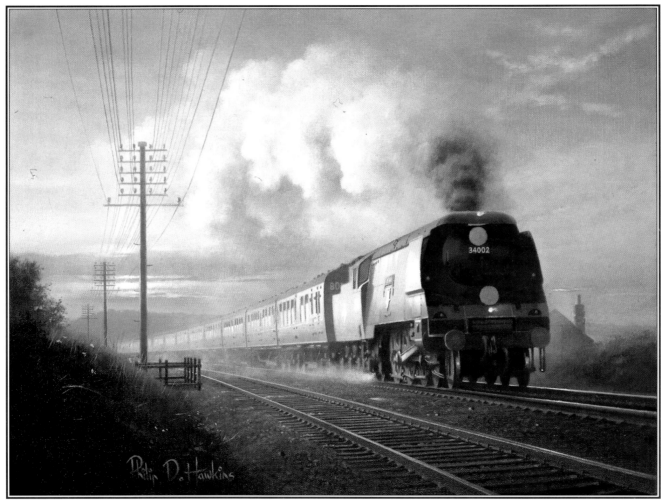

Collection: *Artist's.*

Southern Sunset (1997)
Oil on Canvas 15" x 12"

preservation. Some two years after the painting was completed, published and sold a letter arrived from a well-meaning critic to inform me that the tender is of the wrong pattern for this particular engine at this time. He was quite correct! This is a cautionary tale for all railway artists when working from scraps of reference: be very careful when changing numbers of locomotives among other things! The mistake was particularly annoying because I had made a note regarding the tender early on in the proceedings.

Another Bulleid Light Pacific, this time a 'West Country', No. 34002 *Salisbury*, features in '**Southern Sunset**', hard at work on the LSWR main line in charge of an Exeter–Waterloo express climbing the 1 in 90 gradient of Honiton bank in Devon approaching the tunnel. Quite a straightforward picture with the telegraph poles marching alongside the down line forming a crucial part of the composition.

Both of these paintings were completed for inclusion in the appropriate section of calendars. '**Southern Freeze**' was a long time in the planning stage. The locomotive was no problem and the choice of location was easy, but I particularly wanted to dwell upon the contrast of the arctic conditions with the warmth of the fires, both on the footplate and the brazier. Calculating the angles to show these elements to satisfaction

took some time before deciding on the final composition. Reference for Exmouth Junction shed was also surprisingly shy at the time. Quite a complex picture in some ways but the research and planning paid off with the execution presenting few problems. The harsh winter of 1963 is the period and the locomotive a Bulleid 'Battle of Britain' Pacific, No. 34072 *257 Squadron*, one of 20 such engines to survive into

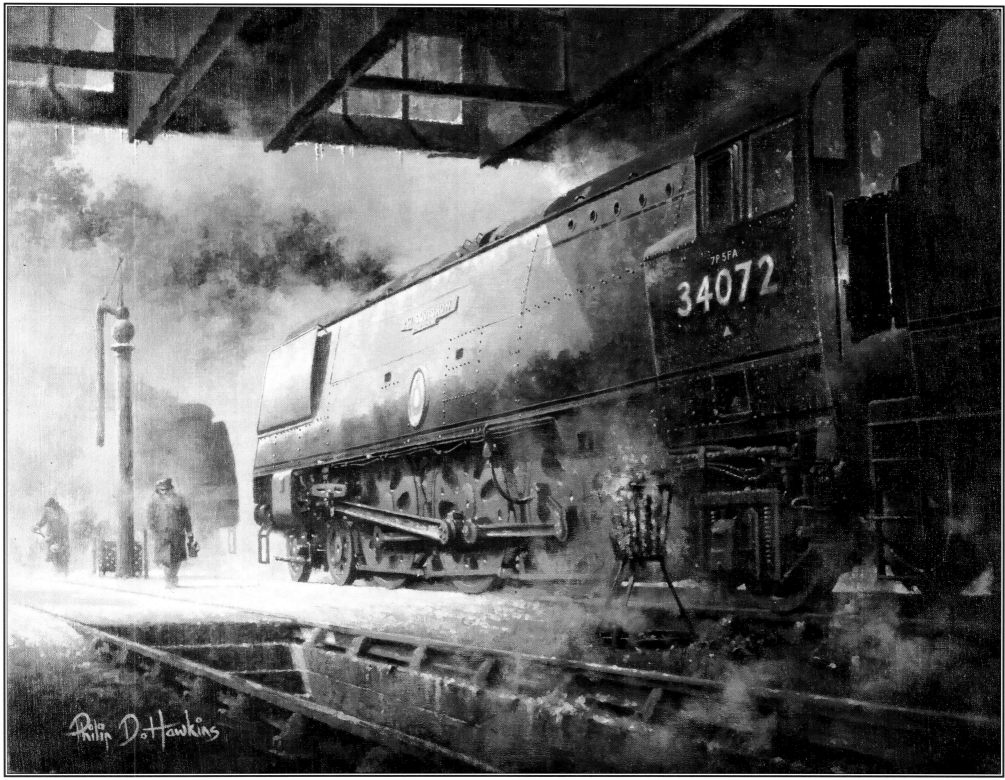

Collection: *Roy Apps Esq.*

Southern Freeze (1985)
Oil on Canvas 20" x 16"

Firth of Forth/Shrewsbury Standard/Iron Duke and the Shed Cat

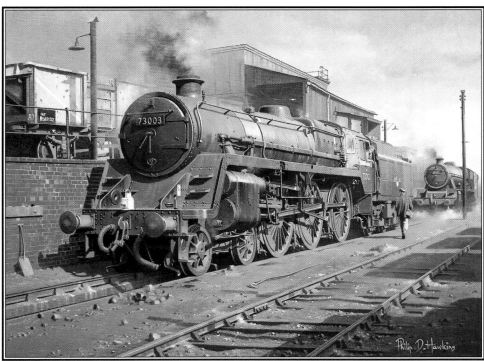

Collection: *David Asbury Esq.*

Shrewsbury Standard (1994)
Oil on Canvas 20" x 16"

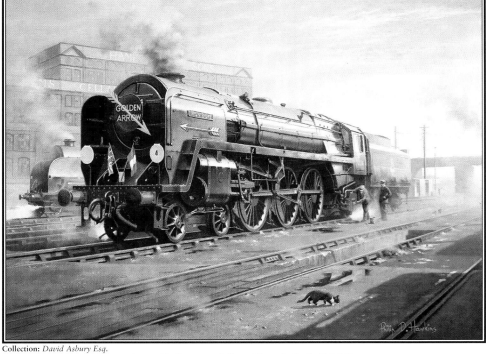

Collection: *David Asbury Esq.*

Iron Duke and the Shed Cat (1991)
Oil on Canvas 20" x 16"

'**F**irth of Forth' was commissioned by Mr Bob Robson who has a passion for 'Britannias', amongst other things I am sure! His specification was quite simple: it was to be a shed scene and to feature one of the 'Brits' which were fitted with the large BR1D tenders (Bob considered the BR1 tenders fitted to earlier class members to be a little on the small side to visually balance the engine). The rest was up to me! Originally, Leeds Holbeck was to be the location with No. 70053 *Moray Firth* taking centre stage, but eventually Polmadie was chosen, partly as an excuse to feature a 'Duchess' and a 'Scot' and also so that this would allow me to portray No. 70051 *Firth of Forth* (one of my favourites) at home as it were. Built at Crewe in August 1954, No. 70051 went directly to Polmadie where it remained until 1962. A night scene was chosen to heighten drama and focus attention on the lovely lines of these engines which, to a kid growing up in the 1950s, were the last word in modernity. After all, didn't the *Eagle*

comic feature a cutaway drawing in one of those marvellous centre spreads?

'**Shrewsbury Standard**' is a portrait of No. 73003 one of a class of 172 British Railways Standard Class 5s introduced in 1951 and intended to replace various elderly Class 5 4-6-0s throughout the system, although most enginemen preferred their own 'Black 5s', B1s and 'Halls' etc. Despite this time-honoured prejudice they gradually found favour in some parts and did good work, particularly on the Southern. No. 73003 stands by the coaling stage at Shrewsbury shed in 1963 and sports the lined, green passenger livery acquired during a visit to Swindon Works.

A weak but effective light plays upon the stylish lines of another 'Britannia', this time No. 70014 *Iron Duke*, in '**Iron Duke and the Shed Cat**'. Many artists have had a crack at the 'Golden Arrow' but usually with a Bulleid Pacific out on the open road. *Iron Duke* as opposed to

No. 70004 *William Shakespeare*, was chosen because it seems that every article about this famous train features the latter and balance needed to be restored. Before starting this painting I was chatting with a buddy whose brother had been a fireman at Aston shed in Birmingham. When the place closed in 1966 he took home the shed cat which consequently spent its remaining years in a far more presentable state than previously. Its name was Sooty! The 'empty corner' problem was solved again. Reference for Stewarts Lane proved to be plentiful except that I could not find a photograph that included the complete legend on the warehouse in the background. The far left section was the problem. All that could be found was 'MS'. Drifting smoke from the 'King Arthur' solved the quandry. Shortly after the picture was published the perfect photograph was found. 'Strongrooms' proved to be the answer. Sod's Law strikes again!

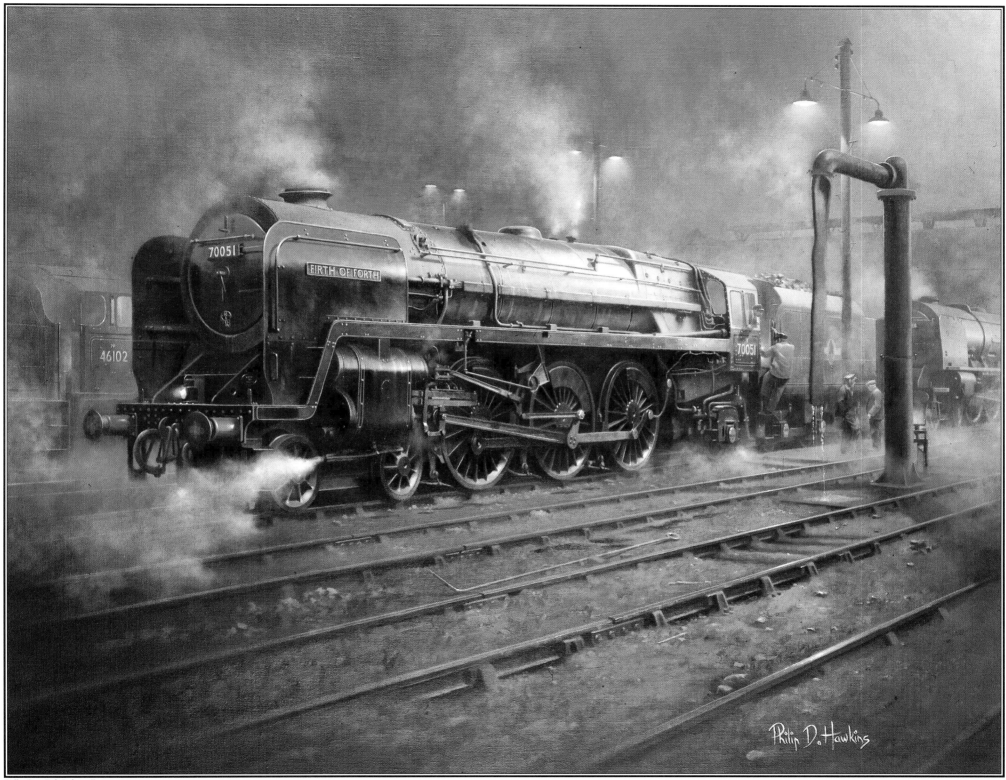

Firth of Forth (1996)
Oil on Canvas 30" x 24"

Dawn at Dillicar/North Western Style

The West Coast Main Line in the Northern Fells, particularly around Shap, felt familiar long before I actually visited the area. Photographs of 'Duchesses', 'Princesses', 'Scots' and 'Patriots' amongst others pounding to Shap summit leapt from the pages of railway magazines and books. Many of the most beautiful had, of course, been taken by Eric Treacy. Countless others recorded the scene but none quite so effectively as the 'Railway Bishop'. My first 'hands on' experience, probably in 1960, was during a trip with the local locospotters club to Carlisle and points north. Having kept our Friday midnight rendezvous outside the Hall of Memory in Birmingham, 30 or 40 miscreants dozed their way northwards aboard the charabanc dreaming of rare 'Jubes' and 'Scots'. These were pre-M6 Motorway days of course and such journeys seemed endless. It must have been around four in the morning when we made a much-needed stop at a transport cafe near Tebay and afterwards looked in at the station, like you do! No sooner had these zombie like figures set foot upon the platform and peered sleepily along the line when, with a sudden, unexpected rush of cold night air, a southbound express headed by a red 'Coronation' careered past at what seemed hundreds of miles an hour. An extremely eerie and exhilarating sensation. No visible steam or smoke, just a roar and the wheels of the long train clattering over rail joints into the distance. It was all over in seconds. The lasting impression is of a 'Duchess' rocking and swaying wildly towards us and then a crescendo of noise. I realise now, of course, that the train had descended from Shap summit and by the time it reached us would be coasting, yet still going like the wind. This is just one of many visions that must be committed to canvas one of these days!

'**Dawn at Dillicar**' takes us back to an earlier era. As mentioned previously, had I been about in pre-Grouping days I am sure that the London &

North Western Railway would have taken my fancy. They certainly knew how to run a railway, providing the customer with a reliable and punctual service, on the main routes at least. Compared with, for example, a GWR passenger engine the average top-link LNWR locomotive was positively dowdy, to say the least, but what dignity they had! In this painting, commissioned by Mr Richard Willcox, the period is about 1920, the tiny 'Precedent' 2-4-0. popularly known as 'Jumbos', No. 1672 *Talavera* has been relegated from working express trains alone and is being used, very effectively, as pilot to an

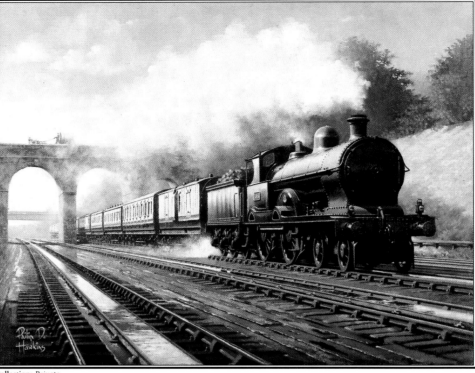
Collection: *Private.*

North Western Style (1985)
Oil on Canvas 20" x 16"

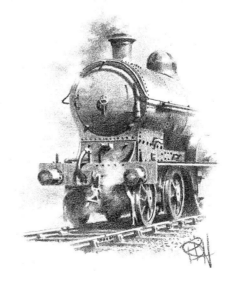

LNWR 'Prince Of Wales'

almost new 'Claughton' 4-6-0. They are shown skimming over Dillicar troughs, just south of Tebay, in preparation for the charge at Shap bank. The M6 Motorway now dominates the background destroying the once-impressive harmony of railway and landscape.

In '**North Western Style**' an LNWR 'Precursor' 4-4-0, No. 1419 *Tamerlane*, is taking water from Bushey troughs with a Euston–Manchester express c1920. The LNWR was the first railway company to make use of water troughs and eventually had nine sets along the main line between Euston and Carlisle. The engine was designed by George Whale and built at Crewe in March 1904, superheated in 1913 and withdrawn from service by the LMS in March 1936. One hundred and thirty of these excellent machines were built up until August 1907 and typified LNWR locomotive design of this period.

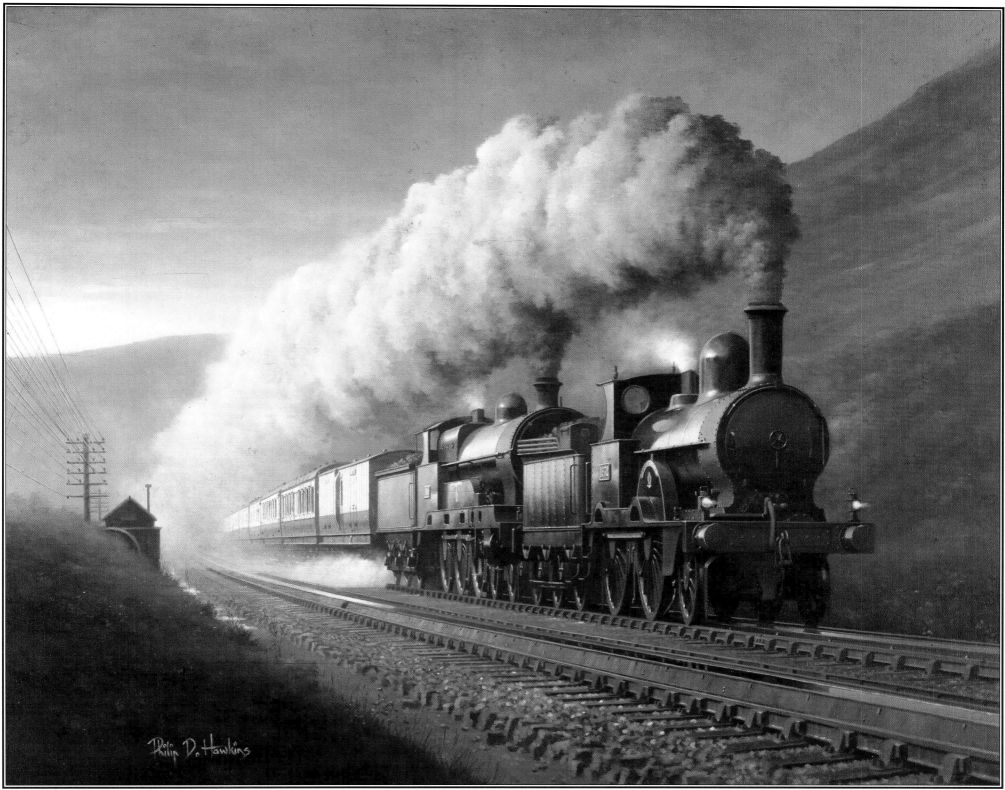

Dawn at Dillicar (1993)
Oil on Canvas 30" x 24"

St Pancras Departure/Crimson Rambler

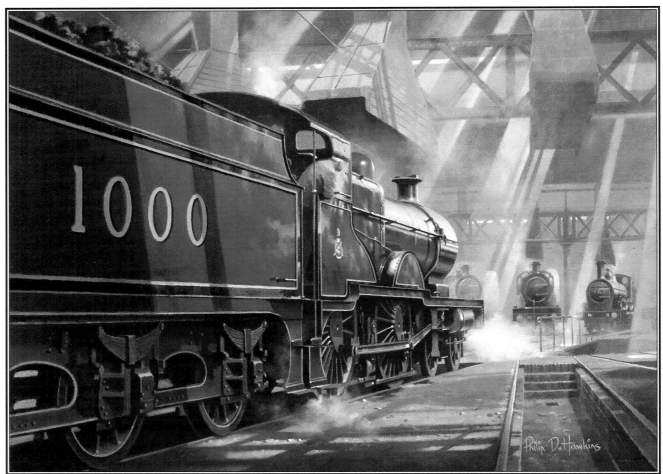

Collection: *The Royal Mail.*

Crimson Rambler (1992)
Oil on Canvas 16" x 12"

'**St Pancras Departure**' was inspired by a visit made in 1987 to St Pancras station whilst killing time waiting for a train from King's Cross, just across the road. Gazing at the marvellous roof and feeling a little sad that absolutely nothing was happening in the way of arrivals and departures it occurred to me that the stage was set for the most wonderful railway spectacle but the actors had failed to show. This grim state of affairs was rectified shortly afterwards in my studio – probably to reassure myself that once there was life.

This is an early morning view in the late 1920s with a weak sun bathing the scene with a golden glow which also serves to reduce the marvellous backdrop almost to a monotone silhouette. The angle is carefully chosen so that the shapely towers are placed so as not to 'throw' the composition. The engine, a Compound 4-4-0, No. 1097, has not long emerged brand new from Derby Works under the auspices of the LMS Railway. Built in 1925 it was withdrawn from service as No. 41097 by British Railways in May 1956.

'**Crimson Rambler**' This was a most enjoyable commission to undertake, simply because I was able to work directly from the locomotive at the National Railway Museum at York. The co-operation and courtesy shown to me by the then Head of the Museum, Mr Andrew Dow, made the job a pleasure. A day was spent with No. 1000 at my beck and call positioned on one of the museum's turntables which enabled me to make the necessary drawings for my needs. The engine is shown as it was c1920, stabled around the turntable at Kentish Town shed, London in company with other examples of Midland Railway motive power, including a Kirtley 2-4-0.

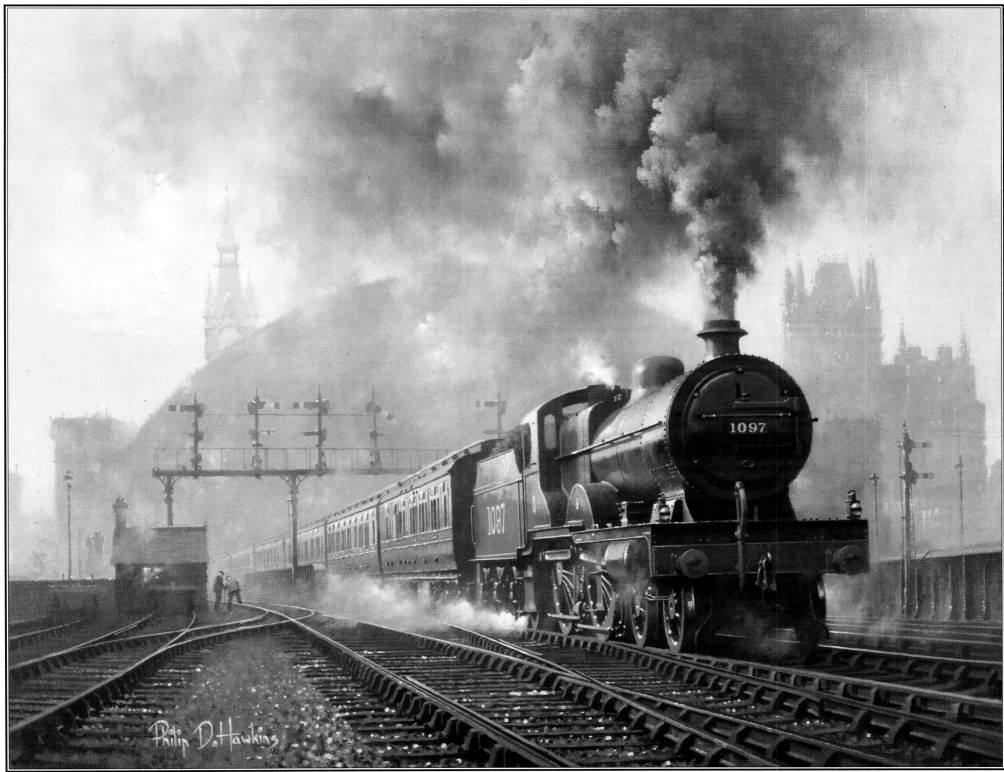

St Pancras Departure (1987)
Oil on Canvas 20" x 16"

Western Blizzard/Old Oak Winter/Heading South

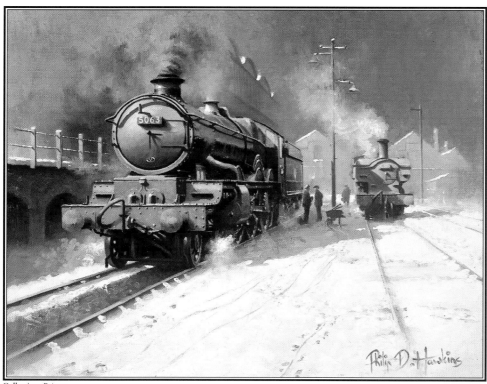

Collection: *Private.*

Old Oak Winter (1983)
Oil on Board 12" x 10"

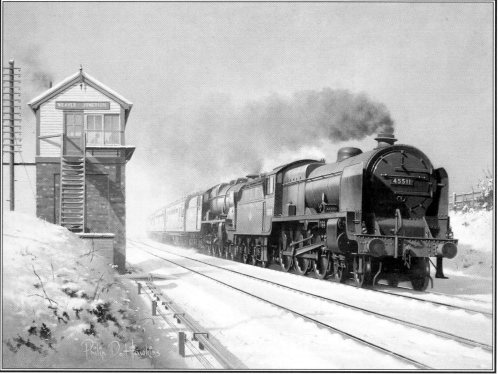

Collection: *David Asbury Esq.*

Heading South (1997)
Oil on Canvas 16" x 12"

Only once can I recall being commissioned to paint a railway subject specifically requesting a snow scene. Yet pictures which include this element have been received enthusiastically by publishers and the originals have sold readily. The preference for sunny, summer days is understandable when one considers that many of us recall fondest memories through sun-tinted glasses. Nevertheless, extreme weather conditions offer fascinating possibilities with most subjects and railways are no exception. A favourite combination is sunlight and snow. Hopefully the pictures on these pages make the point.

The poor lineman in '**Western Blizzard**' illustrates that many aspects of work on the railway were sheer purgatory. The figure was in fact my starting point with this painting, with the train taking something of a back seat for a change. A sculptor friend, Keith Lee, was my model and

very patient too, remaining huddled against the storm (on a lovely summer day) for some considerable time whilst the necessary drawings were made. Sunlight is dispersed by the falling snow and heavy impasto passages are evident, particularly in the lower part of the picture, in an attempt to capture the character of freshly fallen snow. The engine, a 'Castle' class 4-6-0, No. 4082 *Windsor Castle*, treads carefully through the south Birmingham suburbs at Acocks Green & South Yardley with a train from Paddington to Wolverhampton during the winter of 1963. At this time I lived in Acocks Green and although most passenger services were dieselised the severe winter saw many duties worked by steam.

In '**Old Oak Winter**' the subjects are illuminated with reverse lighting, that is the visible side of the locomotives are in shade with shadows forming

a vital part of the composition. Advantage is taken of light reflecting off the snow to add interest to shaded areas. The crew of a Stafford Road 'Castle', No. 5063 *Earl Baldwin*, discuss their plight by the coaling stage as one of Old Oak's pannier tanks listens in, c1960.

One of my favourite locomotive types roars through the winter landscape in '**Heading South**' past the lovely, old London & North Western Railway signalbox at Weaver Junction. Beyond is where the Liverpool route leaves the West Coast Main Line. No. 45511 *Isle of Man*, depicted here double-heading a rebuilt 'Royal Scot' in the late 1950s with an up express, was regularly seen in and around Birmingham during my childhood. It was never rebuilt and was withdrawn from service in February 1961.

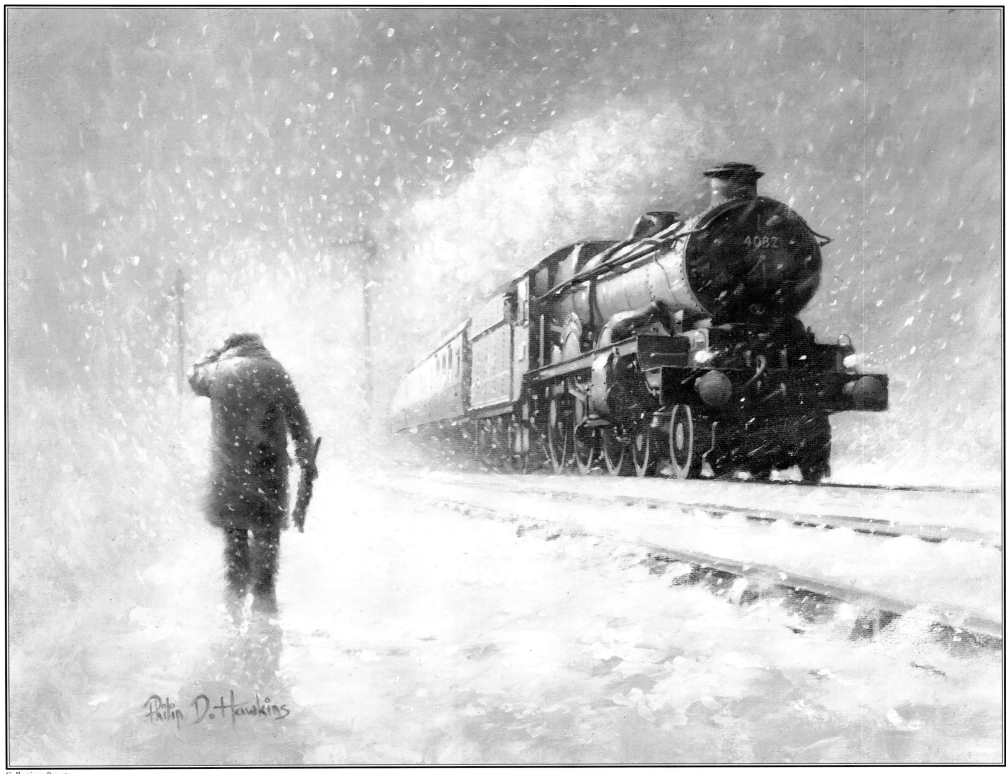

Western Blizzard (1983)
Oil on Canvas 20" x 16"

North Eastern Elegance/Jersey Lily/Clear Road Through Retford

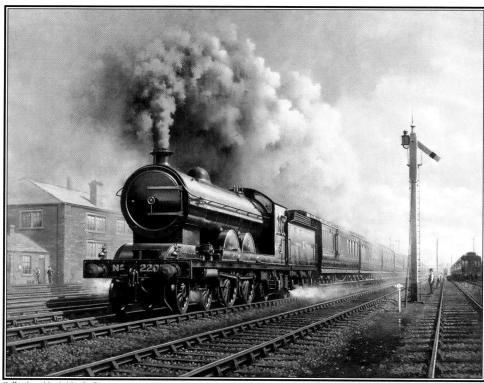

Collection: *Mr & Mrs D. Barrie.*

North Eastern Elegance (1983)
Oil on Canvas 30" x 24"

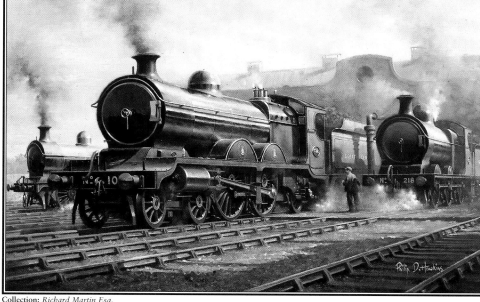

Collection: *Richard Martin Esq.*

Jersey Lily (1984)
Oil on Canvas 30" x 20"

This is an excellent example of a subject that would probably never have been painted had I not been asked to. '**North Eastern Elegance**' was commissioned in 1982 by the late Eric Barrie. Eric had spent much of his life living and working in the North East of England and remembered, with great relish, the massive NER Atlantics designed by Sir Vincent Raven and was quite an authority on them. It was fascinating to discuss the pros and cons of the work with him and I learnt a thing or two in the process, including the typical stance of the drivers on these machines. The period is c1920 and the train is leaving Darlington. Eric subsequently asked if I could add the NER coat of arms to the bottom right-hand corner of the painting, which I did, but reluctantly.

Here are two paintings commissioned by Mr

Richard Martin of Lichfield. Richard has a passion for Atlantics and has, I believe, built O gauge models of both types seen here. '**Jersey Lily**' is a portrait of a Great Central Class 8B Atlantic designed by J. G. Robinson seen at Neasden shed flanked by a pair of 'Pom-pom' 0-6-0s, at the request of the commissioner. The beautiful livery was quite a challenge to an artist who is more used to depicting rather decrepit, work-worn machines. Richard was brought up in Retford which is on the East Coast Main Line, and wanted a reminder of the lovely Ivatt Atlantics that he just about remembered seeing in his childhood. No. 4444 is speeding across Retford North junction with an up express during the thirties in '**Clear Road Through Retford**'. This picture was used by BR Railfreight in their 1987 calendar where they changed the title to 'East Coast Speed'. Take your pick!

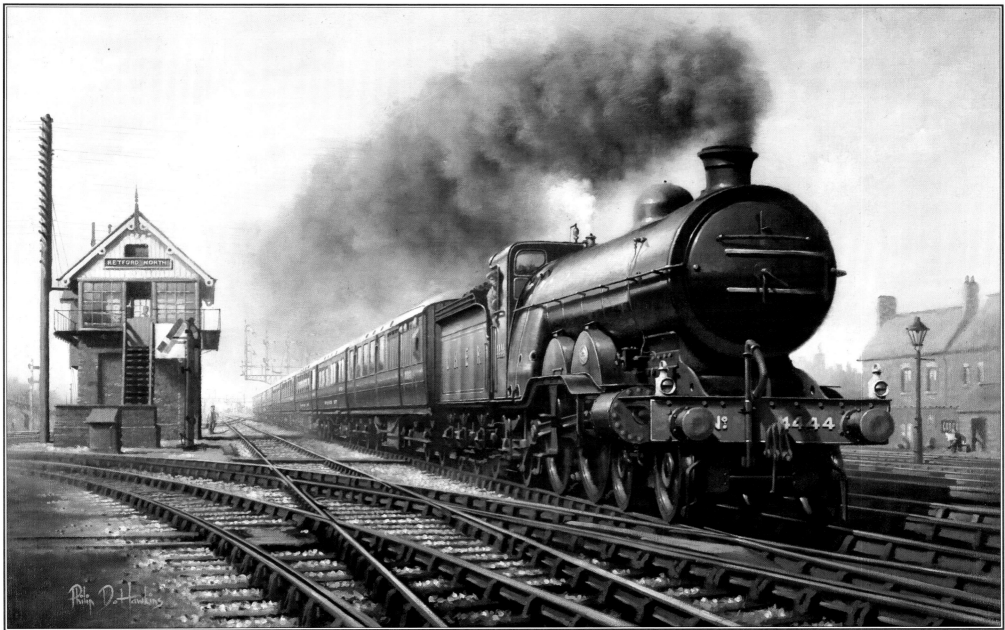

Clear Road Through Retford (1983)
Oil on Canvas 30" x 20"

East Coast Elegance

One of the most noteworthy and well documented events on Britain's railways was *Mallard*'s world record breaking high speed exploits when 126 mph was reached at milepost 90¼ on the East Coast Main Line on 3rd July 1938. To commemorate the 50th anniversary of this marvellous achievement I was anxious to produce a painting that was different to those previously seen, and one that really portrayed the elegance, power and speed of Sir Nigel Gresley's A4 Pacifics. Not wishing to show the engine actually breaking the record, this had been done before, I decided on a low viewpoint as one might snatch a glimpse from the line-side. Also it had to be in the condition and livery as on 3rd July 1938, complete with the valance over the wheels and garter blue livery. A feature which always attracts me are those big red driving wheels, partially hidden as if a little shy to display them, like a shy, elegant lady. The composition had to be dynamic, dramatic and appear to

be simple so as to concentrate attention on this beautiful machine at speed.

I ascertained that *Mallard* was at the National Railway Museum and in February 1988 a day was spent sitting on my camera case, gazing at my prey making sketches and taking photographs. A rear three-quarter view was chosen with the A4

No.4468 'Mallard' approaching Grantham from the north C1938. Drawing made at National Rly Museum York 27.Feb 88

rushing into the canvas. The drawing seen here was made at York with the Grantham elements added later. The approaching A4 is a crafty way of showing the characteristic front-end of these engines but without losing my preferred viewpoint. Grantham was chosen because here there was, and still is, a marvellous, fast, curving approach to the station, far more interesting than a straight run. There was also an attractive signalbox which would make a perfect foil for the on-rushing A4. A suggestion of the shed yard could also be included.

The execution of the work proved to be straightforward and quite brisk in my terms, about eight full days if I remember correctly. The thorough preliminary work proved priceless.

On completion of the painting the erstwhile editor of *Steam Railway* magazine, David Wilcock, chose to feature it on the centre-spread of the July 1988 issue, and Quicksilver Publishing published fine art prints. A satisfactory conclusion!

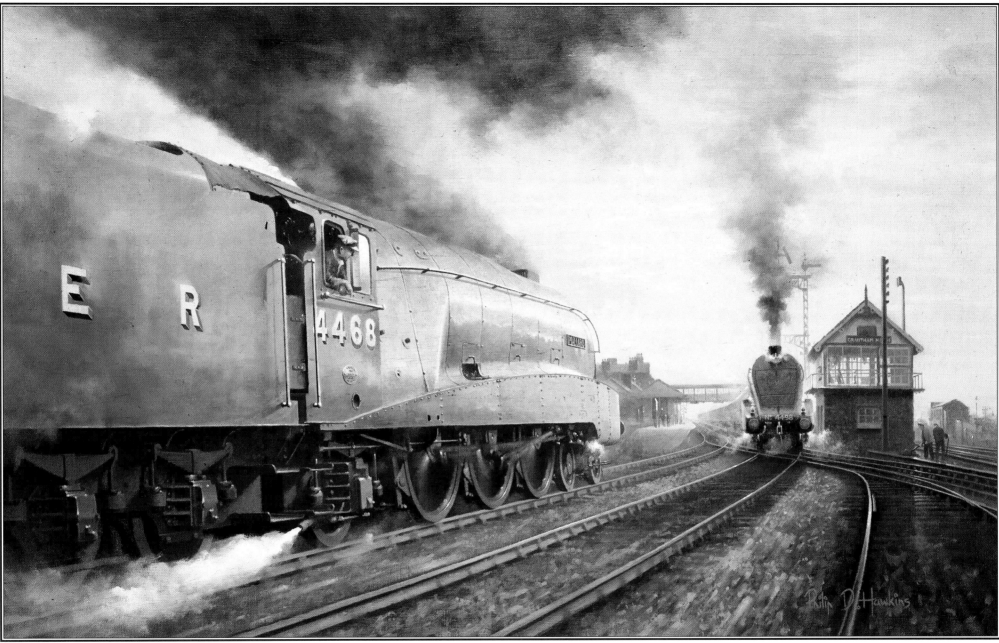

Collection: *Mike Armstrong Esq.*

East Coast Elegance (1988)
Oil on Canvas 30" x 20"

Cock O' The North

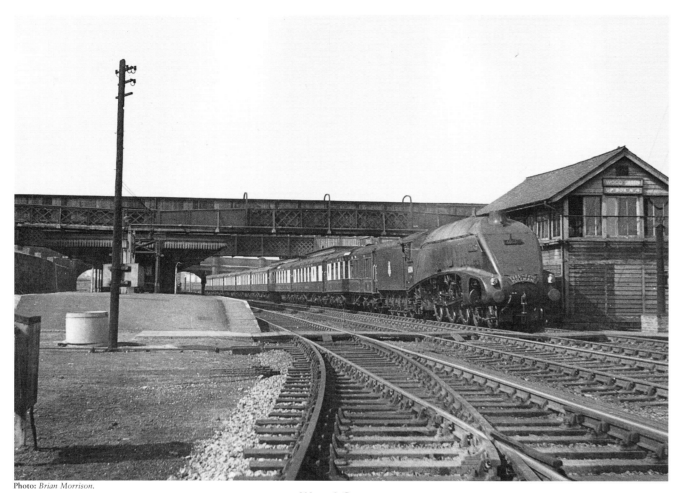

Photo: *Brian Morrison.*

Wood Green
No. 60024 *Kingfisher* on the up 'Tees-Tyne Pullman' – April 1952.

Brian Morrison's OPC book *The Power of the A4s*. I know Brian and phoned him immediately. He confessed that these weren't among his best photographs but would gladly dig out the negatives and make some prints. This he did and kindly sent them within a couple of days. One of them is reproduced here. They provided some good reference for the buildings and layout. Later, more material was discovered, enough to enable me to piece together the total scene. Listening to Eric describing this memorable spectacle was almost as good as being there myself and when work on the canvas began I had acquired a real 'feel' for the task ahead. One of the most rewarding aspects of my work is the ability to recreate someone's fondest memories from way back in the mists of time. I see it as my own, personal 'time machine', not quite as far reaching as that of H. G. Wells, but good enough.

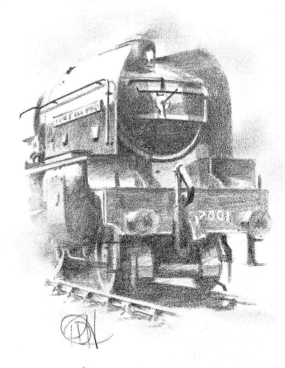

"COCK O' THE NORTH"

When this painting was commissioned by Mr Eric Pearce I was delighted. Nigel Gresley's 'Mikados' had always been a source of fascination. They were rebuilt by his successor Edward Thompson into controversial 'Pacifics' (see 'Night Wolf' earlier), during the war and once again, my only knowledge of the original engines was from photographs in magazines and books. Nevertheless I always felt that No. 2001 looked far more modern than some later designs. Imagine the impression it must have made on small boys, and bigger ones, when it first appeared from Doncaster Works in 1934. Eric was one such small boy and remembers standing on the platforms of his local station, Wood Green on the East Coast Main Line, during the summer of 1934 shortly after the engine was built in May and running trials. In my painting, No. 2001 is passing through Wood Green on one of Eric's fondly remembered summer evenings heading a heavy train towards King's Cross. Shortly after these trials the engine went to France for controlled testing accompanied by Gresley's assistant Mr O. V. S. Bulleid, later of Southern Pacific fame. Whilst in France it was exhibited at the Gare du Nord in Paris.

Reference for Wood Green proved elusive and the only pictures discovered initially were in

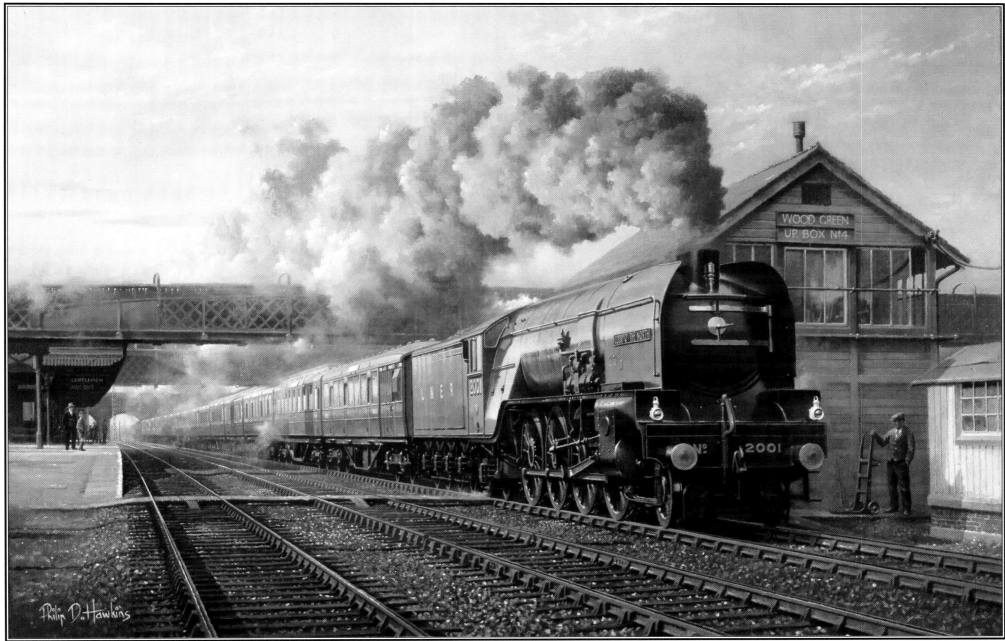

Collection: *Eric Pearce Esq.*

Cock O' The North (1988)
Oil on Canvas 30" x 20"

Summit Meeting/Heavy Freight/Citadel Scot

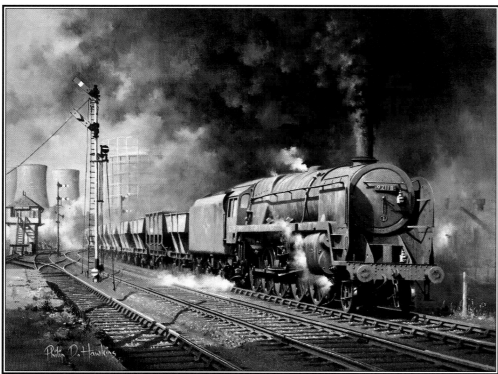

Collection: *Private.*

Heavy Freight (1986)
Oil on Canvas 20" x 16"

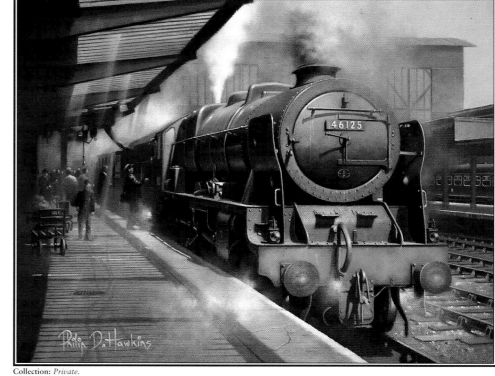

Collection: *Private.*

Citadel Scot (1995)
Oil on Canvas 12" x 10"

The 'Crab' 2-6-0, No. 42790, featured in '**Summit Meeting**' displays the Saltley trademark of the time (c1960) of a clean, black smokebox (actually a liberal coating of grease). The painting was commissioned by Mr Paul Freer who lives a few miles north of here, next to the line, at Barnt Green. The famous Lickey incline climbs for two miles from Bromsgrove to Blackwell, (this view is from the platform at the latter), at a gradient of 1 in 37 was, and still is I believe, the steepest continuous stretch of main line in the country. Here, at the summit, a southbound freight grinds to a halt to enable wagon brakes to be pinned down – one of the many regulations imposed upon trains descending the incline. Battling up the grade with a passenger service from Bristol is a Barrow Road 'Jubilee', No. 45699 *Galatea*, a regular on this route during the late 1950s and early '60s. It was one of the unfortunates slandered as a 'crate' in

New Street station but also happened to be one of the fortunate few that found its way to Barry scrapyard when withdrawn in 1964 and, at the time of writing, is a kit of rusty parts at the Birmingham Railway Museum, Tyseley. The 'Lickey' was a wonderful place to watch locomotives hard at work and indeed, was heavily populated with train watchers of all ages at weekends and holidays during steam days.

In the 1950s we saw a few 9Fs on the Western lines at home but later Saltley shed was discovered where many of them lived. In '**Heavy Freight**' No. 92118, one of the Saltley fleet, is getting under way with a heavy train of iron-ore and viewed from the disused platforms of Saltley station in the early 1960s. Ahead lies the steep climb to Camp Hill (see also 'Bordesley Meeting') and a hard slog for the fireman. I have tried to make the most of the contrast of a sunny

day and filthy engine topped off by the volcanic eruptions from the chimney. Exhausts such as this always remind me of a caption to a photograph by Eric Treacy when he described an A3 as 'talking to the sky' – must use that one of these days! In the background lurk two of Birmingham's beauty spots, Nechells Power Station and Washwood Heath Gasworks. The aroma was intoxicating!

Carlisle Citadel (they don't name them like that anymore) station became well trodden during the early 1960s particularly during the wee small hours awaiting connections to here and there. In '**Citadel Scot**' the purposeful form of rebuilt 'Royal Scot', No. 46125 *3rd Carabinier*, catches the sunlight struggling through the smokey atmosphere as it awaits departure time with a Glasgow–Birmingham express in the early 1960s.

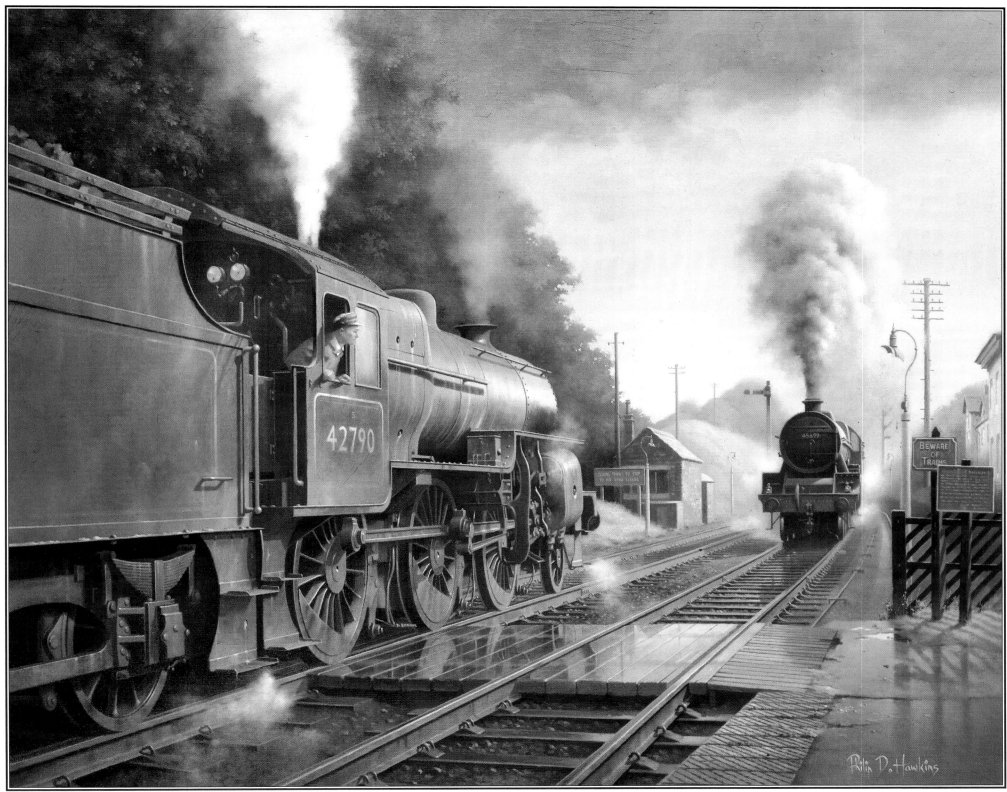

Summit Meeting (1994)
Oil on Canvas 30" x 24"

Low Level Departure/Home From the Seaside/View From a Bridge

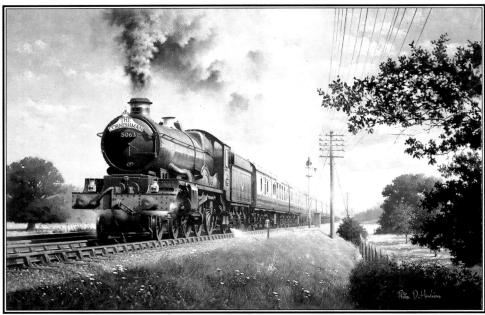

Collection: *Charles Pagett Esq.*

Home From the Seaside (1986)
Oil on Canvas 30" x 20"

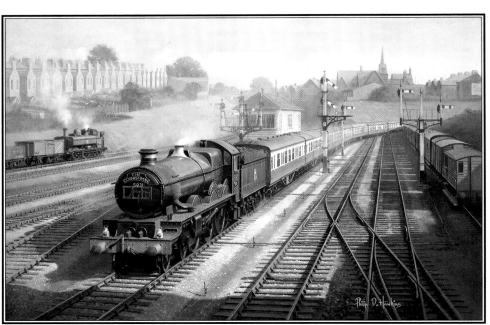

Collection: *David Reynolds Esq.*

View From A Bridge (1996)
Oil on Canvas 30" x 20"

The reader will be aware by now that I saw a lot of the 'Cornishman', indeed from 1960 until 1962 hardly a day passed that did not find me, when the evenings were light enough, perched upon my bicycle saddle propped against Tyseley bridge, glancing at my watch impatient for six-thirty to arrive when this magnificent spectacle would ease into view, if running to time. However, at this stage of the long journey, having left Penzance at 10.30 in the morning, it was usually behind schedule. David Asbury also saw a lot of this train but at Wolverhampton Low Level station during the 1950s. A Stafford Road 'County' would often be the motive power and fittingly, No. 1004 *County of Somerset* is depicted here in 'Low Level Departure', in BR lined black livery in original single-chimney condition carrying the original pattern headboard. Departure from Low Level was at 9.15 in the morning and relief trains would also run on summer Saturdays, both before and after the main train. The other protagonists are a Hawksworth pannier tank, No. 8411, and Churchward Prairie

tank No. 5151, both allocated to 84A at this time. The pannier is engaged on station pilot duties and the Prairie is waiting in the up bay platform with a Stourbridge local. The contraption fitted to the smokebox of No. 1004 is a reporting number frame which should carry the number 825. Presumably shed staff at 84A did not have the numbers to hand or no time to fit them. This characteristic Great Western accessory can be seen in other paintings in this collection, both full and empty!

'Home From the Seaside' features the northbound train climbing away from Stratford upon Avon approaching Danzey on the North Warwickshire line c1960. Commissioned by Mr Charles Pagett who, on regular family visits during the 1950s to his uncle who lived near to the orchard shown on the right of the picture, would spend hours watching the trains at this location. The engine is a Stafford Road 'Castle', No. 5063 *Earl Baldwin*, showing off the later decorative headboard complete with Cornish

piskey leapfrogging over a toadstool!

Whilst discussing what was to become '**View From a Bridge**' with Mr David Reynolds who commissioned the picture, I discovered that he too had spent hours on Tyseley bridge but during the early to mid 1950s, a little earlier than I. His favourite 'Castle' was No. 5031 *Totnes Castle*, another Stafford Road regular. The 'Cornishman' at this time was often made up of Hawksworth stock in BR carmine and cream livery (blood and custard to us) and is seen coming off the North Warwick line to join the down relief on the main Paddington–Birmingham route. After cautiously passing through Tyseley it will join the down main before calling at Birmingham Snow Hill and eventually journey's end at Wolverhampton Low Level. A Tyseley 'matchbox' fusses with wagons on the shunting spur next to the up main. This view is still recognisable today including the terraced houses although the track layout has been rationalised during the intervening years and of course, the signalbox and signals have long gone.

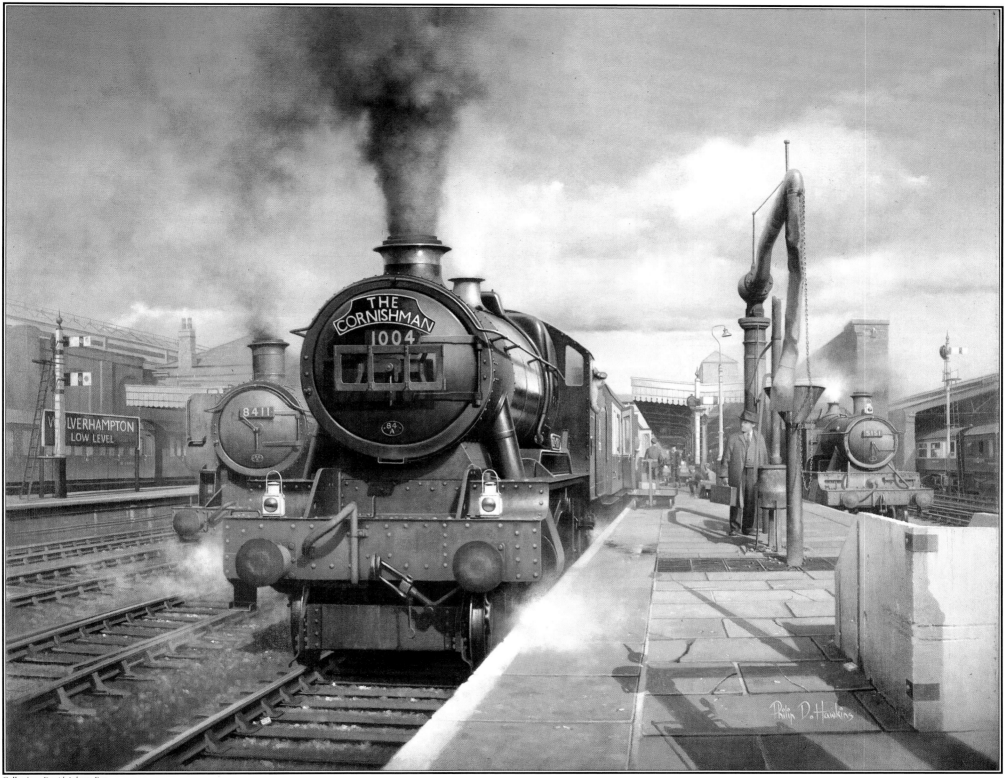

Collection: *David Asbury Esq.*

Low Level Departure (1997)
Oil on Canvas 30" x 24"

Exeter St Davids/Evening at Yardley Wood/The Power and the Glory

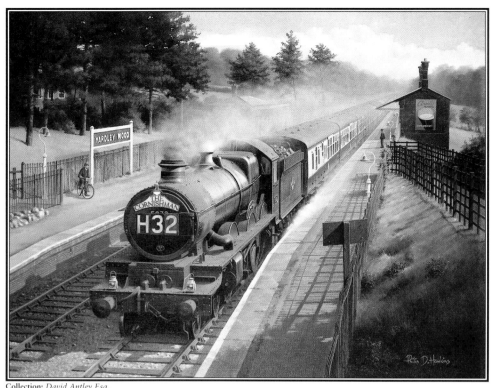

Collection: *David Antley Esq.*

Evening at Yardley Wood (1993)
Oil on Canvas 30" x 24"

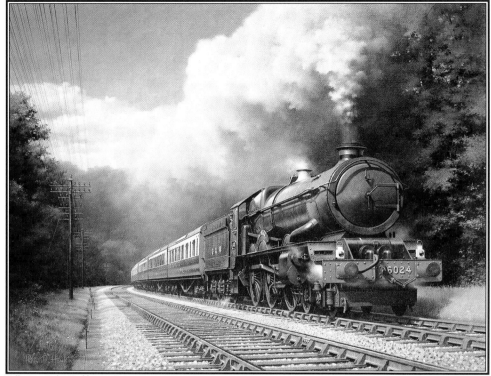

Collection: *Colin Washbourne Esq.*

The Power and the Glory (1991)
Oil on Canvas 30" x 24"

A fine art print of '**Exeter St Davids**' was published in 1994 and launched at the Exeter Rail Fair in that year. It was later realised that the headlamps on *King John* had no handles. Some weeks later I rectified the omission on the original painting and took the opportunity to alter one or two other things including the addition of a driver leaning from the cab. The version seen here is the latter – complete with headlamp handles! The painting depicts the late 1950s, perhaps 1959 when I first discovered St Davids as referred to in Chapter 3 (Holidays and Trains), the footbridge is the very one from which the noisy 'Warship' was witnessed. 'King' class 4-6-0 No. 6026 *King John* sweeps majestically through the centre road in charge of the down 'Cornish Riviera Express' complete with decorative headboard and reporting numbers.

Prairie tank No. 4117 waits to follow with a stopping train for Newton Abbot while 'West Country' No. 34023 *Blackmore Vale* waits for a path to Exeter Central with a train from Plymouth. The building in the background is the same one seen in 'Night Freight', reproduced earlier in this book.

'**Evening at Yardley Wood**' shows the northbound 'Cornishman' passing through the Birmingham suburbs at Yardley Wood in 1960. My brief from Mr Dave Antley who commissioned the work, was straightforward. As a kid he had spent time on the road bridge, which also served as a footbridge, to watch this train, just as I did three stations along the line at Tyseley. I had some photographic reference taken in the 1970s when the station still appeared

much has it had since between the wars, including the lamps, nameboards and platform awnings. There would be a problem with the platform hiding the wheels of the engine, but with some careful juggling of the angles this was overcome. Before a start was made on the canvas a visit was made to the station – still open and well used but much of the paraphernalia of a real railway, the old lamps and nameboards had been replaced with modern functional but heartless substitutes. The platform awnings had also been replaced with perspex sheets. The locomotive incidently, is 'Castle' No. 5072 *Hurricane*.

'**The Power and the Glory**' was commissioned by Mr Colin Washbourne, a member of the 6024 Preservation Society, as a reward for himself having grafted for years on the restoration of the

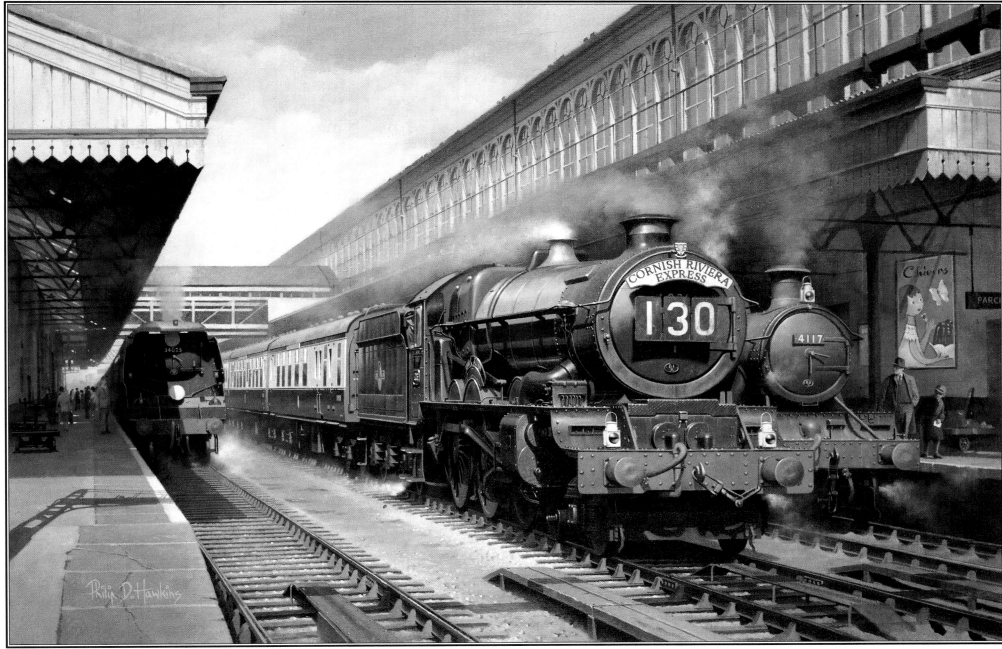

Collection: *Ron King Esq.*

Exeter St Davids (1994)
Oil on Canvas 30" x 20"

engine, first at Quainton Road and then at Didcot. He specifically wanted the painting to portray 'his' engine in Great Western days. This necessitated having to un-rebuild the 'King' with a single chimney, straight steam pipes and so on.

Also it had to be working hard, and as *King Edward I* was a West Country resident during the chosen period, 1947, we decided on Dainton bank as the location, as it would have worked between Paddington and Plymouth almost

exclusively. Ample reference material was at hand having visited the area frequently over the years. The scene is what many would consider to be the epitome of all that was great about the Great Western.

Sunshine and Steam

Early in 1987 I received a letter from the BBC asking if I would accept a commission for a painting with a 'West Country' flavour that could be published as a fine art print. A

Canvas size
30"x 20"

Double chimney,
'King' heading
the 'up' 'Cornish
Riviera', 1958.

DAWLISH PROM' – 1958.

recent years too and was aware that the semaphore signal, railings and practically everything else was still as I knew it in the '50s including, of course, the distinctive red sandstone

Left: A composition which was rejected. The angle made me feel uncomfortable – sitting on those spiked railings!

cliffs. In fact the only noticeable difference, apart from the motive power, was that the footbridge had been replaced by a modern concrete structure. Since 1987 colour-light signalling has replaced the semaphores along this route.

Once again, my son Ben stood in for me and the figure groups are taken from family snapshots of the period, and the locomotive chosen was No. 6023 *King Edward II* which, at this time, was a 'kit of parts' languishing in the 'fish bay' at Bristol Temple Meads. It has since been transferred to the Great Western Society at Didcot where restoration work is currently in progress.

The finished work was well received by the BBC and following some excellent television, radio and press coverage, the prints sold extremely well and raised several pounds for 'Children In Need'.

proportion of the proceeds from each print sold would be donated to the 'Children In Need' fund later in the year. Obviously, I was delighted and, upon inquiring further, realised that I was to have a completely free hand regarding the subject and location. The only criteria was that it should appeal to a wide audience and not only railway enthusiasts. I drifted back immediately to summer holidays with my parents in the 1950s and standing transfixed to the railings on the promenade at Dawlish in Devon watching the trains go by. The attractive headboards proclaiming the passage of the 'Torbay Express', the 'Mayflower', the 'Cornishman', the 'Royal Duchy' and the 'Cornish Riviera Express' remain etched in my memory bank. To extend the West Country theme I chose to portray the 'Cornish Riviera Express'. I knew the location well from

Right: This is the angle finally selected. I preferred the lower viewpoint which I feel adds a certain dignity to the locomotive and allows the viewer to feel more comfortable on the 'right' side of the fence.

DAWLISH PROM – '58

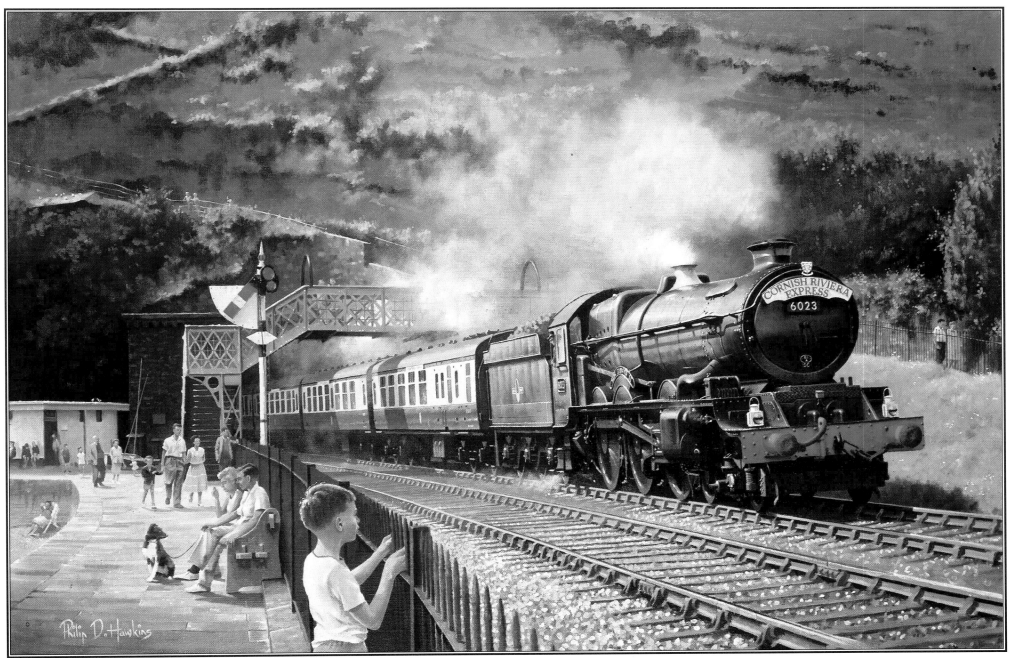

Collection: *BBC Radio Devon.*

Sunshine and Steam (1987)
Oil on Canvas 30" x 20"

Approaching Solihull/Lyme Regis Bound/Great Western Style

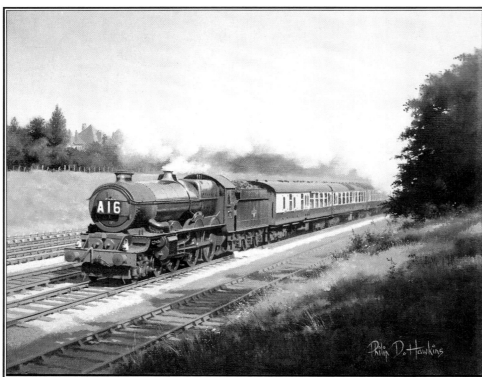

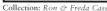
Collection: *Ron & Freda Cass.*

Approaching Solihull (1986)
Oil on Board 12" x 10"

Collection: *Ron & Freda Cass.*

Lyme Regis Bound (1987)
Oil on Canvas 20" x 16"

These three paintings belong to my 'cow parsley' period. This plant, as I'm sure you know, has 'umbrellas' of tiny white flowers and is prolific on railway embankments, and practically everywhere else, during May and June and I became quite enamoured for a while, taking photographs and making sketches with a view to incorporating them in paintings, when appropriate of course. The paintings are also examples of the type of scene that is most often requested by would-be clients. They are straightforward front three-quarter views of trains in a sylvan setting. Perhaps the popular idea of a 'railway painting'. My own preference is for more urban or industrial surroundings, but I can well understand the popularity of the open countryside of course, and enjoy such paintings, especially when they 'work'. An added bonus too

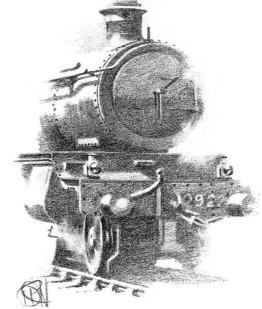

"GREAT WESTERN STYLE"

is that the amount of reference involved is usually less than for a busy station scene, for example.

'**Approaching Solihull**' portrays a 'King' heading the 8.33am Wolverhampton–Paddington express viewed from Streetsbrook Road bridge in 1962 on the four-track main line out of Birmingham. This was a train I saw hundreds of times both when living in Winson Green and later in Acocks Green and was invariably a 'King' job until the end of the summer 1962 when these majestic engines were replaced by the new 'Western' diesel-hydraulics. Many years later, in the 1970s, I was to photograph many 'Westerns' from this same bridge.

'**Lyme Regis Bound**' is an idyllic scene, in the fifties, on the 7-mile long branch line to Lyme

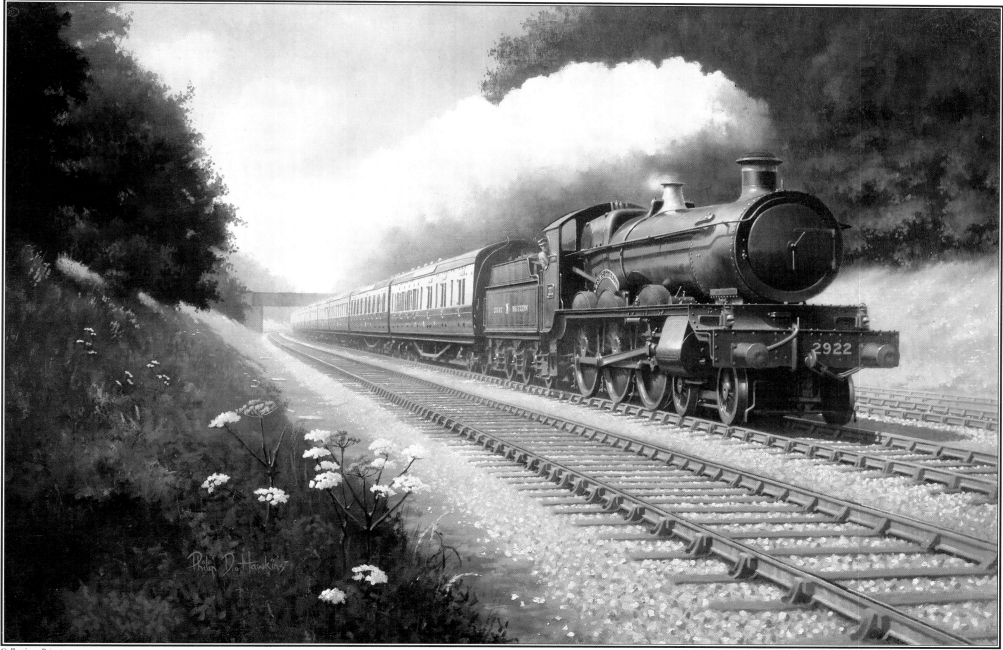

Collection: *Private.*

Great Western Style (1986)
Oil on Canvas 30" x 20"

Regis, which left the ex London & South Western Railway's main line at Axminster. No. 30583 was one of three Adams radial tanks that were retained to work this unusually difficult and twisting line. They proved to be ideally suited to these conditions and were synonymous with this service until 1961. They became something of an anachronism and attracted enthusiasts from far and wide. In my picture the engine wears British Railways lined black livery, which suited it well I think. It has now been preserved for more than 30 years on the Bluebell Railway.

'**Great Western Style**' was the ideal commission. The instructions went something like this – 'A Great Western express train speeding along the open road on a sunny, summer day between the wars'. What more could I ask for? Here was an excuse to paint a 'Saint'. Lovely engines, which make me wish that I had been born earlier. What a pity that none are preserved. The period is the 'roaring twenties' with an up express tearing out of Sonning cutting near Reading, headed by No. 2922 *Saint Gabriel*.

Sonning Cutting/The 'Inter-City'

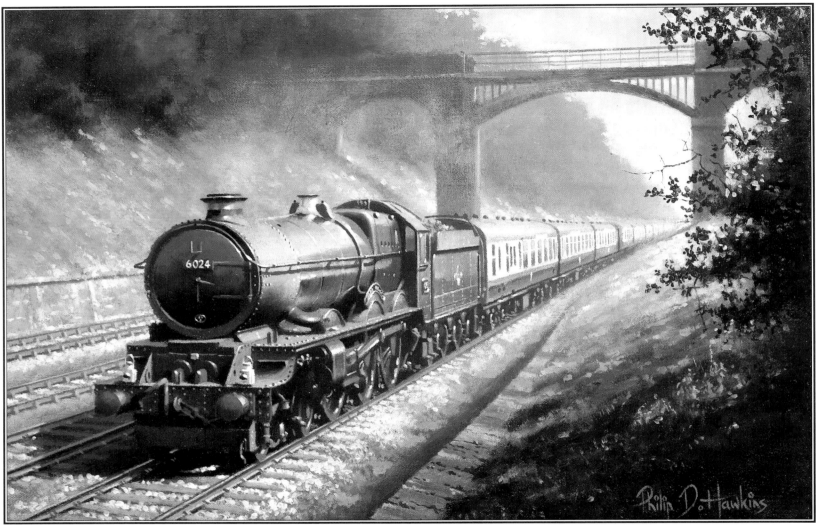

Collection: *Private.*

Sonning Cutting (1984)
Oil on Canvas 14" x 10"

As railway cuttings go Sonning must surely be the most famous. The excellent and much published photographs by the late Maurice Earley have made it familiar to all railway enthusiasts. Brunel's planned route for the Great Western Railway's first broad gauge main line from Paddington to Bristol dictated that his civil engineers had to excavate this long, wide, deep and very impressive cutting on the approach to Reading. Just imagine the manpower required for such an undertaking in those premechanised days. During the steam era there was an almost constant procession of traffic along this very busy main line. In '**Sonning Cutting**' No. 6024 *King Edward I* is heading a down express in the late fifties. 'The Power and the Glory', featured previously, shows this engine at an earlier stage in its career.

The period in '**The Inter-City**' is the same as the previous picture and was commissioned by Mr Charles Pagett, who now lives near the south end of this station, Knowle & Dorridge. The 'Inter-City' was a regular 'King' turn, although 'Castles' were used on occasion. The engine is No. 6013 *King Henry VIII*. Just left, beyond the shops, is the Dorridge Gallery where many of my paintings have been framed over the years, and along Station Approach to the right is an off-licence which dad used to manage.

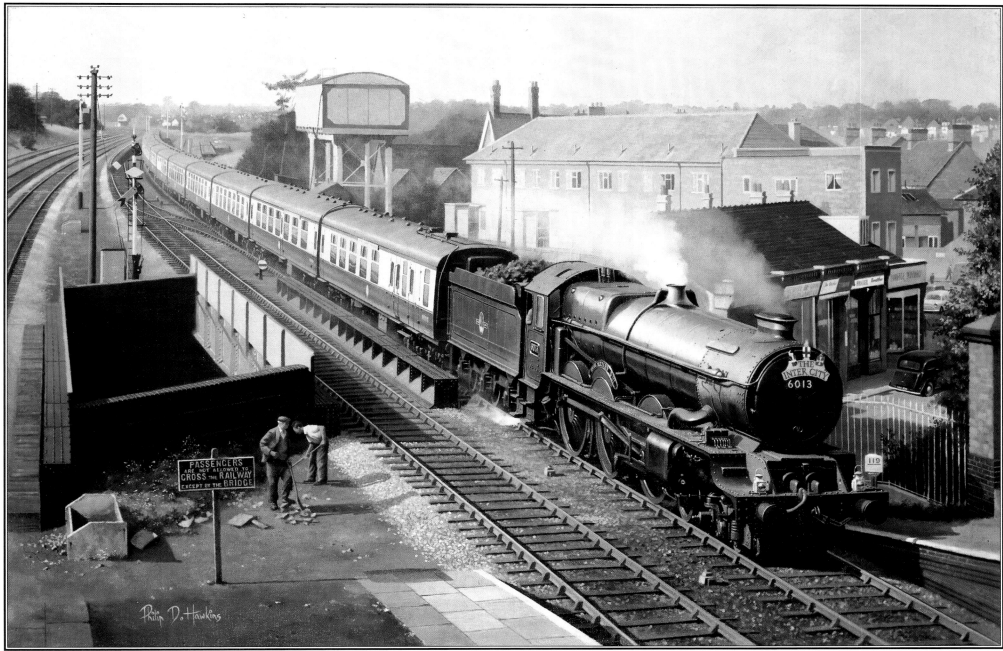

The 'Inter-City' (1989)
Oil on Canvas 30" x 20"

The Bristolian

In 1987 the Bristol United Press newspaper group commissioned a painting to celebrate the naming of an HST power car after the company. The subject chosen, after several interesting meetings, was appropriately, the steam hauled 'Bristolian'. During BR days this train carried a very attractive headboard that incorporated the coats of arms of both London and Bristol. This would feature strongly in the painting as would the beautiful, sweeping arch of the roof at Temple Meads station. Also, I wanted to introduce an element that would indicate the importance of Bristol as an inter-regional crossroads. The West of England to the North services were very busy in the 1950s, particularly during the summer months. One of these trains had to be included in the picture. The year was to be 1959 and July of that year saw the 'Warship' diesel-hydraulics taking over the 'Bristolian' from the 'Castles'. I chose to depict this final phase of steam haulage.

Technically, the picture is rather complex because of the curve of the tracks and consequently the roof called for some careful calculations. Several visits were made to sketch and photograph details of the view required. Unfortunately the viewpoint

in my painting is now ruined by the ugly Royal Mail parcels bridge at the London end of the platforms. Train spotters were a constant feature here, as at many large stations, and they made full use of any available seating. To this end I found some typical Great Western parcels trollies on the Torbay Steam Railway in Devon and duly used these to seat the aforementioned 'spotters' who would be noting down details of their latest 'cops'. The inclusion of such detail is, I feel, vital to the overall impact and also serves to add scale and a certain majesty to the loco-motives and the imposing surroun-dings. Another important touch is the inclusion of one of the ubiquitous pannier tanks on the centre road. This provides an ideal contrast with the two passenger engines. The ever-present 'station' pigeons complete the scene.

The finished painting was unveiled in the newspaper's boardroom in front of several British Rail officials. Later, I was invited, along with the congregation, to witness a naming ceremony at Temple Meads where the nameplates *Bristol Evening Post* were unveiled on HST power car No. 43150 in October 1988.

cream, discoloured, stains etc

Detail of platform canopy awning

Pigeons perhaps on roof.

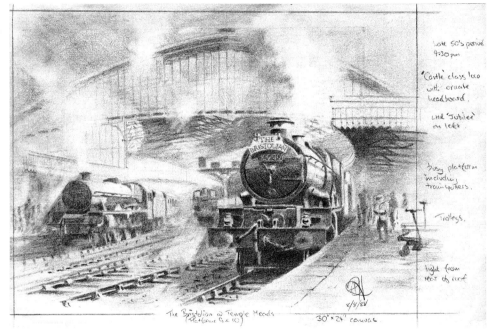

Late 50's period 4.30 pm

'Castle' class loco with ornate headboard.

LNER 'Jubilee' on left.

busy platform including trainspotters.

Trolleys.

light from rest of roof

The Bristolian @ Temple Meads (Platforms 9 & 10)

30" x 24" canvas

Shorten hair - 50's style

'Ben' Aug '88

'Train-spotter' to sit on trolley with note book etc.

Light

'Patriot' No.45509 at far platform. Substitute for 'Jubilee'.

Metal

Black (battered)

Brown

Luggage trolley sketched @ Kingswear. Aug '88.

'Train-spotter' to sit on trolley - 2nd figure.

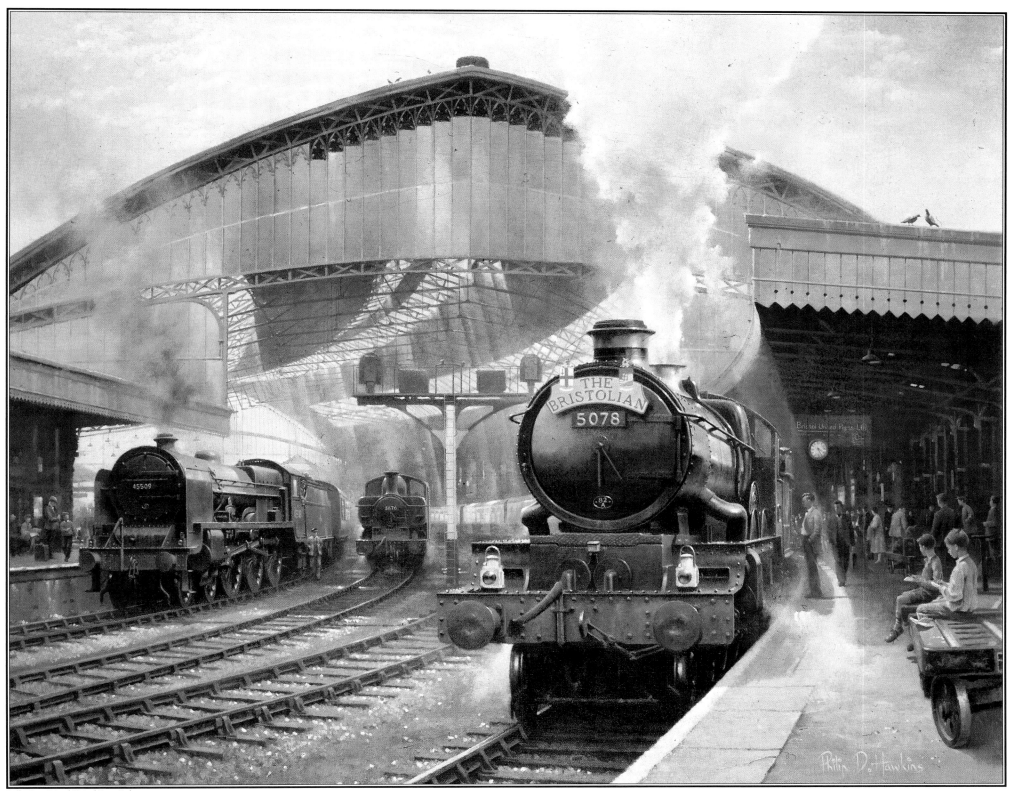

Collection: *Bristol United Press Ltd.*

The Bristolian (1988)
Oil on Canvas 30" x 24"

Preparing for Nightfall/Black 5 at Bristol

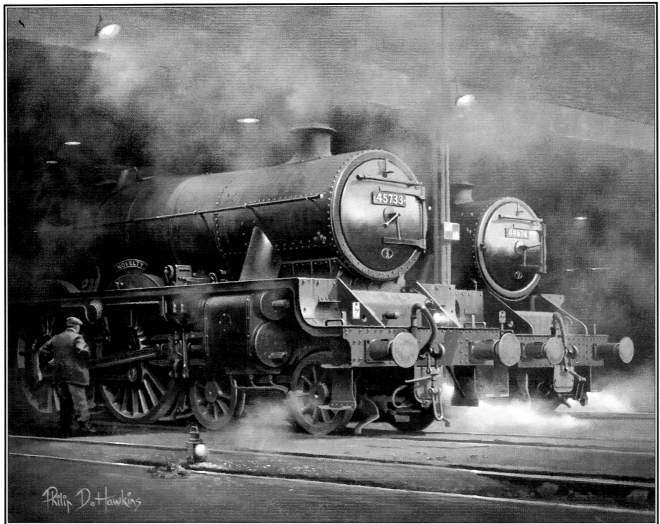

Preparing for Nightfall (1991)
Oil on Board 12" x 10"

Sir William Stanier's engines loomed large in my childhood. 'Black 5s', 'Jubilees' and rebuilt 'Scots' were almost a part of the family. I loved the names, particularly those of the 'Jubilees'. As mentioned elsewhere, I was able to answer some unusual general knowledge questions at school thanks to the 'Jubes'.

'Preparing for Nightfall' features 'Jubilee' No. 45733 *Novelty* and 'Black 5' No. 44674 at Polmadie shed, Glasgow in 1963. The shed lights, such as they are, begin to take over from daylight as the engines are prepared for duty. *Novelty* wears a 2A shedplate indicating that its home shed was Rugby, many miles south, and is making a rare visit north of the border. I knew this engine well during the fifties when it was a Bushbury resident and a regular on 'my bank' and at New Street.

When Mr John Petcher commissioned '**Black 5 at Bristol**' he specifically stated that he wanted a painting of a 'Black 5' and a Compound on shed in LMS days. I enjoy shed scenes, perhaps because the ever-present muck and clutter gives plenty of scope to improvise. The larger Midland Railway shed buildings are attractive and Bristol Barrow Road was chosen because of the amount of reference available. Several of the larger MR sheds shared the same architectural features. Holbeck and Burton, for example, are very similar to this. Great care has to be taken when portraying 'Black 5s'. There are many design and detail variations to trap the unwary. Research revealed that No. 5293, an example from the Armstrong Whitworth factory built in 1936, was a Bristol (22A) engine in 1938, the year in question. At the same time Compound No. 1123 was a Saltley (21A) engine and a regular visitor to Barrow Road. So, I had the actors, and most of the information needed to complete the stage.

The 'Black 5' had to be the main protagonist with No. 1123 in a supporting role. The contrasting liveries had artistic potential and would serve to lift the otherwise sombre tones. Again, the figures are important to add scale and a human presence. The 'banter' between the enginemen helps to make the composition flow. Smoke and steam are kept to a minimum. There is a tendency to overdo this aspect of shed scenes, but in this case I feel that the understatement is more effective. The inspection pit is important and allows the viewer to wander into the picture and 'mooch' around.

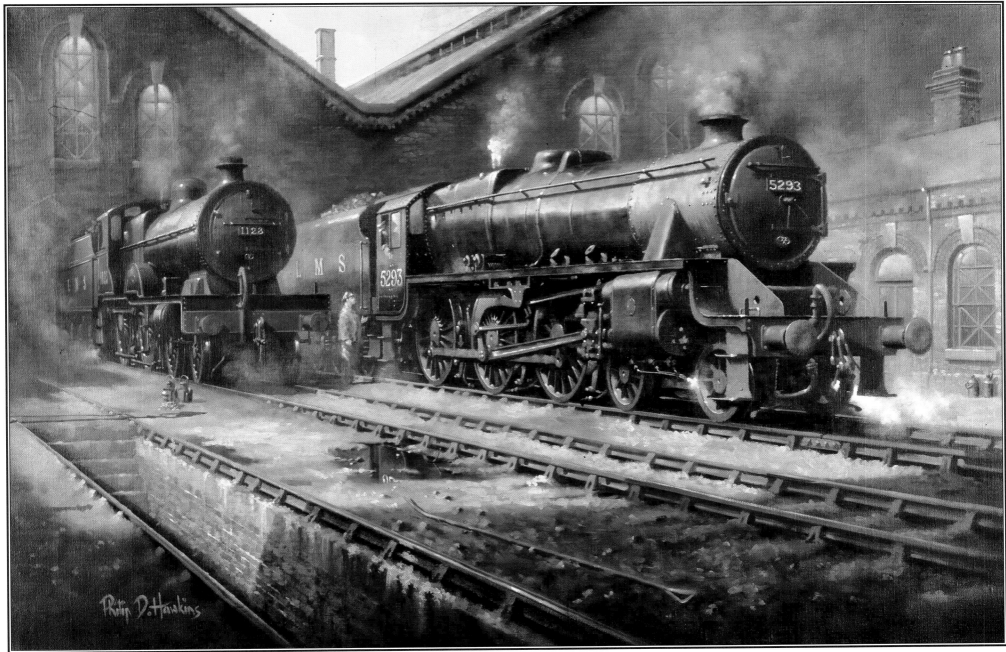

Black 5 at Bristol (1983)
Oil on Canvas 30" x 20"

Newton Heath Morning

When ever possible I use my own photographs as a source of reference but rarely is the final painting based so entirely on these as '**Newton Heath Morning**'.

Reproduced here are photographs taken on a very dull and gloomy Sunday morning in July 1964. With most unusual foresight I realised the potential of a wide shot. As this could not be encompassed within a single exposure I actually took two from exactly the same position with a view to joining them together later. Sadly this is an isolated example of forward planning but it paid dividends some six or seven years later when I made a water colour painting based on this reference. I vaguely remember being rather pleased with the result and sold it soon afterwards. Not one detail of the transaction was noted and consequently I have not seen the painting from that day to this.

Quite by chance, some 17 years later, whilst searching for some quite different London, Midland reference, I came across the two postcard sized photographs still taped together in an ancient Kodak box. The shed setting was exactly what I was looking for at the time and there seemed little point in hunting further. It will be noticed from the finished work that weather conditions have improved drastically over the intervening 23 years and human life has been added to the scene by including the engineman. Carefully planned lighting, smoke, steam and shadows mingle to recreate an evocative memory, to me at least, of a typical shed-bashing trip of more than 30 years ago, and absolutely authentic – except the weather. This was a particularly rewarding project, not least because every scrap of information had been gathered by me including the list of numbers seen at Newton Heath on, just another day in 1964.

Top, right: The relevant page from author's notebook, 1964.
Below: 'Royal Scot' No. 46140 The King's Royal Rifle Corps *at Newton Heath.*
Below, right: 'Jinty' 0-6-0T No. 47582 at Newton Heath.

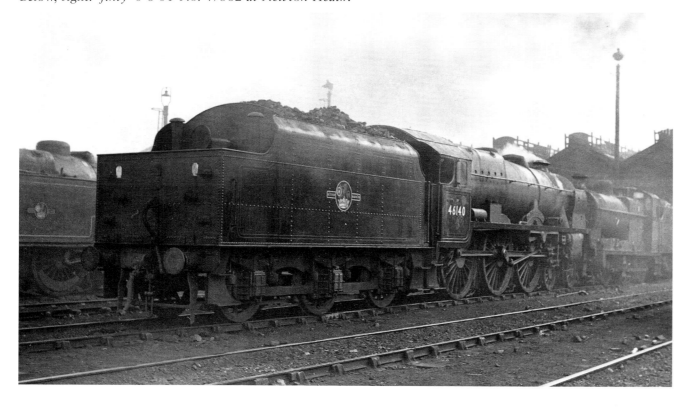

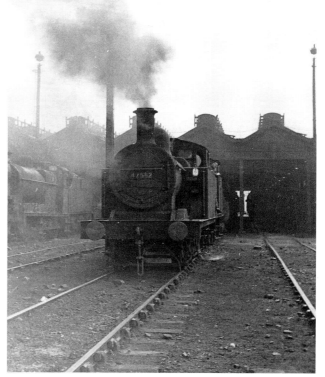

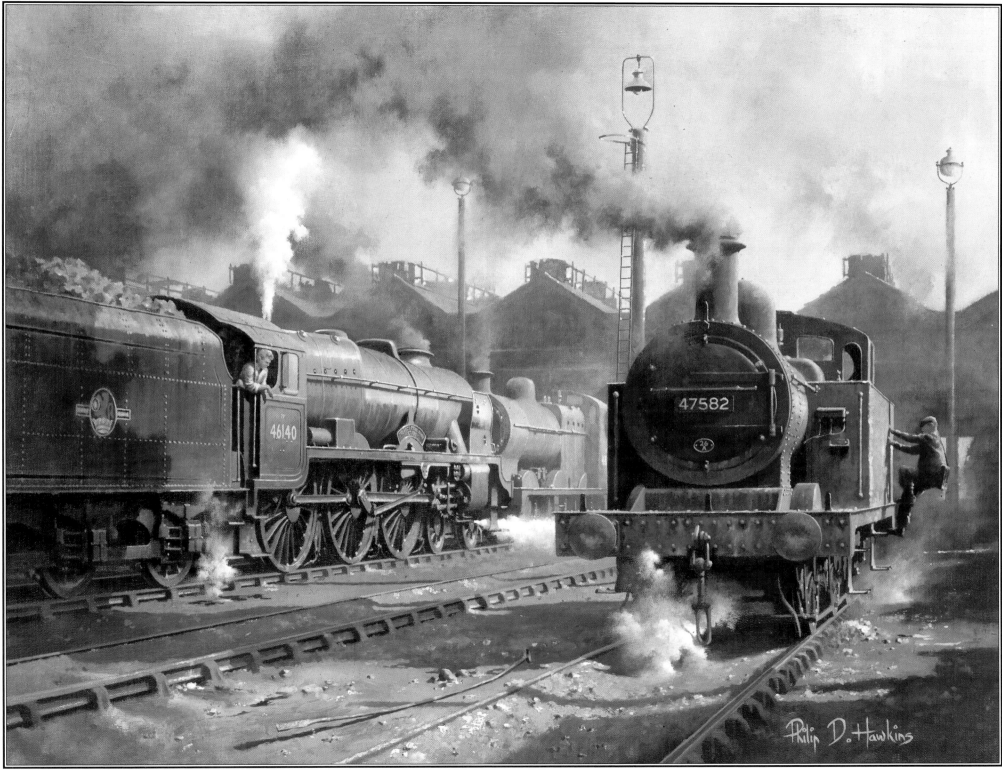

Newton Heath Morning (1987)
Oil on Canvas 20" x 16"

Unsung Hero

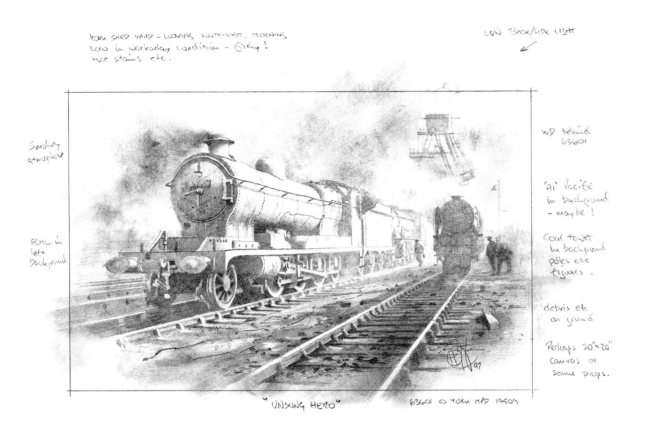

YORK SHED YARD – LOOKING SOUTH-WEST, FLOODLING loco in workaday condition – filthy! rust stains etc.

LOW BACK/SIDE LIGHT

Smokey atmosphere

ECML in left background

WD behind 63601

'A1' Pacific in background – maybe!

Coal tower in background poles etc figures.

debris etc on ground

Perhaps 30"x26" canvas on some props.

"UNSUNG HERO"

63601 @ YORK MPD 1950's

Freight locomotives have cast a spell since the constant parade of 4Fs and 'Super Ds' passed my home as a child. The unglamorous, workaday nature of these grime-covered machines was hard to resist. My first encounter with the O4s was during 1959 on a day out to Doncaster aboard a special train hauled by Compound 1000. Mexborough shed was included in the itinerary and it seemed, to this 11-year old, to consist of 'wall to wall' O4s and WDs, all in absolutely filthy condition. Later visits were made to such beauty spots as Staveley, Retford and Frodingham and so on. With all this in the memory bank, when *Steam Railway* magazine launched a campaign to raise funds for the restoration of No. 63601 in the National Collection, it seemed quite natural to get involved. Quicksilver Publishing would produce a high quality, very limited edition fine art print with almost 20 per cent of the purchase price donated to the 'O4 Fund'. After meetings with

representatives of the magazine, including Managing Editor Nigel Harris, a strategy was resolved with the original painting to be the prize for the lucky winner of a special *Steam Railway* competition. Perhaps the winner is reading this – 'hello!'. The December 1997 edition carried a feature on 'yours truly' and the preparation of '**Unsung Hero**', followed in the January issue by the launch of the limited edition print.

York shed yard was chosen as the location because, as a Frodingham engine, No. 63601 would have been a regular visitor with freight for one of the many yards around York, and adjourned to the shed for servicing. This, plus the fact that on withdrawal in June 1963 for preservation, it had spent many years at the York museum, amongst other places, pending restoration. Who would have thought that it would take well over 30 years? The engines in the National Collection belong to us all for

goodness sake! No. 63601 in ex-works condition just did not appeal – it had to be liberally coated in work-stained glory. The WD coupled up behind was an obvious choice, the two types seem so well matched. By way of contrast, and to illustrate that York shed entertained both freight and passenger locomotives, is the inclusion of an A4 Pacific, No. 60015 *Quicksilver* (you have to keep publishers happy) and A1 No. 60154 *Bon Accord*. The period is c1960.

It will be noticed that the composition was lowered within the picture area and the decision made during work on the canvas to darken the mood – I wanted a more intimate atmosphere.

36C FRODINGHAM

63693 ✗	90053 ✗
63748 ✓	90313 ✗
90158 ✓	90189 ✓
63576 ✓	90578 ✓
63985 ✗	63692 ✗
63773 ✗	90120 ✓
63690 ✓	62017 ✓
63617 ✓	90700 ✓
62018 ✓	63906 ✓
63653 ✓	90522 ✗
90453 ✗	63880 ✗
63741 ✓	63812 ✗
62013 ✓	90540 ✓
90032 ✓	63671 ✓
63628 ✗	63791 ✗
90236 ✗	90610 ✓
63601 ✓	90347 ✓
62020 ✓	90590 ✓
90070 ✗	63666 ✓
63949 ✓	63807 ✓
90537 ✗	63981 ✗
63606 ✓	62068 ✗
63586 ✓	63781 ✗
D3641 ✓	90646 ✗
48685 ✗	90276 ✗
90073 ✗	63836 ✓
90059 ✓	90613 ✗
63862 ✗ ✓	
90714 ✓	

D6811 ✓ (1)

(33)

A page from one of the author's notebooks, complete with No. 63601, 16th June 1963.

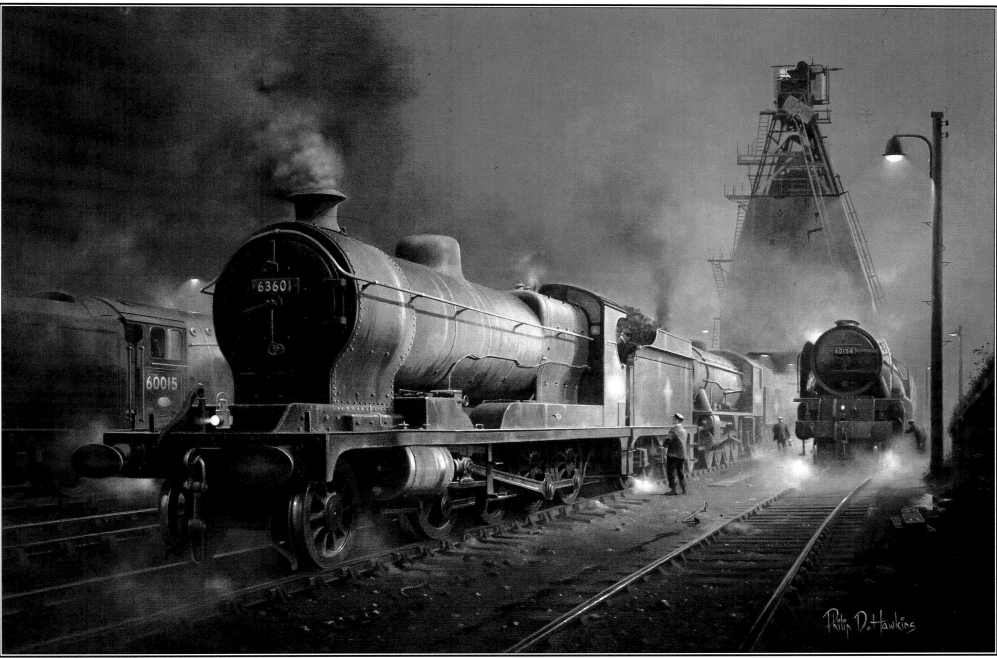

Collection: *Private.*

Unsung Hero (1997)
Oil on Canvas 30" x 20"

Twilight of the Fifties

By the summer of 1991 only a handful of Class 50s were still in service and even those were not expected to see the year out. Quicksilver Publishing was keen to commemorate their passing with the issue of a fine art print. Hence the creation of 'Twilight of the Fifties'.

My immediate thoughts turned to Laira, Plymouth, a depot which had a long association with these diesel-electrics, with the idea of producing a painting of them 'on shed', and to take the opportunity of working from 'life'. Consequently, during May contact was made with British Rail in the person of Geoff Hudson, Area Fleet Manager at Laira. His reaction was very encouraging and after clearance with various departments of BR arrangements were made for me to visit the depot in June. After donning a look-out vest and prowling around for an hour or two, several options had come to mind. What I had pictured was a 'busy' scene inside the maintenance shop with more than one Class 50 in view. Several ideas were discussed with my minders

and the remainder of the day was spent making sketches and taking photographs. Armed with this reference I adjourned to my studio, refined my thoughts and produced the drawing shown here. A copy was sent to Laira to ascertain from Geoff whether or not the scenario could be staged for a second visit, which had to be quite soon to give sufficient time to complete the painting. His reaction was prompt and very enthusiastic. True to his word, and much to my

50002 – LAIRA MAINTAINANCE DEPOT
from reference taken – 6th June 1991

delight, July saw me once again in Devon and as I peered through the maintenance shop door the envisaged picture was there to greet me. The locomotive on the jacks was No. 50048 *Dauntless* with sister engines hovering about which I could arrange to have positioned wherever required.

On being confronted with this enticing spectacle I immediately decided to change my original viewpoint and several other details were altered. Two of Laira's 'B' shift fitters, Mike Collings and Clive Young, entered into the spirit of things when recruited as models and showed great restraint whilst sketches were made. A most enjoyable day made possible by the friendly co-operation and enthusiasm of Geoff Hudson and his staff.

The whole exercise was rounded off by the launch of the print at the Laira open day in September where I spent the day signing copies. A very satisfactory conclusion to five months' work and a real treat to have all the necessary information at my finger tips rather than relying on historical reference.

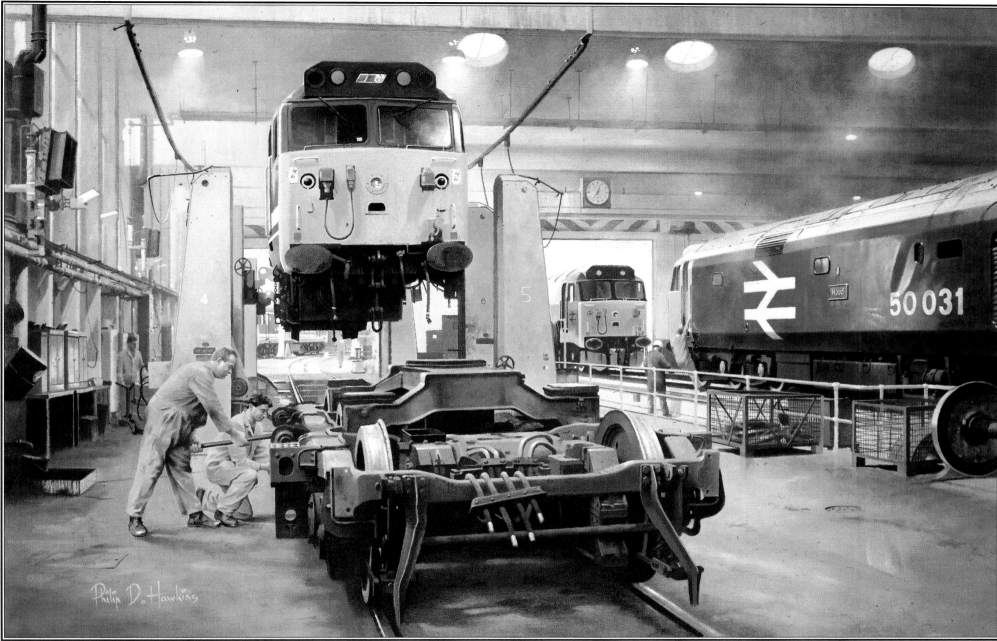

Twilight of the Fifties (1991)
Oil on Canvas 30" x 20"

Twilight of the Twenties

To continue the 'Twilight' theme and the success of the Class 50 project of the previous year, the same publisher was anxious to follow up with a print issue for 1992. The Class 20s presented themselves as perfect candidates. Only a handful of these popular diesels remained in normal service having been an integral part of the British railway scene for 35 years, far longer than intended.

As with the 50s, I was determined to work from 'life' and after several abortive attempts to arrange visits to Toton depot and continually banging my head against British Rail red tape, attention turned closer to home, at Bescot. The response to my initial calls was positive and it soon became clear that the Bescot lads would be willing and able to help with my task. Arrangements were made by the West Midlands Area Freight Manager, Les McDowell, and at 8 o'clock on a very warm June evening I presented myself at the depot to be met by driver Tony Bill who had volunteered to be my guide. Sketches of my intentions had already been made. Ideally my painting was to be a night scene with a pair of Class 20s leaving the yard with a coal train and my immediate task was to find the location

where this scenario could take place. The next two or three hours were spent stalking the marshalling yards with Tony feeding me invaluable information regarding the workings of the yard and details of signalling, amongst other things. Eventually the ideal place was found. At the north end of the down yard, adjacent to the diesel depot, was exactly what I envisaged, right down to the signal which was to

be a crucial part of the composition. Tony even phoned the power box to ask if the coloured light could be changed to the aspect seen in the painting. His request was declined when it was explained that repercussions would be felt for

several miles along the line! The required sketches were made and photographs were taken with the only thing missing being the locomotives.

One of the trains that had departed the yards at the location in question was a merry-go-round service to Ironbridge Power Station. Until a year or two previously Class 20s had been in charge – perfect. More research revealed that several 20s had been based at Bescot including No. 20160 which, although withdrawn in December 1990, was still stored elsewhere in the yards. More sketches and photographs followed. By 3 o'clock in the morning I had sufficient reference to make a start. Tony had been patience personified and a mine of information too.

As at Laira it was very satisfying to work with informed and enthusiastic BR men and Les McDowell and Tony Bill were certainly that.

The prints were launched at Bescot open day on 30th August where my painting was actually duplicated in the yard beside the depot, even to the extent that a Class 37 was positioned exactly as in the picture. The only details missing were the snowploughs! The painting was used on the cover of the open day programme and also reproduced in several magazines at this time.

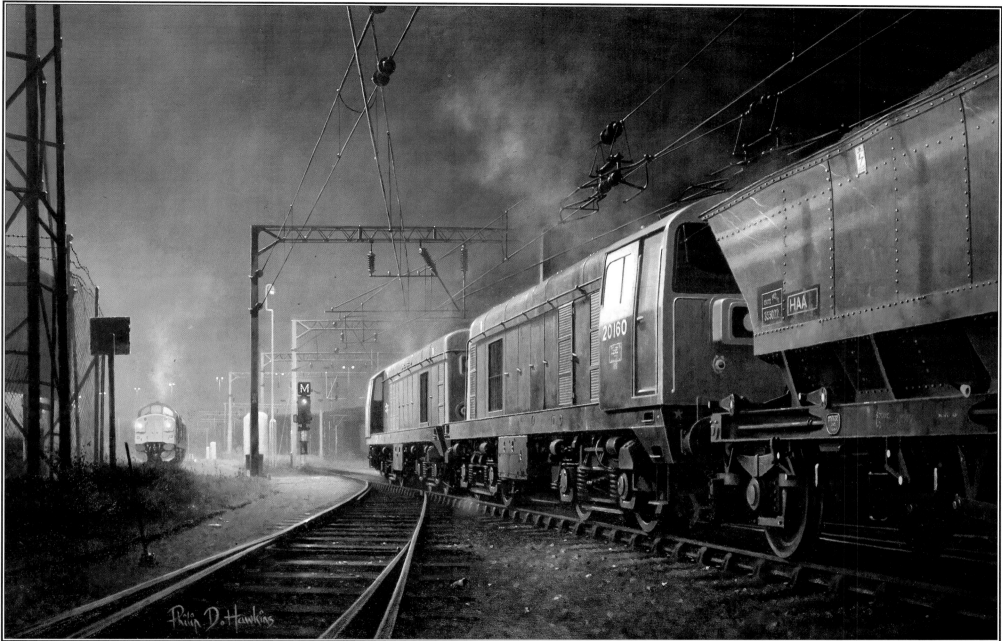

Twilight of the Twenties (1992)
Oil on Panel 24" x 18"

North Pole Dawn/Docklands – Then and Now

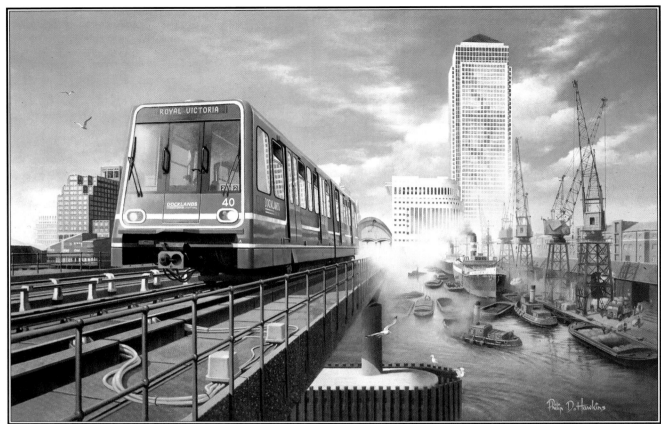

Collection: *Brown & Root, Booz • Allen Ltd.*

Docklands – Then and Now (1994)
Oil on Canvas 30" x 20"

For the most part I graft away in the studio surrounded with reference books, photographs, maps, timetables, notes, drawings, anything that may be of use with the work in hand. You get the picture! Sometimes a breath of fresh air arrives when asked to portray a contemporary subject. These pages illustrate two such cases. Both were commissioned quite out of the blue and unconnected early in 1994, both involved frequent trips to London, initially discussion meetings and later, reference gathering. 'North Pole Dawn' was commissioned by European Passenger Services to celebrate the imminent launch of 'Eurostar' services to the Continent through the Channel Tunnel. A

meeting was arranged at the newly opened North Pole depot in London and after satisfying the gathering that I could come up with the goods, plans were made to make a start. Initially sketches were prepared to ensure that we were all on the same wave length and then some in depth research work was carried out. Mr Stuart Whitter, EPS Fleet Engineering Manager, arranged several visits to North Pole where 'Eurostar' units were placed at my disposal and positioned as required. Stuart's enthusiastic co-operation made for a most enjoyable project resulting in fine art prints of the painting being presented to all members of staff at a presentation at the depot towards the end of the year in

recognition of their tremendous efforts – a lovely touch and one which was much appreciated.

'Docklands – Then and Now' was commissioned by Brown & Root, Booz . Allen Ltd, main contractors for the Docklands Light Railway. During our initial meeting at their London headquarters in Docklands I suggested the idea of combining the old and new as an evocation of the vast changes and regeneration of the area in recent years and, of course, featuring the railway. After several interesting meetings a pass, issued for the Docklands Light Railway system, was extensively used during the following weeks to gather reference for the main subject. Several

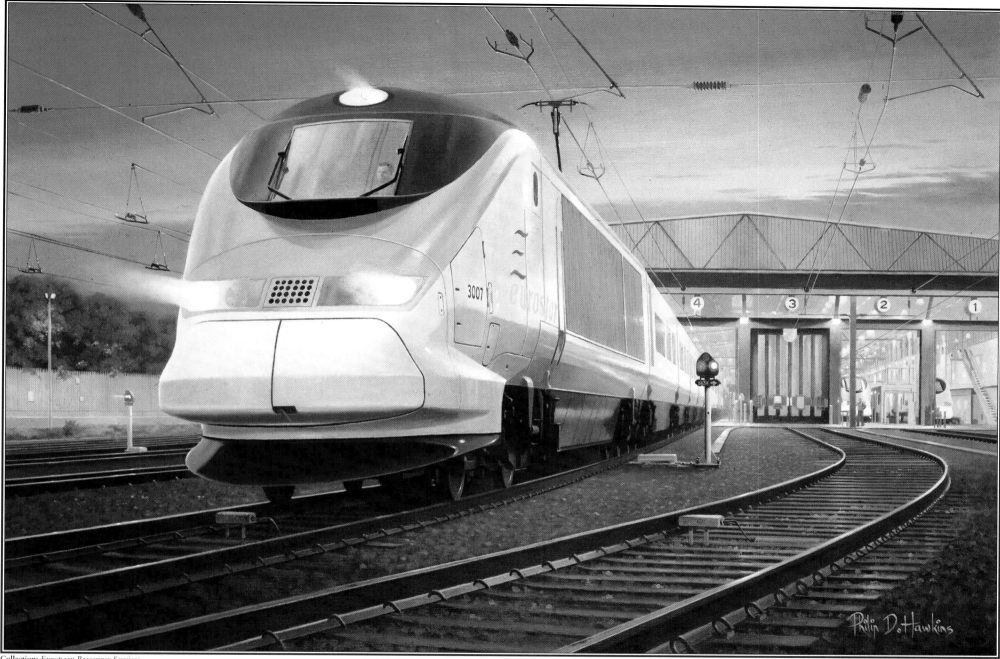

Collection: *European Passenger Services.*

North Pole Dawn (1994)
Oil on Canvas 30" x 20"

visits to the Docklands Archive in Poplar for historic material threw up information on the various docks in the area. This information enabled a start to be made on the canvas. All in all a most enjoyable exercise. A limited edition print and greetings cards were published by Quicksilver Publishing for internal circulation throughout the company. It's not all steam you know!

96

BRITAIN
from the air

Publisher and Creative Director: Nick Wells
Editor: Polly Willis
Picture Research: Gemma Walters
Designer: Vanessa Green
Production: Kelly Fenlon, Chris Herbert and Claire Walker

Special thanks to: Sara Robson, Rosanna Singler, and Brenda Marks and
Phill Dolphin at Skyscan Photolibrary

FLAME TREE PUBLISHING
Crabtree Hall, Crabtree Lane
Fulham, London SW6 6TY
United Kingdom

www.flametreepublishing.com

Flame Tree is part of
The Foundry Creative Media Company Limited

Copyright © The Foundry 2006

10 12 14 13 11
3 5 7 9 10 8 6 4

ISBN: 978-1-84451-519-6
Special ISBN: 978-1-84786-953-1

Printed in China

Guy de la Bédoyère (author) lives in Lincolnshire and is a freelance historian, archaeologist, writer and broadcaster with degrees
in history and archaeology from the universities of London and Durham. He has written more than two dozen books on historical subjects
as diverse as Roman Britain, the polio vaccine, the Home Front and the Correspondence of Samuel Pepys, and has contributed to Flame Tree's
World History, *World Facts* and *Irish History*. His numerous appearances on television include many spots on Channel 4's archaeology series Time Team.
He has also presented live archaeology programmes for Channel 5, and co-presented a genealogy series for UKTV History.

Picture Credits:
Skyscan Photolibrary (www.skyscan.co.uk): A. Hunter: 64, 66, 68, 69; APS: 70, 76, 80; ARCo: 130; B. Croxford: 186, 187; B. Evans: 37, 41, 160, 161, 170,
175, 176, 177, 181,182, 183, 185, 188, 189, 192, 193, 196; B. Lea: 57, 194, 195, 197; CLI: 71, 88, 89; D. Wooton: 122, 123, 124; E. Clack: 138, 156, 157;
Flightimages: 51, 73, 131, 143, 146, 147, 148, 151, 152, 164, 165; I. Bracegirdle 90, 91, 94, 95, 96, 97, 191, 173; I. Pillinger 168, 169; J. Farmer: 128, 129;
Jarrold Publishing: 43, 45, 50, 54, 59; K. Allen: 126; K. Hallam: 105, 155, 159; K. Whitcombe: 34; M. Bradbury: 55; R. West: 12, 13, 15, 16, 17, 18, 20, 23,
24, 26, 27, 28, 29, 30, 31, 32, 33, 36; Skyscan Balloon Photography: 14, 40, 42, 44, 49, 52, 53, 56, 62, 63, 64, 65, 74, 75, 92, 98, 99, 101, 102, 103, 104, 106, 109,
110, 111, 112, 113, 114, 115, 116, 117, 125, 132, 133, 134, 135, 136, 137, 139, 142, 144, 158, 162, 163, 171, 172, 174, 178, 179, 180; W Cross: 46, 72, 77, 78, 79,
81, 82, 83, 84, 85, 93, 100

Topham Picturepoint: HIP: 107, 108, 190; Imagework: 150; Vincent Lowe: 22; PA: 145, 149, 153, 154; Topfoto: 47, 125; Charles Walker: 118, 119, 184;
Ronald Weir 21, 25; Woodmansterne 19

BRITAIN
from the air

by Guy de la Bédoyère

FLAME TREE
PUBLISHING

Contents

Introduction

It is very easy to take it for granted that the British Isles are clustered off the edge of north-west Europe and forget how fundamentally this fact has characterised everything about Britain's geography and history.

Despite covering only a small area, Britain features a phenomenal array of landscape and environmental conditions, but escapes the worst extremes the world's weather can offer. Britain has no baking deserts or frozen tundra, nor vast mountain ranges and deep canyons. The British love complaining about the weather but the truth is that the range of temperatures is very limited. It is rarely stiflingly hot in summer, and the winters are relatively mild. There are no tropical storms and hurricane force winds are exceptionally rare. Instead, most of the south and east is fertile agricultural land, and the abundant rivers and streams have made it possible for human beings to have lived in almost every part of Britain since prehistoric times.

Constantly bathed by the Gulf Stream flowing all the way from the Gulf of Mexico, Britain has the great good luck to benefit from the warmth of tropical seas. That way Britain cheats the consequences of a latitude that places it as far north as the much colder Calgary in Canada and Moscow in Russia. Of course it is the sea that defines Britain, just as much as its landscape. The sea provides a natural security, as important in 1940 as it was for thousands of years before. It is a short but dangerous crossing which means nobody has invaded Britain since 1066, but the sea is neither wide enough nor cold enough to prevent people from using it to sail past Britain or to her. So, that way the sea protects Britain but she has never been isolated from the Continent.

It is therefore no surprise that Britain has had the most extraordinarily varied history. Tens of thousands of years ago during the Ice Age men made their way to Britain across the valley where the English Channel is now. By 5,000 years ago, with the ice long gone, the people of the Stone Age were farming and also beginning their great monuments like Avebury. Two and half thousand years ago, Britain's Iron Age tribes were trading with the Continent, including Phoenician traders who came here from the eastern Mediterranean for Cornish tin. In the first century AD, the Roman natural historian Pliny the Elder describes an island off Britain's coast called Mictis where tin was found. That was probably St Michael's Mount in Cornwall. By the time Pliny wrote, the Romans had already invaded, arriving in AD 43. Britain became a Roman province for 360 years, leaving great relics of their presence especially Hadrian's Wall and London.

After the Romans came a succession of new invaders: the Anglo-Saxons from Germany, the Vikings from Denmark and Norway, and then the Normans from Normandy. Each left an indelible stamp on Britain's landscape. The Romans, for example, created the basis of today's road network, while the Normans in 1066 and afterwards built castles and cathedrals that remain amongst the most remarkable monuments in the whole world.

There may have been no invasion since 1066 but Britain's history has guaranteed a constant drama being played out between the British and the land they live in. The Middle Ages saw a continual struggle between the king and his barons, resulting in the castles built almost everywhere from Orford Ness to the coast of Wales. When life became more settled in the sixteenth and seventeenth centuries the rich and powerful found time to build great houses like Longleat and Hatfield.

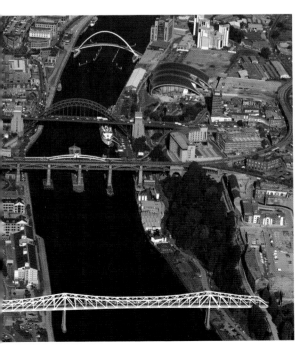

Britain gradually became stronger and stronger until by the dawning of the eighteenth century she had become a world power. It was Britain's Royal Navy and the great seafaring tradition that stretched back over centuries which gave her this colossal advantage. But the most profound impact Britain's new status brought her came in the form of the Industrial Revolution. Until then Britain had always been a rural place – the towns, apart from London, were small and far between. Most of Britain's people lived off the land as they had done from prehistoric times.

By the late 1700s Britain had started to change forever. New industrial towns like Birmingham and Manchester grew where there had been scarcely anything before. Iron ore, coal and water came together to fire the steam engines that drove the mills that grew up in the new towns, supplied by canals carved across the British landscape and the coalmines that gave birth to new towns themselves. Within a few generations, factories, vast chimneys and clouds of smoke became seemingly indelible features of the landscape.

The reason this happened is that Britain is small enough for those essential resources to be brought together when the only power sources available were men and horses. The fact that the stone quarried from the cliffs of the Isle of Purbeck was carried to London and many other places within the British Isles is a reminder that this is a small place. So Britain was the first nation to industrialise, and by the nineteenth century Britain was the most powerful industrialised nation in the world. Her population was growing faster than it had ever done before. What had been only four to five million in medieval times at the most was over nine million by 1801 and had doubled again within 50 years and has tripled from that since then.

During the nineteenth century the railways arrived. The railways did something that was really new. Suddenly men, women and children could travel from one end of Britain to the other quickly and cheaply. It meant not only that towns and cities could grow bigger because workers could commute from further, but it also meant that people could travel from those cities to visit places like the Lake District and the Scottish Highlands, which had once been as remote as the Gobi Desert is to us today. The railways carved their swathes across the landscape, seemingly oblivious to the obstacles in their path. Nothing could stand in their way. Tunnels were built through high ground, and embankments were laid across the Fens. Farm-workers in remote country regions could only look on in amazement as the railways changed their world forever.

No man symbolises the spirit of that age more than Isambard Kingdom Brunel. He built steamships, hacked his way through hills to create tunnels, laid railways and did it all with an unstoppable zeal. It is only appropriate that his Clifton Suspension Bridge still stands today as such a magnificent union of nature and man's industry.

Since those heady days Britain's industrial landscape has changed again. Most of the factories are gone, along with the coalmines. But traces remain everywhere, as do the relics of the most recent great drama Britain experienced: the Second

World War. When Britain faced total defeat in 1940 it might have seemed that all was lost. Air raids led to tens of thousands of casualties, and many of Britain's major towns suffered a great deal of destruction. When the war ended in 1945 Britain faced an uncertain future. Over the next few decades much of her heavy industry disappeared, and a vast amount of urban regeneration followed.

Britain's geographical role today would have been unthinkable to the ancients. She lies midway between Asia and America so that Britain wakes in time to trade with the Far East and is still awake when North America starts its day. The thriving City of London, built on the ruins of the Blitz, makes Britain one of the world's most important financial centres.

No part of Britain's history has escaped being reflected in the landscape visible to us today. It is from the air that this is most apparent and it is a truly wonderful thing to behold. To fly across Britain is to see an endless patchwork of fields, hills, rivers, Iron Age hillforts, Norman castles, villages with their

ancient medieval churches and the cities with their cathedrals and sprawling suburbs. Not everyone has the chance to do that, but in the pages of this book you can see the outstanding beauty of Britain's landscape and also the sheer fascination of seeing the way men and women across the centuries have made this land their own and used it, whether that means admiring the prehistoric people who made Stonehenge or the engineers who built Spaghetti Junction.

But it is also the way to see that however much impact human beings have had on this, one of the most densely populated parts of the world, the natural landscape is still far greater than anything we have done. The epic vistas of the Lake District, the barren ruggedness of Snowdonia, the emotional sight of the white cliffs at Beachy Head and the rolling fields of Worcestershire remind us in the end that Britain is one of the most beautiful and memorable places in the world with more variety and colour than places a hundred times its size.

Scotland

Despite having a population of only a little over five million, Scotland's land area covers the northern third of Great Britain and has played an enormously important role in the history of the British Isles.

Her most distinctive features are the dynamic geology of the Highlands, the lochs, the epic coastline with its endless inlets, the islands scattered around and stretching out in the North Atlantic, and the rolling hills and farmland of the Southern Uplands. It always was a challenging landscape, yet from ancient times tribal peoples braved the elements and made their homes here. The Romans found it impossible to conquer Scotland, and the same challenges faced the invading English kings of the Middle Ages.

It was a curious twist of fate that meant a Scottish king became king of England in 1603 when James VI, Mary Queen of Scots' son, was the only available descendant of Henry VII of England after the death of the childless Elizabeth I. But Scotland remained a separate kingdom until the Act of Union in 1707, though since 1998 devolution has brought Scotland her own parliament once more. Scotland's striking scenery and its remarkable monuments, from castles to the Forth Rail Bridge, make it the perfect place to explore from the air.

OLD MAN OF HOY
Orkney Islands

Hoy is the most south-westerly island in the Orkneys with its sheer west-facing cliffs battered by the Atlantic off Scotland's most northerly tip. Here we are flying north past Hoy's jagged cliffs where far below is the most famous sight in the area: the Old Man of Hoy. The wind, rain and sea have ravaged the sandstone cliffs on their basalt base but this 137-m (450-ft)-high stack has stood firm. First scaled in 1966, it is now an essential challenge for climbers from all round the world.

LISMORE ISLAND
Western Isles

The sun sets over Lismore, a long thin island lying in the Lynn of Lorn just off the coast from Oban in a narrow loch open to the sea. Lismore points to the Island of Mull and its very low-lying land contrasts with the mountains on either side, so it is apt that its Gaelic name means 'great garden'. In AD 592 St Moluag founded a monastery here. Lismore became the seat of the Bishop of Argyll who could sail from here to anywhere.

DUNROBIN CASTLE
Northern Highlands

From this point of view you could easily be forgiven for thinking this is a Bavarian fairytale castle teetering over its terraced gardens with its white stone walls and conical spires, but instead this is the work of Sir Charles Barry, who designed the Houses of Parliament. In the nineteenth century Barry remodelled the medieval castle of the earls of Sutherland and created a 189-roomed castle, said to be the largest in the Highlands, in a unique mix of French Renaissance and Scottish Baronial styles.

RIVER TAY
Southern Highlands

Autumn has just started creeping across the River Tay here as it winds its way across the southern Highlands. The water has the longest journey of any in Scotland, for it fell as rain far to the west in Argyll and Bute and flows 193 km (120 miles) east through Loch Tay and then south to Perth. Here it pours into the North Sea at such a rate that in terms of sheer volume it is the largest river in the British Isles.

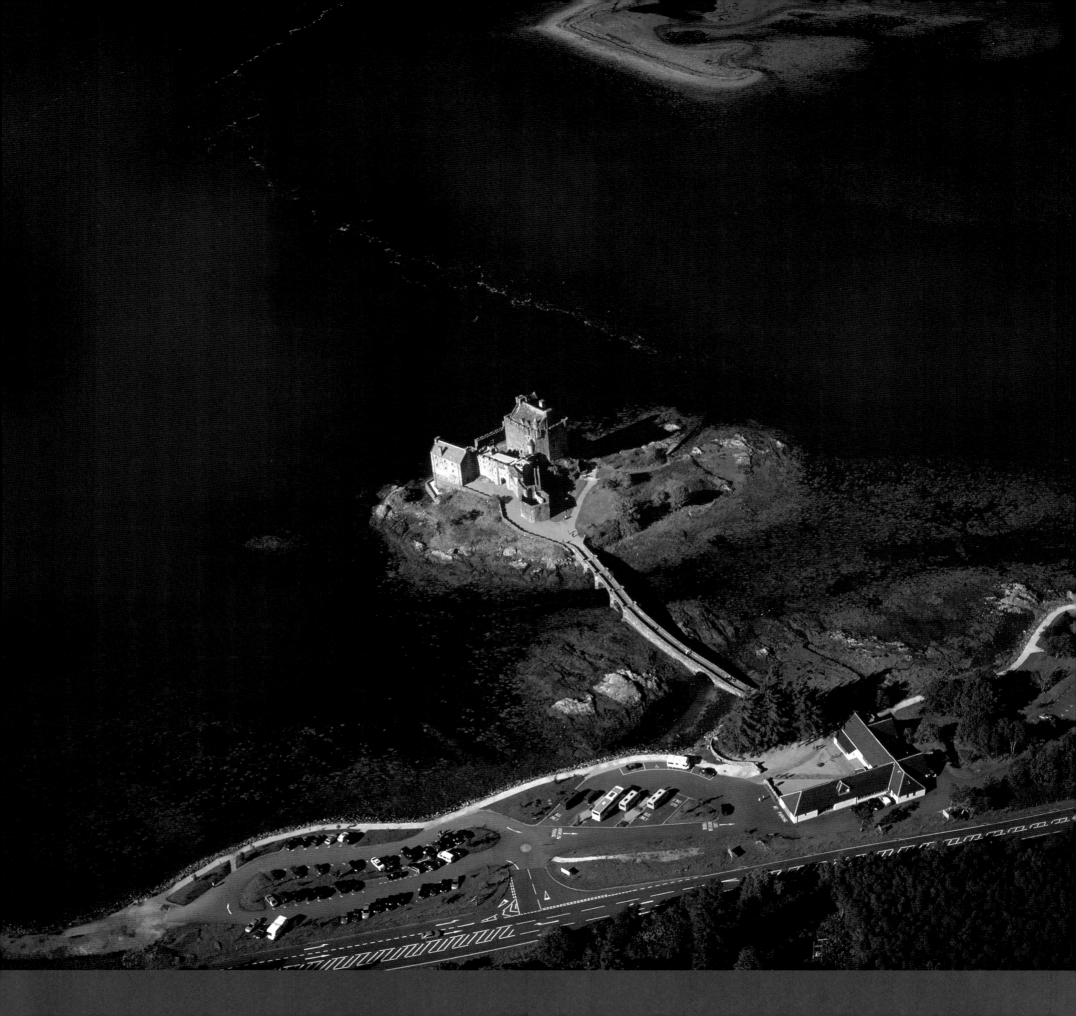

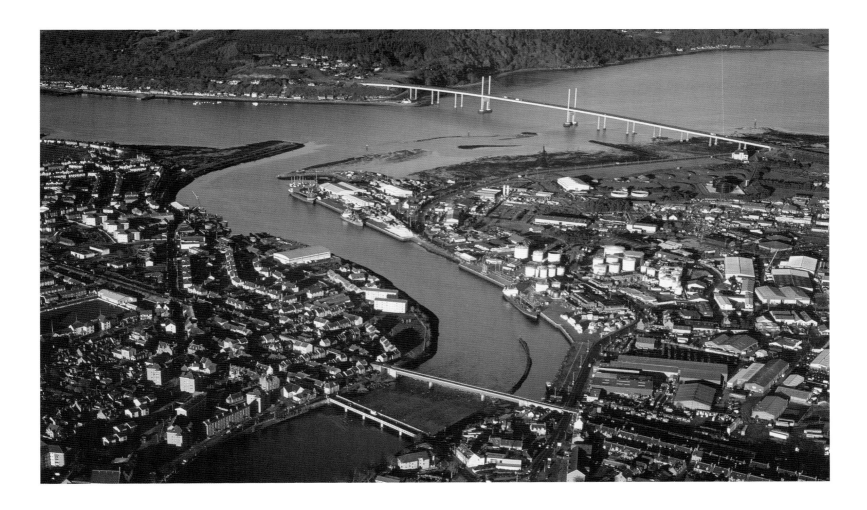

EILEAN DONAN CASTLE
Ross-shire

On Scotland's west coast, near Kyle of Lochalsh, three sea lochs (Loch Long, Loch Duich and Loch Alsh) come together at Eilean Donan. Alexander II of Scotland built this castle in the thirteenth century to guard the narrow crossing on the main west coast road. Demolished by the Royal Navy in 1719 after the Spanish captured the castle in support of the Jacobites, Eilean Donan lay in ruins for 200 years until an early twentieth-century restoration, creating a location now popular with film-makers.

INVERNESS
Inverness-shire

Inverness takes its name from the Scottish Gaelic *Inbhir Nis*, meaning 'the mouth of the Ness', a river which flows north-east just a short distance from Loch Ness into the Moray Firth. As such a vital crossing point on Scotland's east coast, it is no wonder that Inverness has been an important place since ancient times and became a royal burgh under William the Lion (1165–1214). Once home to distilling industries, today Inverness is a modern industrial city with a bright outlook.

LOCH LEVEN
Inverness-shire

With an early morning mist swirling above its waters, one would hardly imagine that Loch Leven is now narrowly skirted by the M90 motorway on its way from the Forth Road Bridge north to Perth. Unusually for a Scottish loch, Leven is roughly circular with a 16-km (10-mile) shoreline. Directly below is the thirteenth-century Loch Leven castle on an island, built by the English but later captured by the Scots. The Scottish lords imprisoned Mary Queen of Scots here in 1567.

BEN NEVIS
Inverness-shire

This barren peak is Britain's highest mountain. At just 1,344 m (4,410 ft) Ben Nevis pales into insignificance compared to the Alps or the Rockies, but Scotland is justly proud of this famous place, just a short distance from Fort William. Despite the bleak appearance, Ben Nevis can be walked up by the fit and well-equipped. Thousands of people make it to the top every year. But the mountain is a dangerous place where the weather can turn treacherous in an instant.

GLENDEVON
Perthshire

This is Glendevon, a valley not far from the Firth of Forth on the road south from Auchterarder in Perth and Kinross, and halfway between the city of Perth itself and Stirling. Overlooked by the 485-m (1,590-ft)-high peak of Steel Knowe, and with the gentle undulating Ochil Hills around it, Glendevon is perfect reservoir country, fed by the River Devon. Once this strategic route was controlled by the Douglas family from their castle, but today it is a place for hikers, cyclists and pony trekkers.

DUNNOTTAR CASTLE
Aberdeenshire

Only a mile or so south of Stonehaven on the Aberdeenshire coast facing the North Sea, Dunnottar is the perfect place for a castle. Perched on a rocky outcrop 50 m (164 ft) above the sea, Dunnottar was first fortified at least 2,000 years ago but the present castle dates back to the thirteenth century. Mary Queen of Scots stayed here. It was rebuilt in the seventeenth century to create a luxury castle, but it was largely demolished after the Jacobite rising of 1715 as a punishment.

TROTTERNISH
Isle of Skye

The Isle of Skye is a geologist's dream, and one of its most exciting features is a phenomenal 32-km (20-mile)-long landslip in the Trotternish peninsula at the northernmost end. This is a place of rock, moss and heather, where trees can hardly grow. No wonder climbers and walkers come here to explore the vast rock stacks and pinnacles made of volcanic basalt, braving the 200-m (656-ft) cliffs constantly eroded by the lashing wind and rain in this wild and remote part of Scotland.

SKYE BRIDGE
Isle of Skye

The Skye boat song commemorates romantically how Bonnie Prince Charlie fled to Skye by boat after the defeat of the Jacobite rebellion at Culloden in 1746. Until recently it was still necessary to take a ferry to Skye across the short 500-m (⅓-mile) hop from Kyle of Lochalsh. The controversial toll bridge was opened in 1995 to ease the pressure on ferries as tourism to Skye increased but furious protests about the cost led to the state buying the bridge, and tolls ceased in 2004.

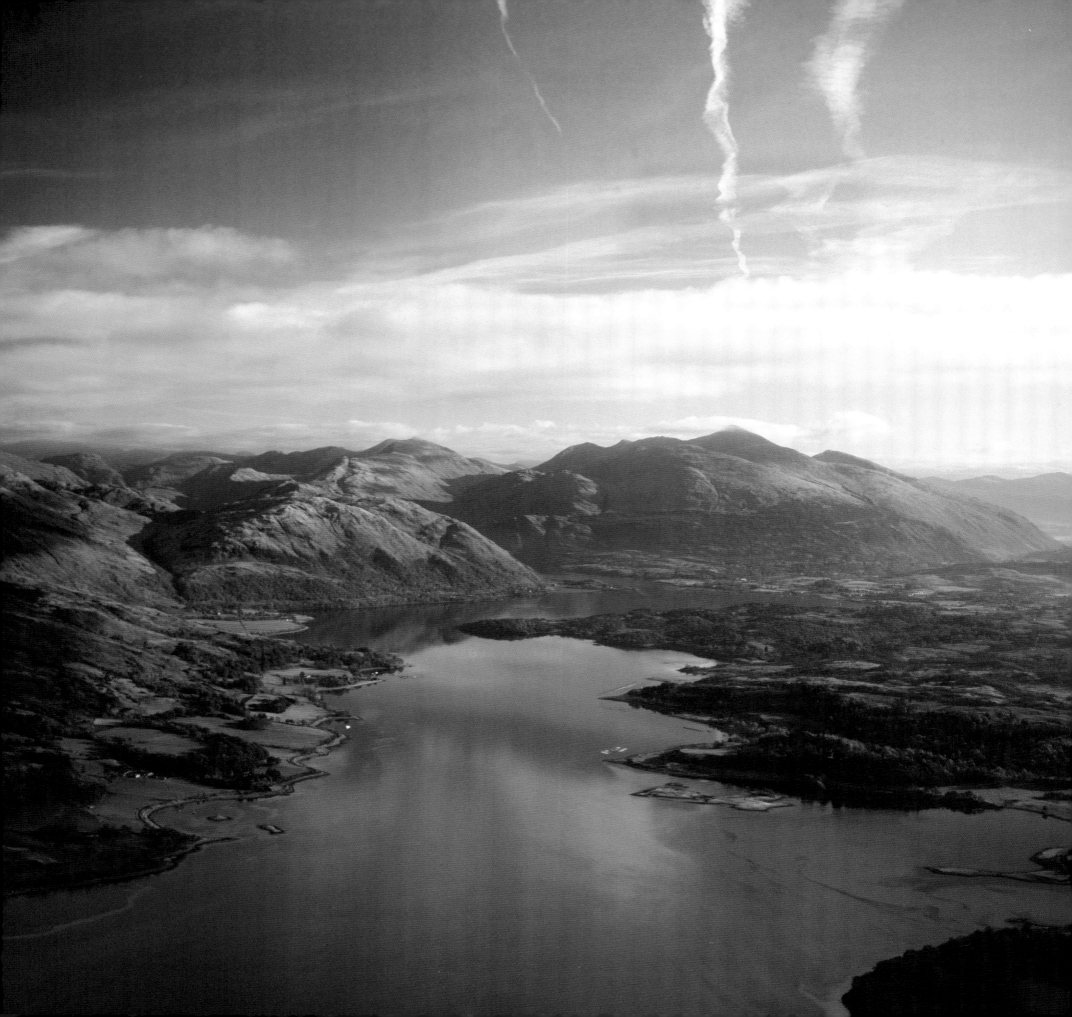

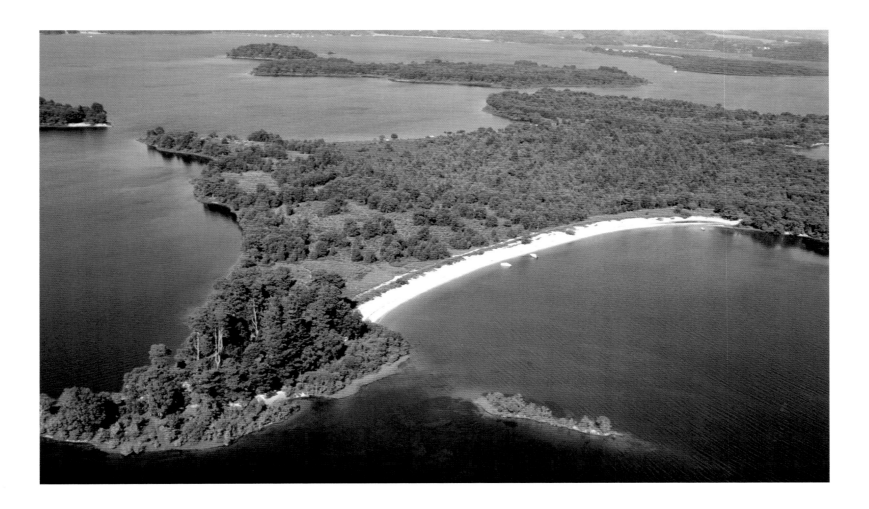

LOCH ETIVE
Argyll and Bute

Loch Etive in Argyll and Bute is a long winding loch fed by the River Etive, fed by water falling on mountains many of which are more than 1,000 m (3,281 ft) high. The loch heads south-west and then makes a sharp turn at Bonawe to head west through a narrow gap at Connal where the waters tumble down the Falls of Lora to meet the sea, about 8 km (5 miles) north of Oban. The contrails in the sky mark the route passenger jets take from London to North America.

LOCH LOMOND
Argyll and Bute

At 37 km (23 miles) long and up to 8 km (5 miles) wide, Loch Lomond has the largest surface area of all of Scotland's lochs though Loch Ness actually has more water in it. Loch Lomond was carved out by glaciers in the Ice Age, and now forms the centrepiece of the Loch Lomond and Trossachs National Park, but is only 22.5 km (14 miles) from Glasgow. Of course it has been immortalised in the famous song with its line 'the bonnie, bonnie banks of Loch Lomond'.

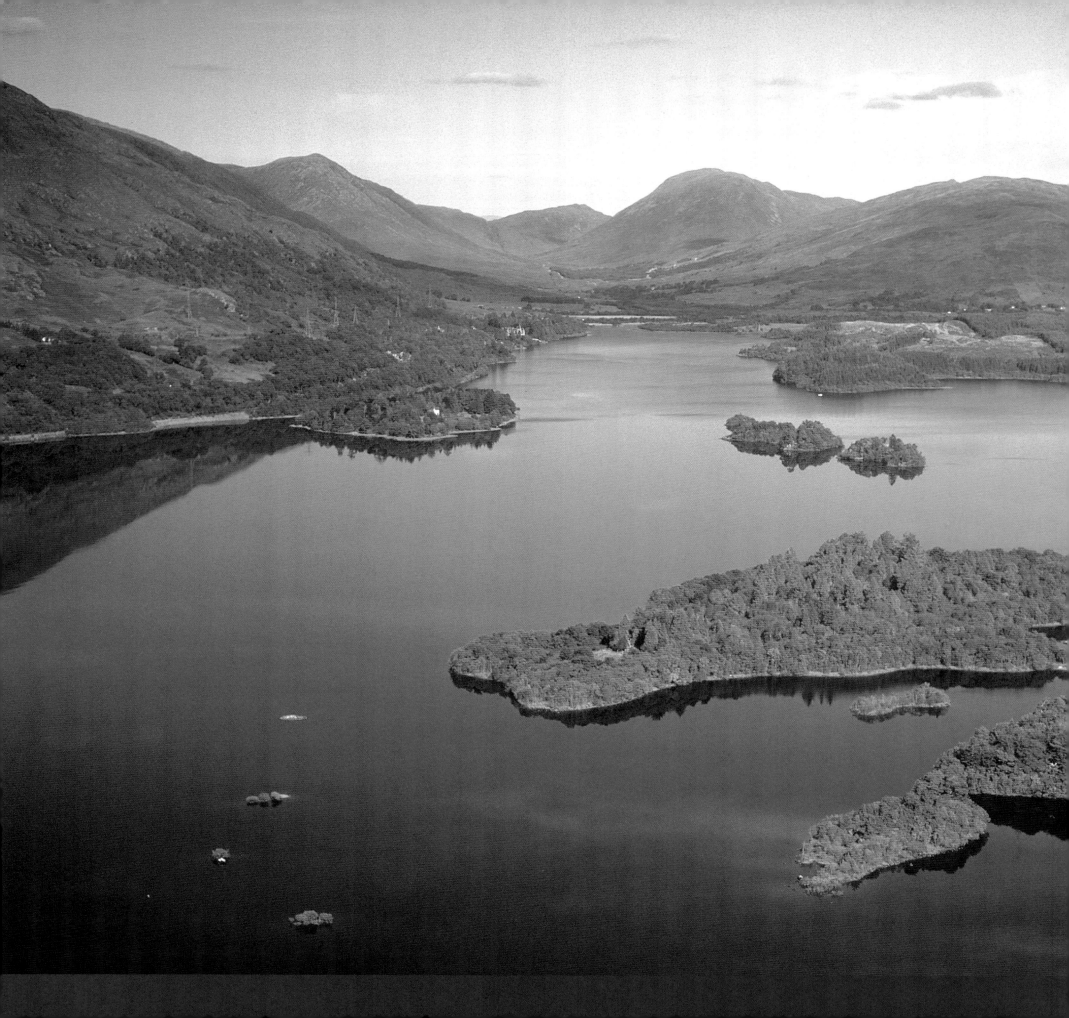

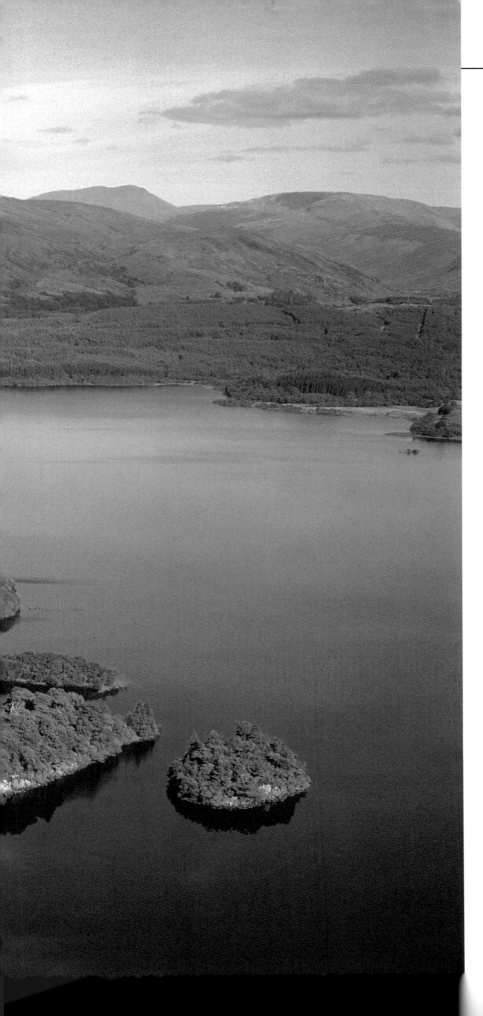

LOCH AWE
Argyll and Bute

At nearly 35 km (22 miles) long, Argyll and Bute's Loch Awe is the longest freshwater loch in Britain, and the third largest. Shaped like a hugely elongated 'y', this is a view of its northern part. Here, overlooked by the mountain of Ben Cruachan, the loch is divided into two by the island of Innis Chonain, now a popular bed-and-breakfast stop on the main road to the coast at Oban. Today the loch is famous for its fishing and the ruined castles perched on several other little islands.

KILCHURN CASTLE
Argyll and Bute

Kilchurn Castle lies at the most northeasterly point of Loch Awe just by the A85 which crosses the Highlands from Perth to Oban. The castle sits by the water's edge on a tiny marshy peninsula and is only easily reached by water. The fifteenth-century castle reached its final form under John, the Earl of Breadalbane in the late 1600s, but was destroyed when a lightning bolt struck it in 1769 and has stood ever since as one of Scotland's most evocative and picturesque ruins.

ST ANDREWS
Fife

The 'Home of Golf', this is St Andrews in Fife on Scotland's east coast overlooking the North Sea. The Society of St Andrews Golfers was founded here in 1754, making it one of the oldest golf clubs in the world. In 1834 the society changed its name to the Royal and Ancient Golf Club of St Andrews when King William IV became its patron. It organises a series of annual championships and dictates the rules of golf all round the globe, except for the United States and Mexico.

FORTH RAIL BRIDGE
Fife

Until the Forth bridges were built, travellers heading north had to take a ferry across the Firth of Forth or head inland to Stirling to cross the river. Between 1883 and 1890 the 2.4-km (1.5-mile)-long Forth Rail Bridge, with its four cantilevers, was built from over 55,000 tons of steel on foundations dug down 27 m (88.5 ft) into the riverbed. It was an epic achievement for the age and is still regarded as one today. The road traffic suspension bridge did not follow until 1964.

STIRLING CASTLE
Stirlingshire

No-one could fail to see the strategic importance of this piece of high ground. This is where the River Forth widens out to make the Firth of Forth. From ancient times it was a vital crossing point on the east coast of Scotland. It was King Alexander I who built the castle here in the early twelfth century, taking advantage of a volcanic outcrop with a sheer drop on three sides. The castle changed hands many times during the wars with the English and was rebuilt in the sixteenth century.

GOUROCK AND RIVER CLYDE
Firth of Clyde

This magnificent view is from high above Gourock and Greenock looking east, on the south side of the Firth of Clyde where the River Clyde flows out to the sea after having passed through Glasgow, just visible in the far distance. In Glasgow's heyday the Clyde was one of the most important rivers for shipbuilding and industry in Britain since it faces west and therefore America. Gourock became a seaside resort for Glasgow's burgeoning population in the late nineteenth century.

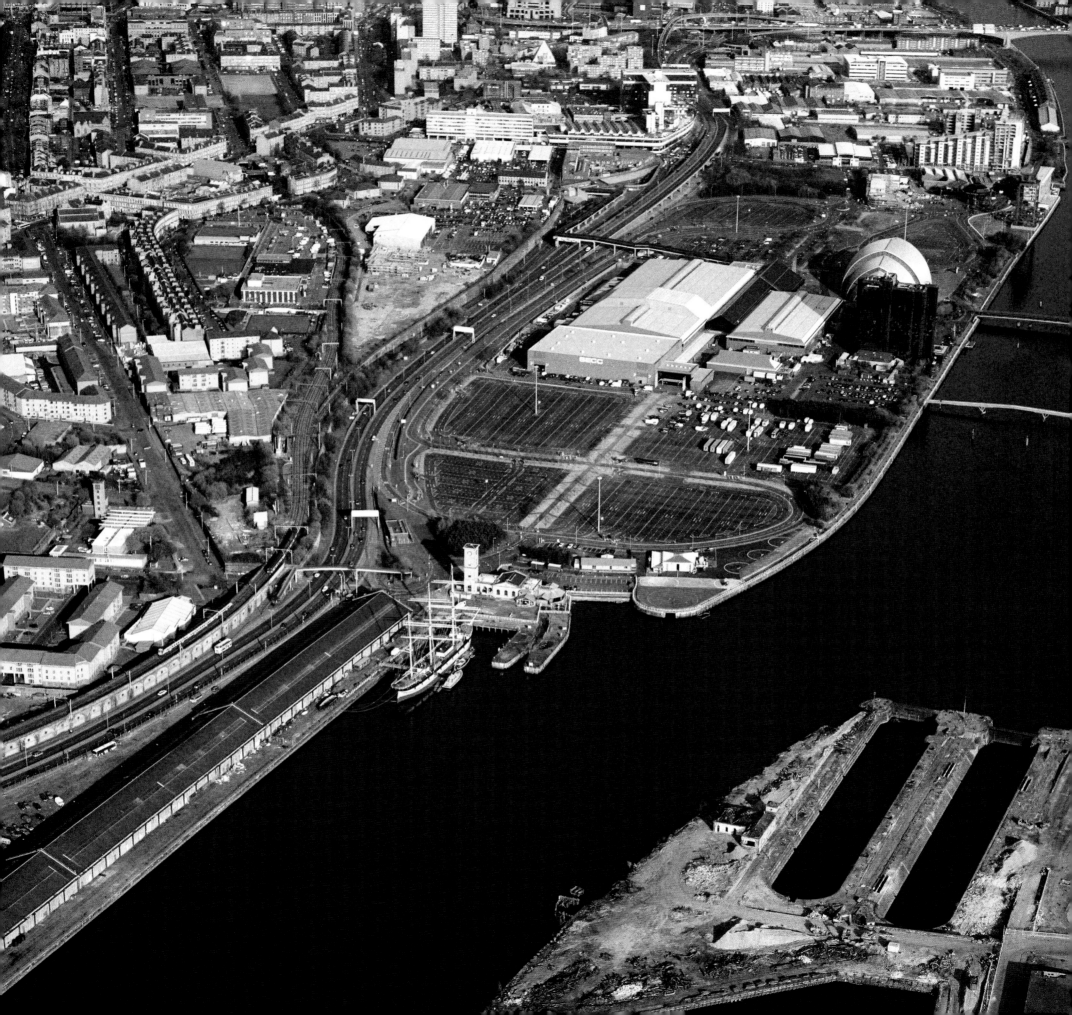

CLYDESIDE DOCKS
Glasgow

With Glasgow's greatest days as a shipbuilding centre and port behind her, regeneration of the Clydeside docks is the future. Below to the left are the Yorkhill Quays, built about a century ago where ships bound for America and India set sail, and the SV *Glenlee*, built in Port Glasgow in 1896 and now restored by the Clyde Maritime Trust as one of the nation's core collection of historic ships. Beyond is the Scottish Exhibition and Conference Centre, and to the right the Canting Basin where ships were turned.

EDINBURGH CASTLE
Edinburgh

Princes Street runs through Edinburgh, dividing the Old Town and the New Town, beside the Royal Mile from Holyrood Palace. On the New Town side the street is packed with shops but on the Old Town side there are no buildings, which makes for a marvellous view of Edinburgh Castle, perched on top of the 133-m (436-ft)-high basalt plug of an extinct volcano. As the glaciers retreated at the end of the Ice Age, rubble was trailed behind the basalt plug, creating the Royal Mile.

AILSA CRAIG
Ayrshire

Eighteen km (11 miles) off the South Ayrshire coast from Girvan in the Firth of Clyde, Ailsa Craig is a vast granite volcanic plug that juts out from the sea like the nose of a vast missile. An impressive 338 m (1,110 ft) high, Ailsa's granite was once quarried to make stones for Scotland's traditional sport of curling. In 1833 William Wordsworth wrote a poem about the crag after watching it grow dark during an eclipse of the sun 'towering above the sea and little ships'.

Wales

Wales covers more than 20,720 sq km (8,000 sq miles) and is surrounded by the sea on three sides, making more than 965 km (600 miles) of coastline, despite being no more than 96.5 km (60 miles) wide.

Around three million years ago the Ice Age deepened, and as the ice moved down across the landscape it carved out the mountains and valleys that make Wales so different from the England Midlands to which it joins. The ice only retreated 10,000 years ago, and those hills and valleys became home to ancient prehistoric tribes like the Silures and the Ordovicians who defied the Roman invaders in the first century AD.

Although the Romans conquered Wales the wild landscape never became truly settled and it is little wonder that by the late thirteenth century England's King Edward I had such a struggle to control the Welsh. A massive programme of castle-building brought about the end of Wales's independence. Since then Wales has been ruled along with England but has always retained a powerful sense of its own tradition and history. Welsh, a descendant of the ancient Celtic languages of Europe, is still widely and proudly spoken and today Wales has its own parliament, the Welsh Assembly.

BEAUMARIS CASTLE
Isle of Anglesey

The ultimate textbook castle, Beaumaris was the last castle built in Wales by King Edward I. It was started on the east coast of Anglesey in 1295 to guard the approaches to the Menai Strait (visible in the distance), but before long Edward's attention had turned to Scotland. With neither the money nor the resources to finish it the symmetrical Beaumaris, which means 'the beautiful marshland', was abandoned half-built leaving it a superb example of medieval castle technology at its climax.

MENAI STRAIT
Isle of Anglesey

A real bird's eye view of Thomas Telford's 1826 triumph of engineering in the Industrial Revolution: the Menai Suspension Bridge that joins the island of Anglesey to north-west Wales just by the town of Bangor. At 200 m (656 ft), this is the shortest crossing point in the Strait and might well be the place where the Romans forded across to wipe out a Druid stronghold in the year AD 60. The Druids had been leading the resistance against the Roman invasion.

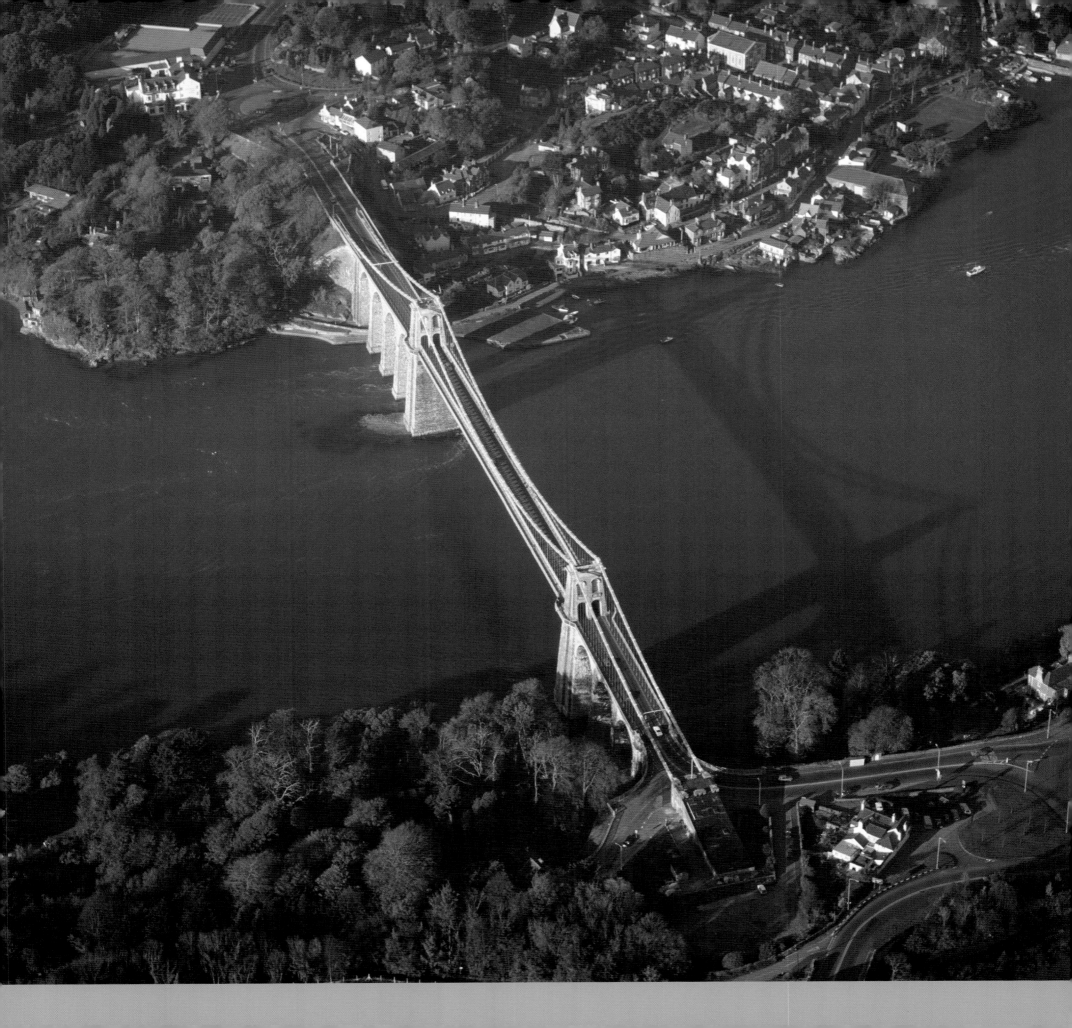

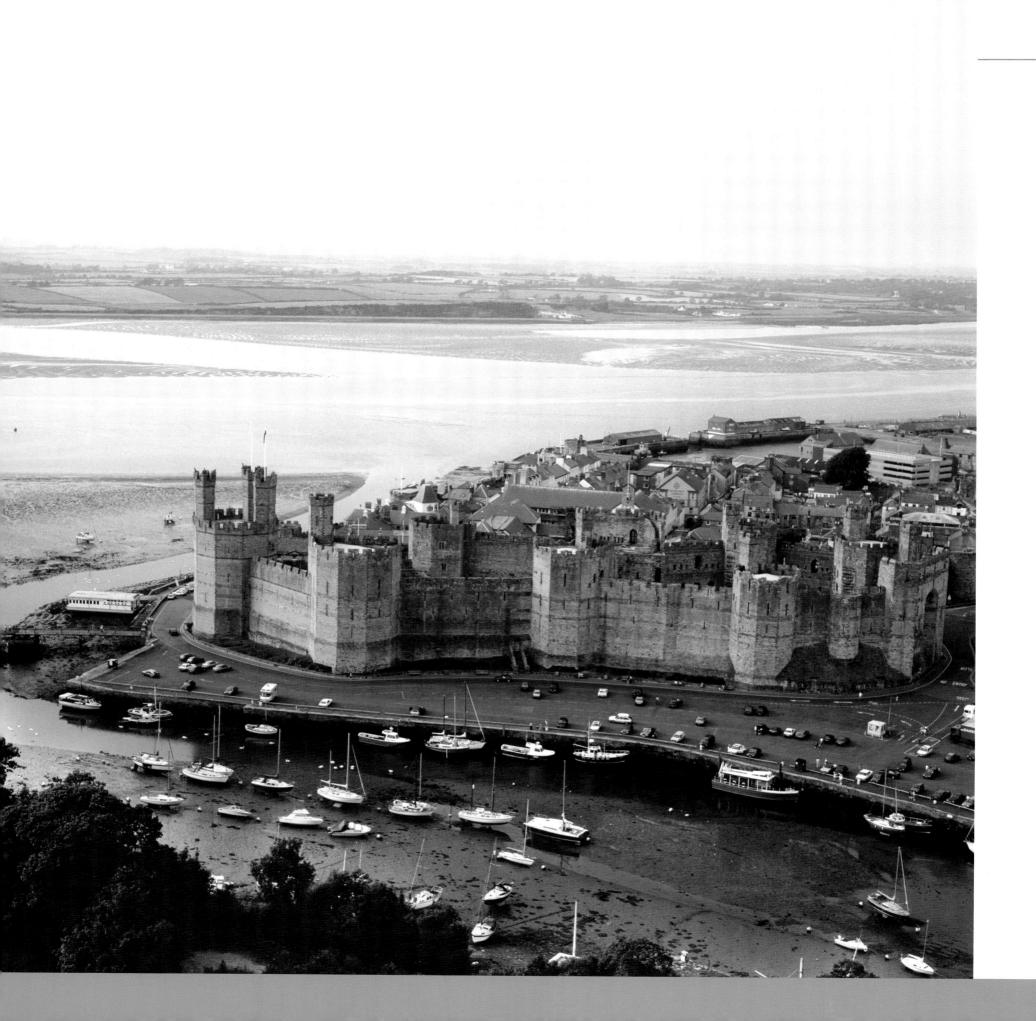

CAERNARFON
Gwynedd

Here we are flying north-west over Caernarfon in north-west Wales where in the late thirteenth century Edward I built a mighty castle modelled on the walls of Constantinople to guard the Menai Strait. This is where the investiture of the Prince of Wales was held in 1911 and 1969 because the first Prince of Wales, the future Edward II, was born here in 1284. But this is a place where the Welsh identity is at its strongest. Many of the townsfolk speak Welsh.

SNOWDONIA
Gwynedd

Wales's first National Park (created in 1951), Snowdonia, covers over 2,072 sq km (800 sq miles) of epic highland scenery in the principality's north-west. Immensely popular amongst hikers and sightseers alike, the park's centrepiece is Mount Snowdon itself that, despite being 1,085-m (3,560-ft) high, can be reached by taking the Snowdon Mountain Railway. For all its accessibility, Snowdonia is immensely impressive and imposing, a boulder-strewn place of bleak beauty that challenges climbers, especially those who brave the peaks in bad weather, and is one of Britain's wildest places.

PORTMEIRION
Gwynedd

With its Italian Riviera-style architecture, Portmeirion is instantly recognisable as the setting for The Village in the celebrated 1967 television series *The Prisoner*, starring Patrick McGoohan. In reality Portmeirion was designed by Sir Clough Williams-Ellis as a deliberate fantasy place to come and stay. Work started in 1925 and lasted another 50 years, incongruously creating a unique Mediterranean setting on the Welsh coast near Porthmadog. The whole of Portmeirion is a hotel with self-catering houses, but day visitors can explore the place too.

PONTCYSYLLTE AQUEDUCT
Denbighshire

Thomas Telford was one of the inspired men who created great feats of engineering that transformed the British Isles. Canals played a vital part in the Industrial Revolution, transporting raw materials and finished goods. This is the Pontcysyllte Aqueduct, finished in 1805, which carries the Llangollen Canal over the River Dee about 5 km (3 miles) east of Llangollen itself. It took ten years to build the 307-m (1,007-ft)-long aqueduct, using cast-iron to carry the water over masonry arches and piers 38 m (125 ft) above the river below.

BALA LAKE
Gwynedd

The view here is above the town of Bala in Gwynedd looking south-west right down Bala Lake, which is 6.5 km (4 miles) long and 3.3 km (1 mile) wide. It is the largest natural lake in Wales, though it has been made larger as part of local water management systems to control flooding and also the level of the Llangollen Canal. Bala Lake is a very popular place for sailing in the summer months and also boasts the Bala Lake steam railway, which runs along its eastern shore.

HARLECH CASTLE
Gwynedd

Harlech Castle overlooks Tremadog Bay on Wales's west coast and commands the coast road and approaches into Snowdonia. The seaward cliffs made it virtually impregnable and it was cut off from the land by a massive moat and gateway. Like so many Welsh castles, it was built by Edward I in the late thirteenth century. It is no surprise that during the Wars of the Roses Harlech held out for seven years. Supplies arrived by sea and were brought up a narrow cliff staircase to the castle.

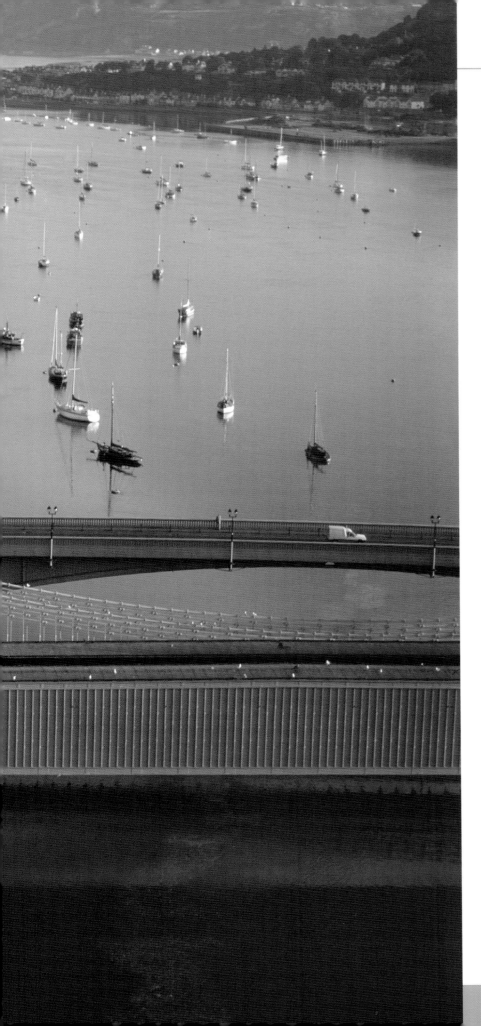

CONWY CASTLE
Conwy

Built between 1283 and 1289 by Edward I to control the
Conwy estuary and the medieval walled town, Conwy
has a long thin layout to fit on the rocky outcrop. Eight
massive round towers in the walls surrounding the
adjacent inner and outer wards protected the garrison
and barbicans reinforced the entrances at either end.
Conwy soon fell into disuse apart from a brief revival
during the Civil War in the 1640s but remains one of
Britain's most impressive castles.

OFFA'S DYKE
Welsh Borders

From ancient times the Welsh Marches saw constant territorial disputes between tribes and later the chieftain kings of the Dark Ages. Offa, Anglo-Saxon King of Mercia (757–96), was one of the most powerful. He ordered the construction of a huge ditch for the western border of his territory with Powys. The Dyke survives to over 20-m (66-ft) wide in places and over 2 m (6.5 ft) in height. One hundred and twelve km (70 miles) of the Dyke can be walked as part of the Offa's Dyke Path National Trail.

PEMBROKESHIRE CASTLE
Pembrokeshire

England's history was made at Pembroke Castle. This was where Henry Tudor grew up, before he defeated Richard III in 1485 and became Henry VII of England. The castle dates back to Norman times but the massive circular keep was built around 1200. Of course it was a perfect place for a castle. The River Cleddau surrounds the site on three sides, and it lies sheltered from Atlantic storms at the eastern end of a bay that stretches west past Milford Haven.

ST DAVID'S

Pembrokeshire

St David's is at almost the most westerly tip of Wales at the very end of St David's peninsula in Pembrokeshire. The city is the smallest in the British Isles, with barely 2,000 inhabitants, and is named after a sixth-century monk born near here who was canonised in 1120. The cathedral was begun about that time and soon became a place of pilgrimage in the Middle Ages. In the foreground here are the ruins of the fourteenth-century bishop's palace.

GOWER PENINSULA

Swansea

The Gower peninsula is on Wales's south coast just a short distance from Swansea and easily reached from the M4. But it remains one of Wales's most outstanding beauty spots, with its 180 sq km (70 sq miles) surrounded on three sides by a coastline with sandy bays used by surfers, such as Oxwich and Port Eynon, the fourteenth-century Weobley Castle, and the small villages scattered across the peninsula. This view is from the north coast across the Llanrhidian Sands towards Llanelli on the mainland.

CATHAYS
Cardiff

Cathays is in the heart of Cardiff, the largest city in the country thanks to the now long-gone coal and steel industries, and capital of Wales since 1955. The building with the tower is Cardiff's city hall, surrounded by other municipal buildings including the crown court and the National Museum of Wales, as well as those belonging to the National Assembly for Wales, created in 1998. Behind is Cathays Park and beyond that is the sprawl of Cardiff University, founded in 1883.

MILLENNIUM STADIUM
Cardiff

For a short while Cardiff's Millennium Stadium held the record for being the largest stadium in the whole of the United Kingdom. It was built in 1999 by the Welsh Rugby Union and can hold nearly 75,000 spectators, as well as having a roof that can be drawn across the pitch to protect it from the rain that Wales knows so well! The pitch itself can be lifted in components so the stadium can be used for non-sporting events like concerts.

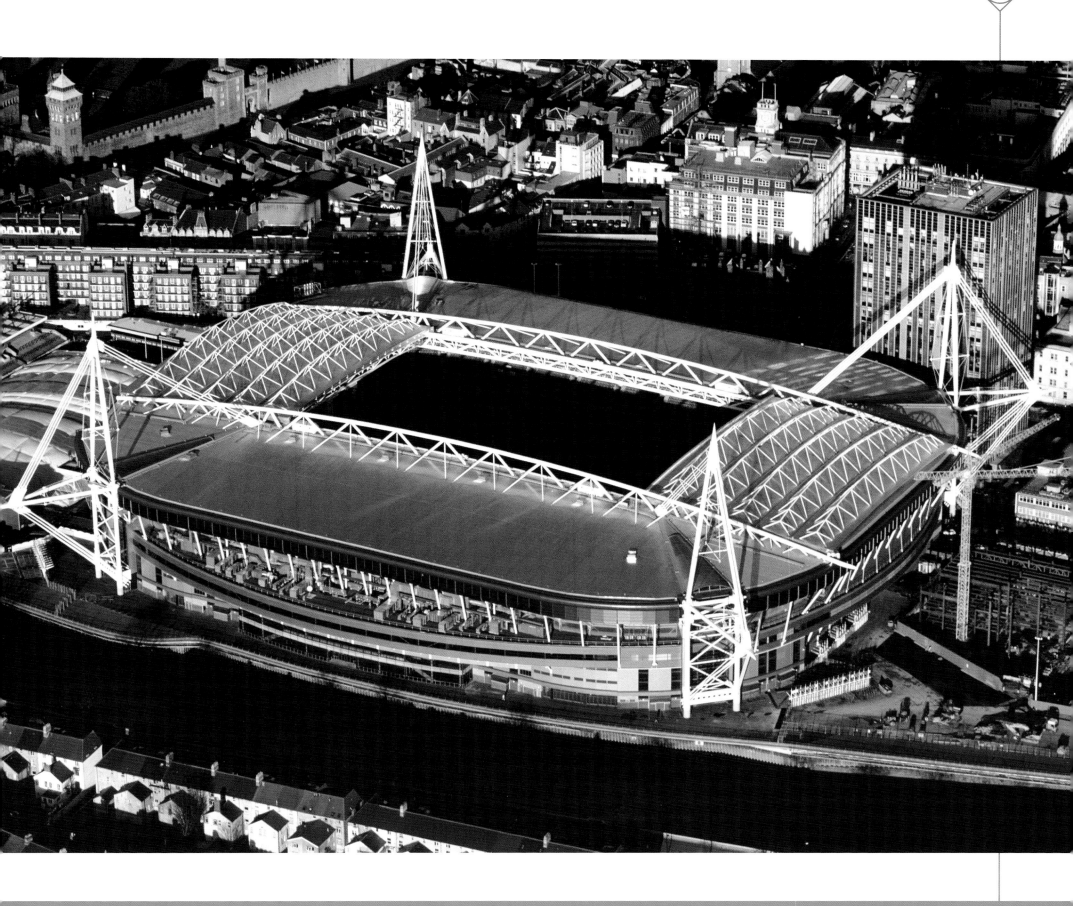

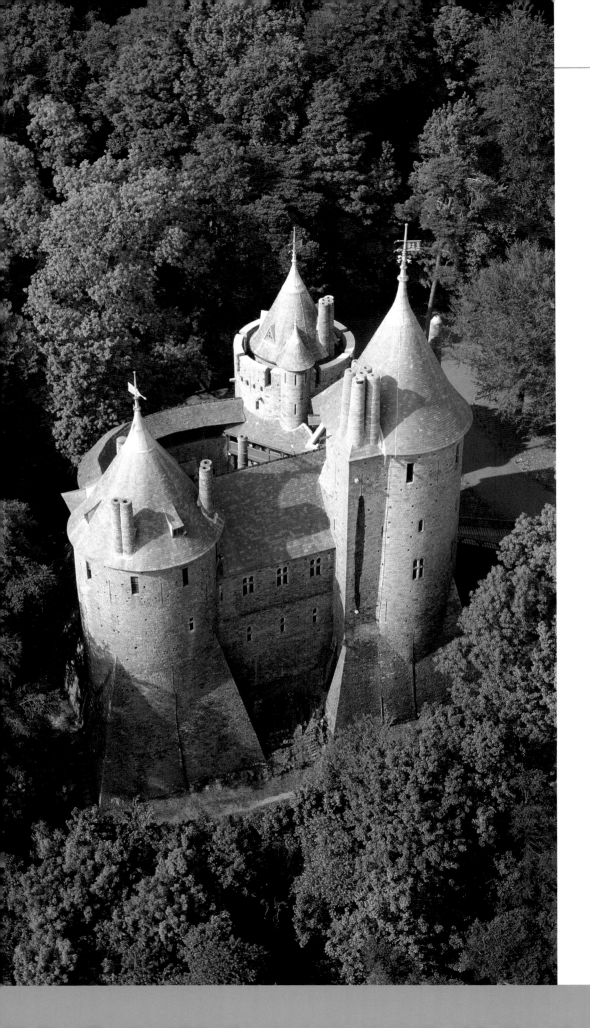

CASTELL COCH
Cardiff

Coch is the Welsh word for 'red', so this means 'Red Castle', and of course one can see why. Although there was a castle here for centuries, little was left by the 1800s. The third Marquess of Bute, who also restored Cardiff Castle, decided to rebuild the ruins on the original design as a fantasy castle which appealed hugely to the Victorian love of medieval chivalry and Gothic architecture. The result survives today as a place popular amongst tourists and film producers alike.

BROCKWEIR
Welsh Borders

Here, the River Wye sweeps its way through the magnificent Welsh Borders' countryside, with Wales to the left and England to the right. As the river swings round in a graceful curve, it passes the Glocestershire village of Brockweir, which until 1925 had a thriving shipbuilding industry. Vessels up to 90 tonnes could reach Brockweir from the sea; their cargoes then completed their journeys up the river in shallow barges. The bridge was built in 1906; until then travellers had to cross by ferry.

SEVERN BRIDGES
Severn Estuary

The mighty Severn Estuary was once a barrier between England and South Wales. All traffic had to cross at Gloucester, or take a ferry. The bridge in the distance is the original one, finished in 1966 where the ferry once ran, and now carrying the M48 motorway from Bristol. The bridge in the foreground is just over 5 km (3 miles) in length, and was opened in 1996 to carry the M4. Tolls are charged for crossing into Wales, but the way back is free!

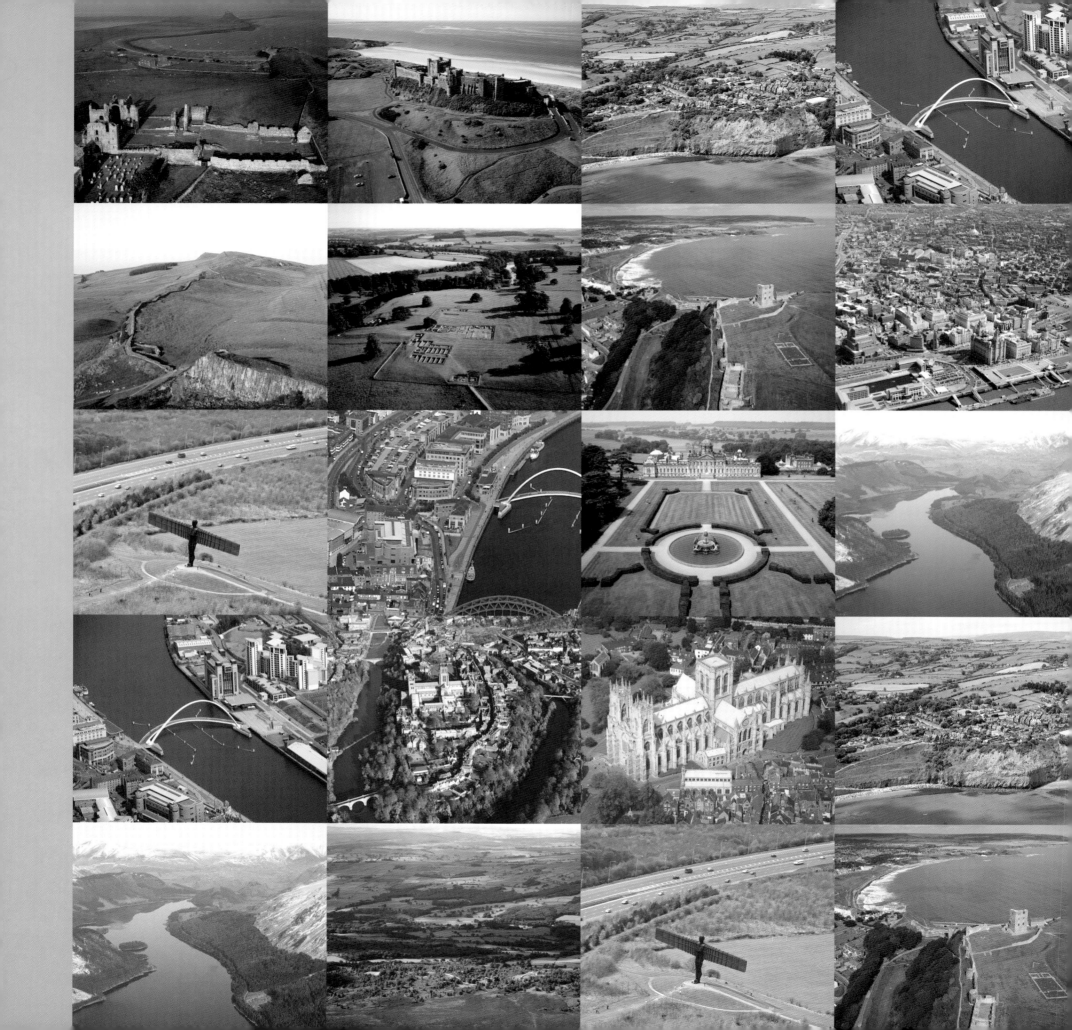

Northern England

Northern England is a proud place, but each of its own regions is prouder still of local traditions and identities.

The landscape is one of rocks, hills, valleys and rivers, with bleak stretches of coastline where places like Scarborough or Bamburgh cling to the rocks on the east. The climax of northern England, though, is probably the Lake District, a place that the Victorians popularised and which remains the region's most famous outdoor destination.

The Romans struggled to tame this part of the province they called Britannia, and their military fortifications are some of the most visible relics of their presence, especially Hadrian's Wall. Later, great medieval cities were founded here to control the roads to the north like Lincoln, York and Durham, where their stupendous cathedrals are amongst the finest examples of medieval architecture in the whole of Europe.

But the north is also where England's Industrial Revolution transformed the country's history and future. Cities like Manchester, Liverpool and Newcastle exploded into prominence during the nineteenth century as centres of industry and trade, with their rivers playing a vital role in their importance. The industry might be largely gone but these places are now undergoing a renaissance, best symbolised by Newcastle's Millennium Bridge and the Imperial War Museum in Salford.

HOLY ISLAND & LINDISFARNE PRIORY

Northumberland

This view is east across the southern part of Holy Island (or Lindisfarne), a tidal island off the Northumberland coast only accessible by road during low tide. In the foreground is the monastery, founded by St Aidan in the seventh century, where some of the most important and famous illuminated Biblical manuscripts were created by the monks. After the Dissolution of the Monasteries under Henry VIII, the buildings were robbed to build the castle in the distance, later remodelled by Sir Edwin Lutyens.

BAMBURGH CASTLE

Northumberland

The mighty castle at Bamburgh on Northumberland's coast owes its importance to the basalt outcrop on which it was built by Henry II in the twelfth century, from where it commands views in every direction. Three hundred years later Henry VI made Bamburgh his base during the Wars of the Roses, but the castle fell to one of the first uses of gunpowder in England when Edward IV attacked it. The castle would have remained in ruins had it not been for a late Victorian restoration.

HADRIAN'S WALL

Northumberland

When the Romans built their Wall in northern Britain as a frontier in the AD 120s, on the orders of the emperor Hadrian, they took advantage of every natural feature. Here the Wall, roughly halfway along its 122 km (76 mile) course, hugs the top of steep north-facing crags. In the foreground is one of the miniature forts built every mile along the Wall. A small band of troops was billeted in each one to guard this bleak outpost of the Roman Empire.

CHESTERS

Northumberland

The foundations visible here are some of the buildings belonging to the Roman fort of Cilurnum (Chesters) on Hadrian's Wall, built about the year AD 125 and home to a unit of cavalry who guarded this crossing on the River Tyne. The land was owned in the nineteenth century by an antiquarian called John Clayton who loved the Wall and its monuments. He turned the fort ruins into a country park and built a museum, which are today in the care of English Heritage.

ANGEL OF THE NORTH

Gateshead

This is where the A167 to Gateshead parts company with the A1, which takes through traffic past the west of Newcastle-upon-Tyne. Travellers heading north are greeted by the enormous steel Angel of the North, commissioned by Gateshead Council and designed by Anthony Gormley. She has overlooked the junction with her 54-m (177-ft)-wide wings since 1998. The curious and distinctive colour was created by mixing copper with 200 tons of steel, which oxidised. Not surprisingly, the sculpture has both fans and critics.

TYNE BRIDGES

Gateshead

The River Tyne is the soul of Newcastle and also the driving force behind its growth in the Industrial Revolution. Bridges over the river have played a vital role in the city's history – the Romans built the first one here in about AD 125. The bridge in the middle, known as the 'High Level Bridge', was built by Robert Stephenson in 1849 to carry a road and railway. The one beyond is the Tyne Bridge, built in 1928 and based on Sydney Harbour Bridge in Australia.

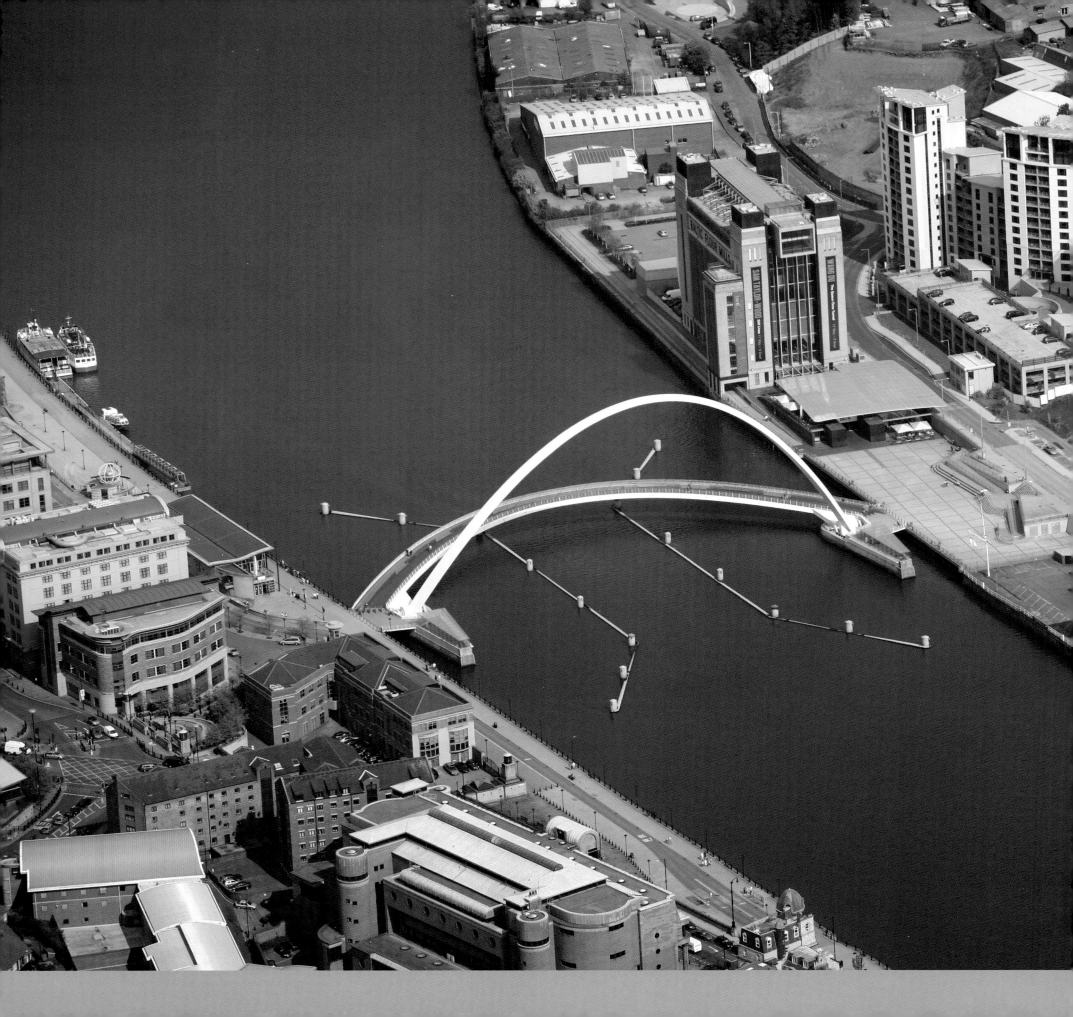

GATESHEAD MILLENNIUM BRIDGE

Gateshead

This is the stunning award-winning Gateshead Millennium Bridge which carries pedestrians and cyclists only between Newcastle and Gateshead across the River Tyne. A triumph of curves and imaginative design, the bridge was lifted into place as a single piece in 2000 by the world's largest floating crane, and opened in 2001. The entire structure rotates where the curves join on either bank to lift the walkway high above and let water traffic pass through the channel marked by the posts in the river.

DURHAM
County Durham

It is hard to appreciate Durham's unique geography without an aerial view like this. The view is from the south and here we can see the remarkable and strategic setting created by the tight loop in the River Wear that forms the peninsula on which the medieval city was founded, and which the massive Norman cathedral sits astride. Beyond is the Norman castle, now part of the university for whose students Prebends Bridge, in the lower-left foreground, is a popular walk.

LAKE DISTRICT
Cumbria

Formed from valleys carved out of Cumbria by the glaciers of the Ice Age that then filled with water, the Lake District is the largest National Park in England. Once almost beyond the hand of man, it was the Victorians who fell in love with this place once the railways made it possible for almost anyone to come here. This is Thirlmere, in the heart of the Lake District, not far from Keswick, now made bigger by a dam to quench the thirst of Manchester.

BRIMHAM ROCKS
North Yorkshire

This is Brimham in Nidderdale in the heart of Yorkshire, west of Harrogate and Ripon. Millions of years ago this was a river delta, where the water deposited the granite and silt it had carried down from mountains to the north, creating a hard sandstone known as millstone grit. At the end of the Ice Age 10,000 years ago, the rock was exposed to the wind and rain, creating a spectacular series of eroded formations known today as Brimham Rocks.

ROBIN HOOD'S BAY
North Yorkshire

Robin Hood's Bay is where the York Moors National Park meets the sea near Whitby, though there is no known connection with Robin Hood. The little village, also known as Robin Hood's Bay, is these days a place for holidaymakers, with camping and caravan parks dotted round about, offering everything from visits to the old coastguard station and pony-trekking to fossil hunting along the cliffs. In time gone by this was a fishing village, with a reputation for smuggling.

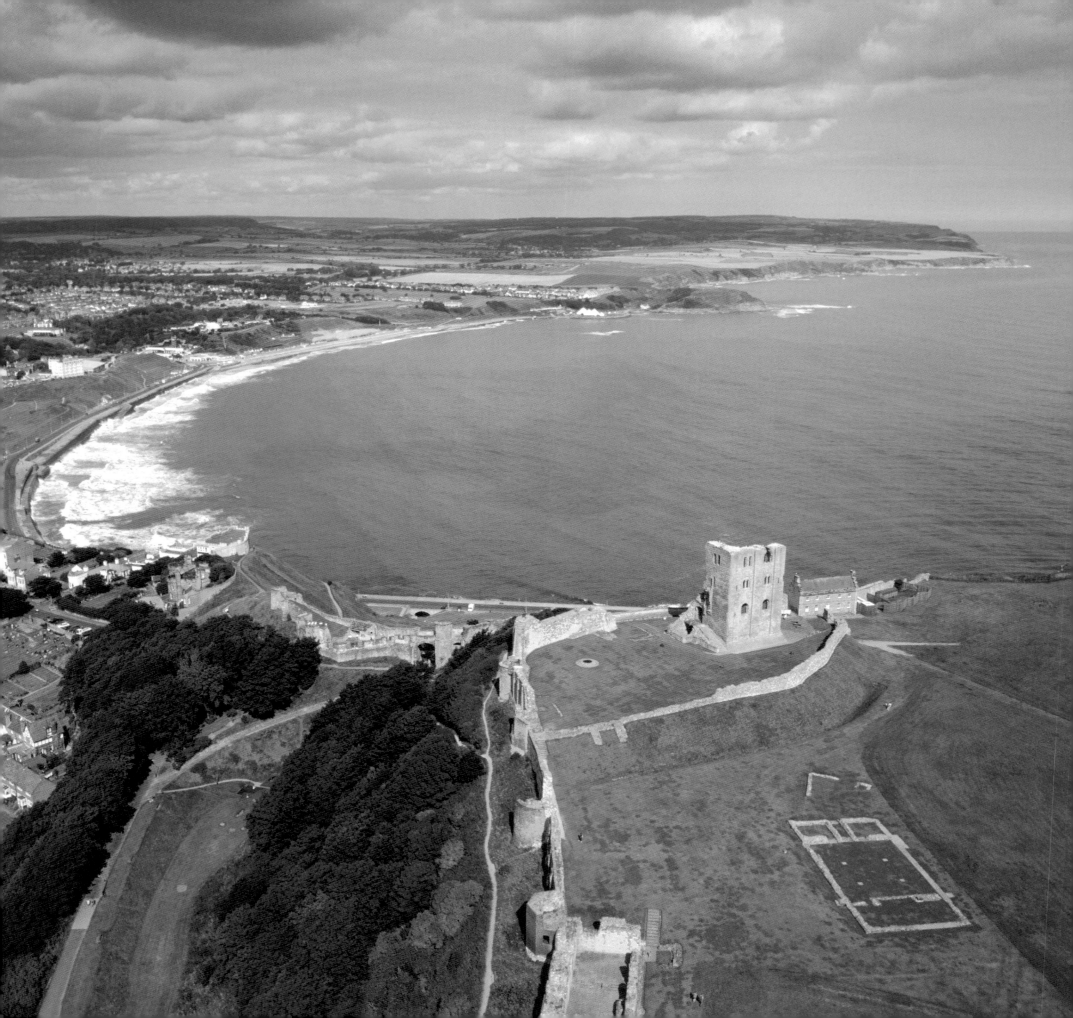

SCARBOROUGH
North Yorkshire

Scarborough is Yorkshire's most famous seaside resort and lies on the coast where the Vikings founded it in the tenth century. The twelfth-century castle is the most prominent feature in this view, and rightly so since it sits on top of a headland nearly 100 m (328 ft) high. Eight hundred years before, the Romans built a signal station here to protect their coastal shipping. Scarborough today is a major town with a Victorian promenade, the Stephen Joseph Theatre, and also hosts a jazz festival.

CASTLE HOWARD
North Yorkshire

Castle Howard is one of the glories of Yorkshire, sitting within its vast gardens a few miles north of York. Built by John Vanbrugh and Nicholas Hawksmoor for the Earl of Carlisle at the beginning of the eighteenth century, it is really a magnificent country pile rather than a castle. This view is from behind the house looking across the formal garden. It is hard to believe a fire in 1940 devastated Castle Howard because since then the building has been entirely restored.

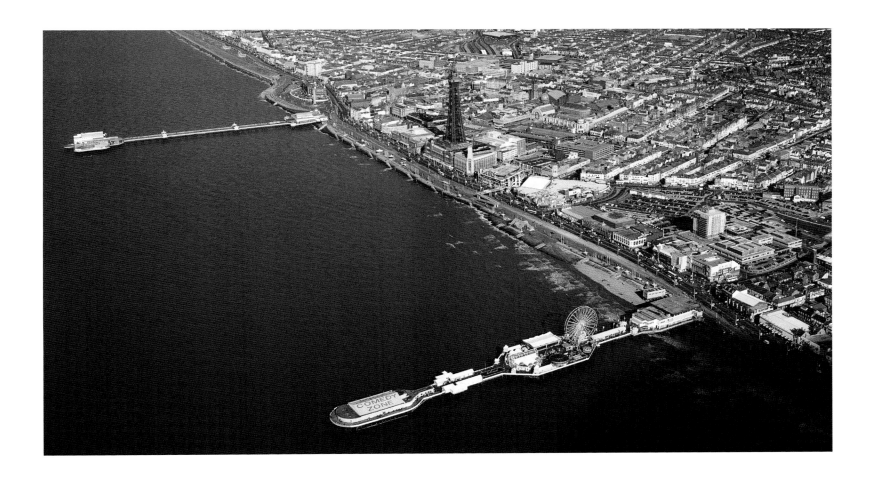

YORK MINSTER
North Yorkshire

Mighty York Minster is England's largest cathedral, and still towers over the largely medieval streets that cluster round below, including the famous Shambles. Once known as Eboracum, York began life as a Roman fortress, remains of which can be seen beneath the Minster. The present church dates back to the eleventh century but repairs and alterations ended up creating one of the greatest Gothic twelfth-century buildings ever created, though work carried on until 1472. A terrible fire wrecked the south transept in 1984, which has since been restored.

BLACKPOOL
Lancashire

There is no doubt that this is England's most famous seaside view. On the Lancashire coast, Blackpool has three piers built by the Victorians, but in 1894 its most distinctive feature was built: Blackpool Tower. Blackpool's greatest days came in the twentieth century when working-class people arrived in their tens of thousands every week during the summer season from all round the country. Blackpool remains an important leisure destination and also plays host to party political conferences and many other events.

IMPERIAL WAR MUSEUM NORTH

Manchester

This extraordinary piece of engineering is the Imperial War Museum North in Salford, Manchester. The building was designed with aluminium as an outer skin by the Berlin-based American architect Daniel Libeskind to be a symbol of world war by creating a series of conflicting shapes and angles. The view shows the museum under construction before opening in 2002 in The Quays, Manchester's cultural and leisure centre that includes shopping, watersports and other museums. The ship at lower right is the minesweeper HMS *Bronington*.

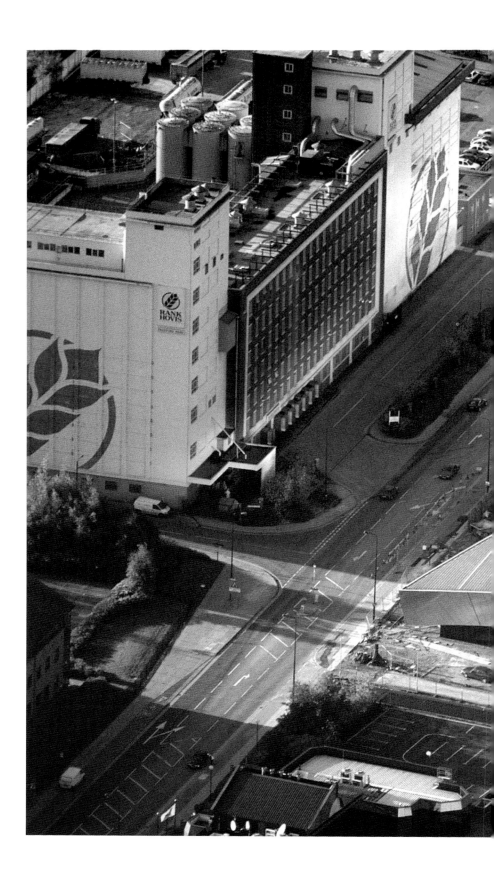

MERSEY ESTUARY
Liverpool

Few cities in England have as much civic pride and identity as Liverpool, seen here from above the Mersey Estuary. Liverpool grew to colossal commercial importance in the eighteenth century as the British Empire became more and more powerful. By the early 1800s nearly half the world's trade passed through Liverpool. It remains an important port today though its greatest modern fame has come from the association with popular music in the 1960s, mainly of course due to the Beatles.

MANCHESTER SHIP CANAL
Manchester

A ship makes its way up the 58-km (36-mile)-long Manchester Ship Canal. Starting at Runcorn on the south side of the Mersey Estuary, the canal was finished on 1 January 1894, having taken six years to build. During its constrcution, as many as 17,000 men removed 41 million cubic m (54 million cubic yds) of spoil. The reason for this Herculean effort was to provide Manchester with its own access to the sea and end its dependence on nearby Liverpool.

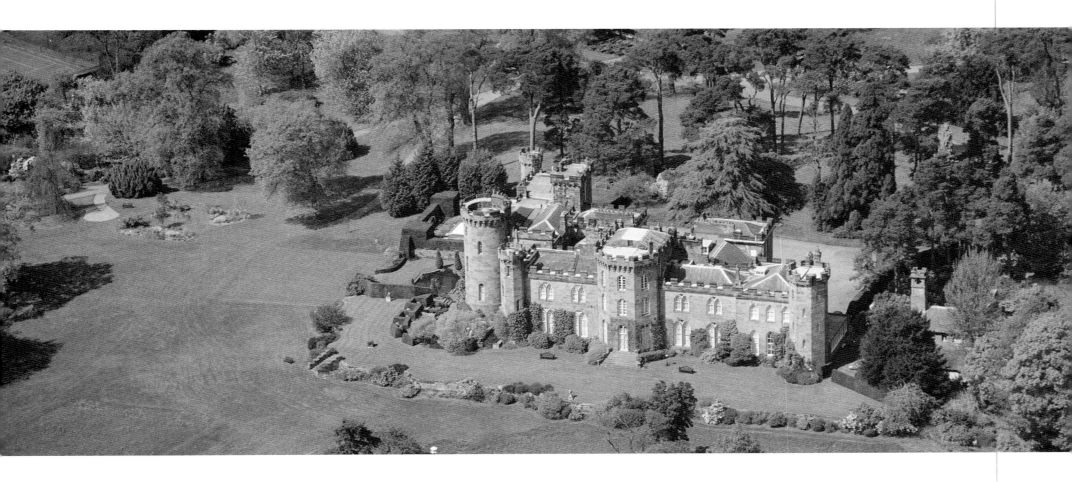

CHESTER
Cheshire

Chester was once Roman Deva, founded by the River Dee as the fortress of the Twentieth legion to control northern Wales. Within the ancient walls, though, Chester's proudest boasts are its thirteenth-century cathedral with its freestanding bell tower built in 1974, and its magnificent half-timbered buildings with their unique double-rows or 'galleries' of shops, making this one of England's best-preserved medieval cities. Although the Victorians added Gothic buildings like the town hall, they also replicated the medieval style, helping to preserve Chester's character.

CHOLMONDELEY CASTLE
Cheshire

Cholmondeley Castle is near Malpas in Cheshire. Cholmondeley looks medieval but in reality was built in the nineteenth century as a mock castle, a time when many people loved the idea of medieval life and tried to recreate it. Cholmondeley's fame, though, belongs to its magnificent gardens surrounding the house, which overlooks a lake. As well as a water and a rose garden, Cholmondeley has plenty of full-grown trees, many of which can be seen here clustering around the house.

LINCOLN CATHEDRAL

Lincolnshire

No other English cathedral dominates its surroundings like Lincoln. Lincoln Cathedral was begun by the Normans in 1072 in the middle of the upper town, on a hill which towers over the lower town and the surrounding flat Lincolnshire farmland. No wonder the site was earlier a Roman legionary fortress. The cathedral was destroyed by fire and an earthquake before the end of the 1100s and most of the present building belongs to the thirteenth century. Lincoln's 83-m (272-ft)-high tower commands staggering views across the county.

Heart of England

The Heart of England is a vast area that stretches from the River Trent in the east to the River Severn in the west.

A wonderfully varied landscape, so often crossed by travellers hurrying from London to the north or vice-versa, this is a region without the extremes of the north and west but with its own beauty and endless range of fascinating places. It enjoys the advantages of being close to the crowded south-east, as well as the luxury of its own cities and towns like Stratford and Cheltenham, and parks.

The natural landscape includes the Peak District National Park, which is probably the most unspoiled part of the region, as well as the rolling Cotswolds. In the Middle Ages castles ruled this part of England as they did everywhere else, but by the sixteenth and seventeenth centuries stately homes had replaced them as places for the rich and influential to demonstrate their power, resulting in spectacular houses like Chatsworth and Blenheim.

But the heart of England was also home to the Industrial Revolution, with Ironbridge setting the trend for the future as far back as the late eighteenth century. More recently Leicester's Space Centre and Alton Towers place the region firmly in the present.

LADYBOWER RESERVOIR
Derbyshire

A beautiful lake it might look, but Ladybower reservoir was created to provide water for Sheffield by damming the River Derwent in the heart of the Peak District National Park, and also help control the river's flow along with two older reservoirs higher up. The price was submerging the villages of Derwent and Ashopton when the reservoir was built between 1935 and 1943. It took two years to fill but has since had its dam raised in case of a major flood.

PEAK DISTRICT
Derbyshire

An early morning mist waits to burn off in the Peak District National Park, an area bounded by Manchester, Huddersfield, Sheffield and Matlock in the centre of England. Apart from Buxton there are no towns, only villages, in the park which is bisected by the River Derwent. The Peaks are popular for day trippers from the towns around, with some people coming to walk while the more ambitious go climbing on rocks like the gritstone Stanage, or caving underneath the White Peak.

HARDWICK HALL
Derbyshire

Bess of Hardwick was one of the richest women in Elizabethan England, and she used her wealth to build this spectacular showcase of Tudor ostentation near Chesterfield in the late sixteenth century. The huge windows, easily visible even from this height, were a way of showing off Bess's extravagance, as were her monogrammed initials 'ES' displayed along the roof line. The house survives more or less as it was built, together with its ornamental gardens, and is now owned by the National Trust.

CHATSWORTH HOUSE
Derbyshire

Chatsworth, a few miles from Bakewell in Derbyshire, is home to the dukes of Devonshire. The Tudor house was completely remodelled in the 1600s by the first duke. Like so many great houses, Chatsworth faced ruin in the twentieth century with the upheaval of war, death duties and the astronomical running costs. But by turning the house into a charitable trust, the family reinvented Chatsworth and it is now one of the most successful and popular stately homes in England.

DOVEDALE
Derbyshire/Staffordshire

The River Dove drains the gritstone moor from Axe Edge in the south-west part of the Peak District National Park, bounded by Ashbourne, Leek and Buxton, and marks the line between Derbyshire and Staffordshire. The river, responsible for cutting through the limestone to create remarkable rock formations, has also been famous for trout-fishing for centuries, immortalised by Izaak Walton in his *The Compleat Angler* (1653). Now known as Dovedale, and owned by the National Trust, the area is one of the most beautiful in England.

KERSALL

Nottinghamshire

This might be almost any part of rural England with an endless patchwork quilt of fields. In fact this is late one autumn afternoon at a tiny village called Kersall, halfway between Sherwood Forest and Newark in Nottinghamshire and connected by the A616, visible in the middle distance. Far beyond at the upper right is the power station at Cottam. It sits by the great River Trent, which has made this such a fertile place for farmers since ancient times.

SHERWOOD FOREST

Nottinghamshire

Sherwood near Edinstowe in Nottinghamshire was once a royal forest but is now a park with a visitor centre and tourist attractions. No-one can hear the name 'Sherwood Forest' without thinking of the legendary Robin Hood of Sherwood, who reputedly defended the downtrodden during the time Prince John ruled England while his brother, Richard I (1189–99), was away on the Crusades and imprisoned in Austria. Deep in its heart is the ancient 1,000-year-old 'Major Oak', said to have been Robin's headquarters.

INNER-CITY HOUSING
Nottingham

Inner-city housing is a necessary evil and goes all the way back to the Industrial Revolution when the rural population started heading to the towns looking for work in the new factories. Ever since then, Britain's cities and towns have grown bigger and bigger and now most of us live in one. These houses were built around the end of the nineteenth century to take advantage of railway commuter lines, and still form part of essential housing stock in all of Britain's major conurbations.

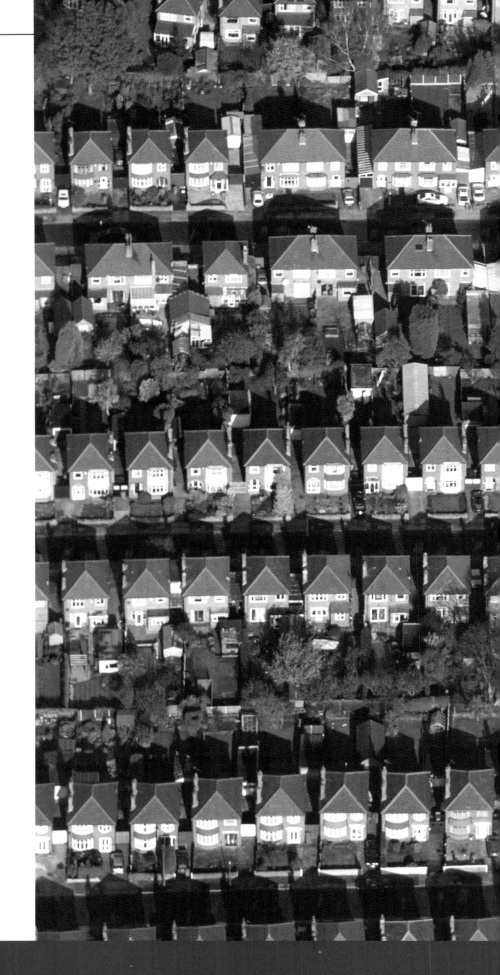

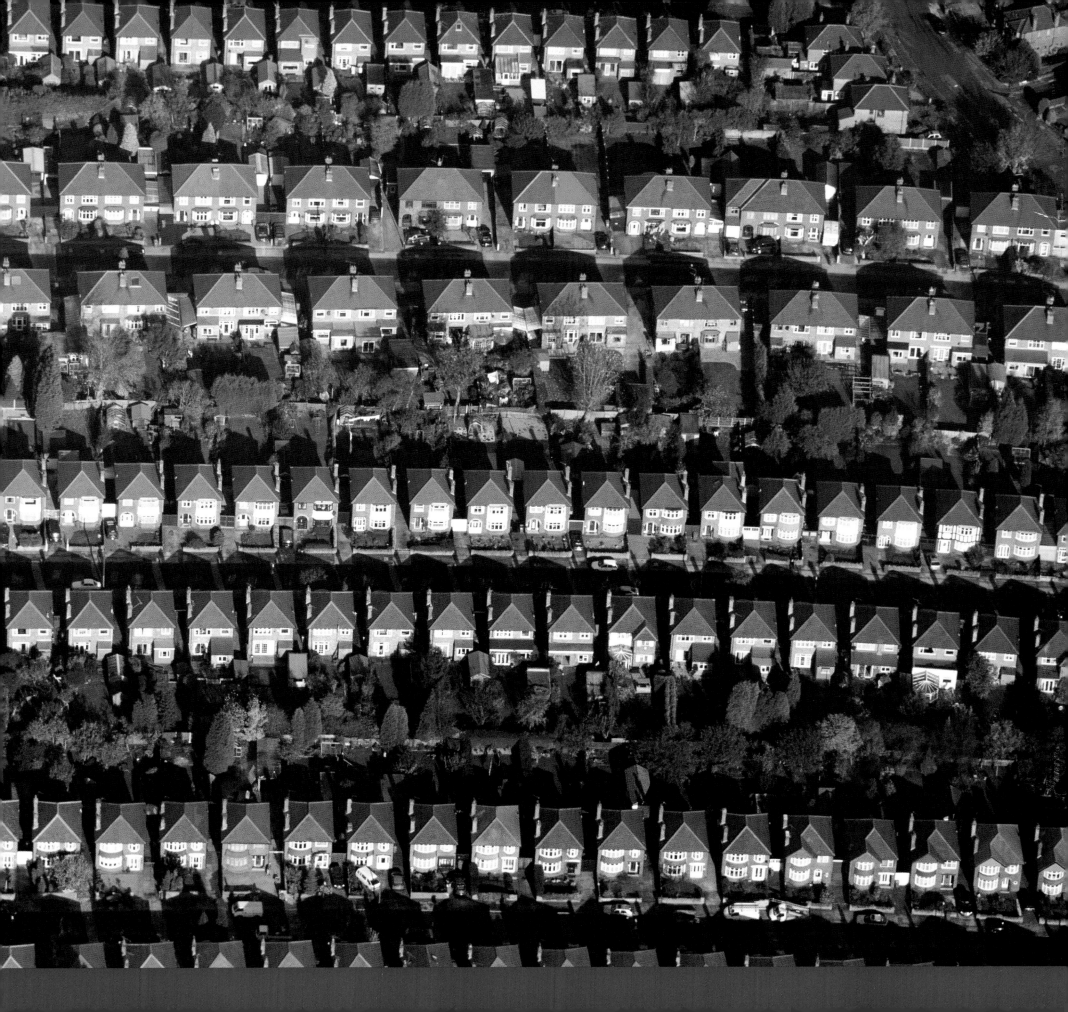

ALTON TOWERS

Staffordshire

From up here, Alton Towers' Corkscrew ride looks fairly harmless but this is the theme park's original roller-coaster, built here in 1980. Alton Towers is England's biggest and best-known theme park, built around the nineteenth-century Alton Towers mansion in Staffordshire. Alton Towers is known today for its terrifying and eye-watering rides like Nemesis and Oblivion, which plunges riders deep below the ground in a vertical drop. But Alton Towers also has plenty of other gentler activities, including a petting zoo.

NATIONAL SPACE CENTRE

Leicestershire

Leicester is one of the most important Midlands cities. One of its latest and proudest boasts is the futuristic National Space Centre with its Rocket Tower visible here beside the museum building. It is the only such place devoted to the history and future of space exploration of the Earth and Moon, the planets and beyond the Solar System in the United Kingdom. Visitors can explore Jupiter's ice-bound moon Europa and tour a lunar base set in the year 2025.

RIVER SEVERN

Shropshire

At about 354 km (220 miles) long the Severn is the longest river in the British Isles with the greatest water flow, helped by the Avon and the Wye that pour into it. The Severn flows out into the Bristol Channel after having passed through Shrewsbury, Worcester and Gloucester since it rose in Wales. Thanks to a 15-m (492-ft) tidal range, its most remarkable phenomenon is the Severn Bore caused by exceptional high tides pushing back up the estuary against the river to create a wave.

IRONBRIDGE GORGE

Shropshire

In the upper reaches of the River Severn is the Ironbridge Gorge in Shropshire, a place enshrined in history as the 'birthplace of the Industrial Revolution' because this was where Abraham Darby found the most effective way to smelt iron with coke in 1709. Appropriately enough, the most famous monument here is the Ironbridge itself, constructed from 800 separate cast iron parts by Darby's grandson, also Abraham, in 1779. Although small by modern standards, Ironbridge was a momentous achievement that changed the course of history.

HILL CROOME
Worcestershire

The heart of the rolling Worcestershire countryside seems totally at peace here, in spite of the fact that this is Hill Croome, a tiny hamlet just yards from the busy M5 motorway that carries traffic from the West Midlands to Bristol and the south-west. Although the county is mainly rural, Worcesteshire's most famous product is Worcestershire Sauce, made in the cathedral city of Worcester from (amongst other things), vinegar, molasses, onion, garlic, and anchovies and used throughout the world.

GRAND UNION CANAL
Birmingham

Begun in the 1760s, the canals helped the Industrial Revolution get underway by making it possible to move the resources needed to smelt iron to the same place, and to ship out the products of industry. But the result was also to create the railways and road transport. By the early twentieth century canals faced ruin, so a scheme was devised to join canals together and create a single 217-km (135-mile) canal link with 160 locks to connect London and Birmingham, which remains in use today.

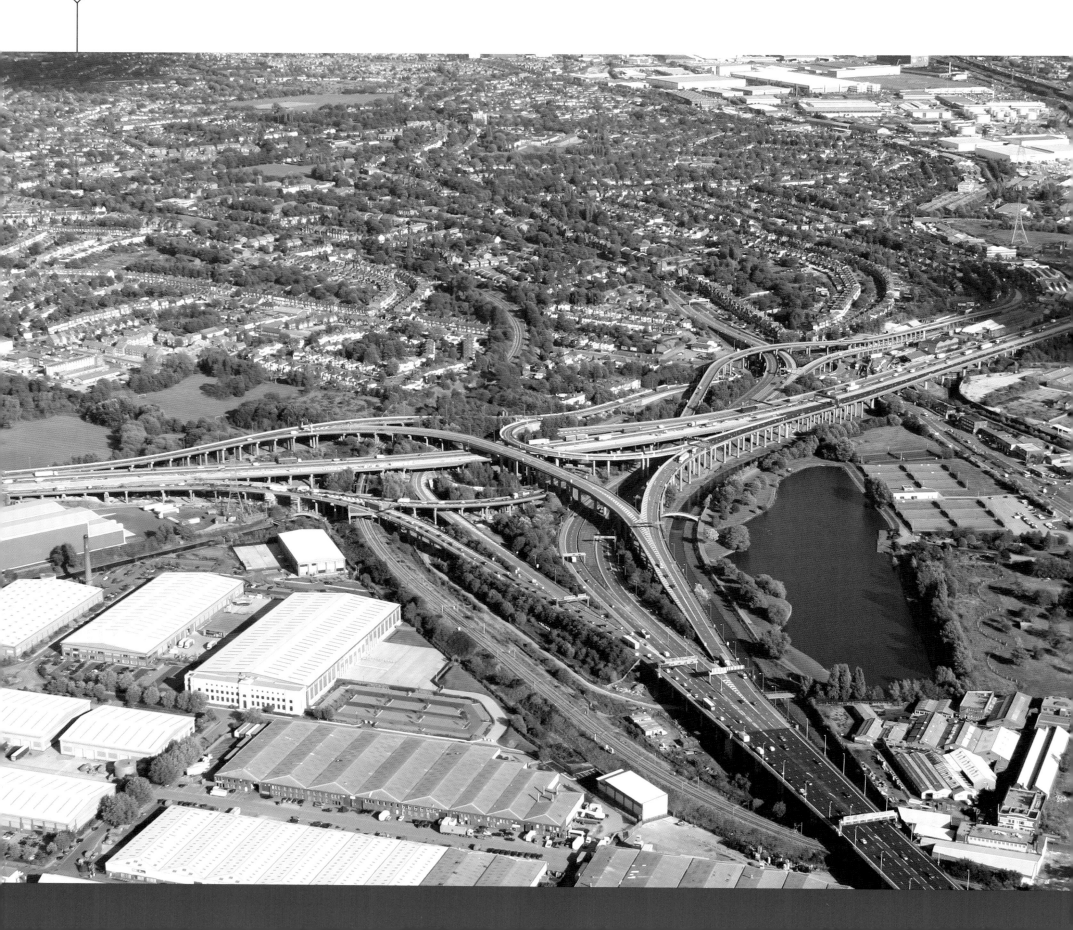

SPAGHETTI JUNCTION

Birmingham

It was the Industrial Revolution that turned a cluster of villages in the West Midlands into England's second city. Road development in the twentieth century, especially motorways, made Birmingham into a major junction. That resulted in what was seen by many as a symbol of how Britain was sacrificing the environment to the car, and by others as a necessary evil: Spaghetti Junction, built from 1968–72. Its real name is Gravelly Hill interchange on the M6 and it covers an amazing 12 ha (30 acres).

UNIVERSITY OF BIRMINGHAM

Birmingham

With around 25,000 students, Birmingham University is one of the largest in Britain. The university was awarded its charter in 1900, and the red brick of its buildings visible here happily echoes the fact that this was the first of the modern era of so-called 'red-brick universities' to achieve that status. This view shows the D-shaped design of its Edgbaston campus, designed by the architects Aston Webb and Ingress Bell, around the Chamberlain clock tower which rises to 100 m (328 ft).

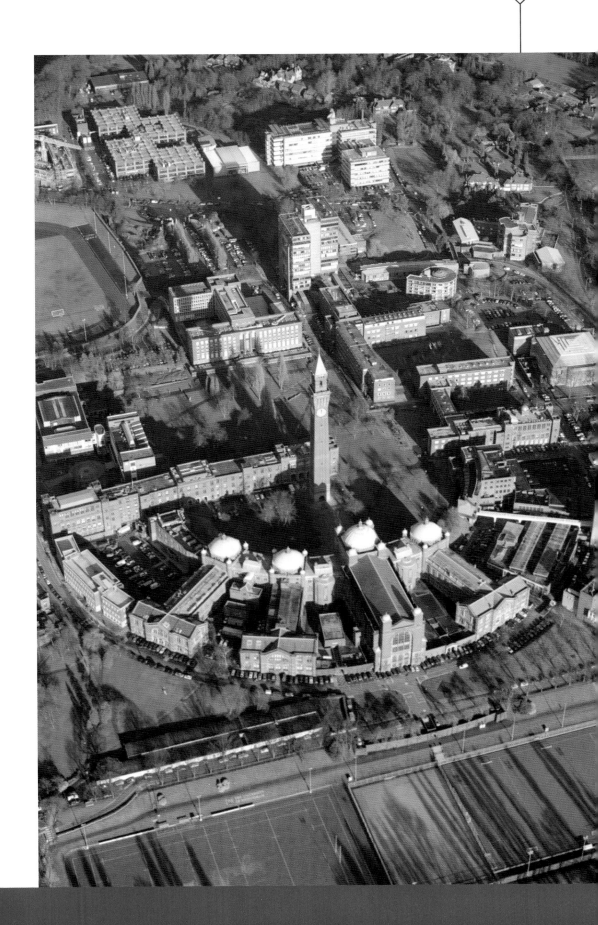

WEOLEY CASTLE
Birmingham

Today Weoley Castle is a south-west suburb of Birmingham, but it takes its name from the fortified medieval manor house of that name whose ruins are still visible. Weoley reached its climax in the fifteenth century and it is almost impossible to believe now that it was once surrounded by its own 121 ha (300 acres) of farmland. Soon afterwards it changed hands and fell into ruin only to be swamped as Birmingham swallowed up surrounding countryside in the nineteenth century to become England's second biggest city.

GOODRICH CASTLE
Herefordshire

Goodrich's red sandstone walls mirror the Herefordshire farmland that surrounds this massive stronghold built near Ross-on-Wye by Godric Mappeston in the twelfth century. The earls of Pembroke enlarged and strengthened the castle, cutting the rock out from around the castle to create the moat at the same time. The abandoned castle was used by both sides in the English Civil War and was later partly demolished to prevent it being of further use, but as one can see the castle resisted well.

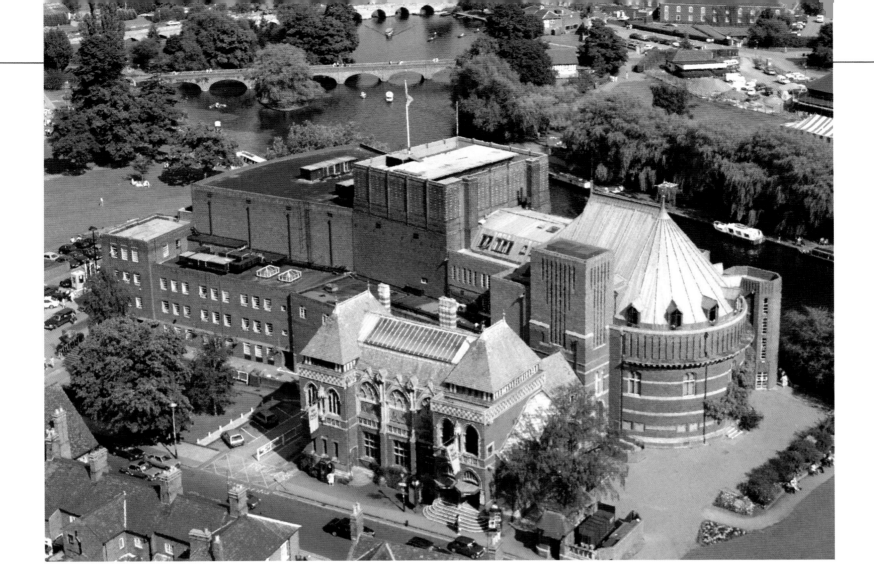

WARWICK CASTLE

Warwickshire

Warwick is an exceptionally magnificent medieval castle with a splendid history stretching all the way back to William the Conqueror, though it did not reach its present form until the late fourteenth century. It remained in the hands of several different families, each successively different creations of the earls of Warwick until, in 1978, it was bought by the Tussauds Group. The group turned it into a major medieval heritage centre where visitors can watch medieval siege warfare machines and the training of birds of prey.

STRATFORD-ON-AVON

Warwickshire

Stratford-on-Avon is an international shrine to William Shakespeare, born here in 1564, though he spent much of his life writing and performing in London. This prominent building is the Royal Shakespeare Theatre where the playwright's works are constantly performed to audiences who have travelled here from every part of the world. Built in 1933, it can seat around 1,500 people. Stratford also boasts Shakespeare's birthplace, and the house of his wife Anne Hathaway. From here the Avon flows south-west to join the Severn at Tewkesbury.

TEWKESBURY
Gloucestershire

Tewkesbury stands where the River Avon meets the Severn and was where, in 1471, the Wars of the Roses ended in a battle between Edward IV and the supporters of Henry VI. The last bloody moments took place in Tewkesbury's Abbey of the Blessed Virgin Mary, the town's greatest building, built in the twelfth century from Normandy Caen stone shipped up the Severn. The church survived Henry VIII's Dissolution of the Monasteries and is today England's second largest parish church.

SUDELEY CASTLE
Gloucestershire

Sudeley, near Winchcombe in the Gloucestershire Cotswolds, is the burial place of a queen. Katherine Parr, the last of Henry VIII's six wives is buried in the chapel here. After the king's death she married Thomas Seymour, whose home this was, and died in 1548. Sudeley fell into ruin after it was used as Prince Rupert's headquarters in the Civil War, but a massive restoration programme began in the nineteenth century when the Dent family, still the owners, bought the castle.

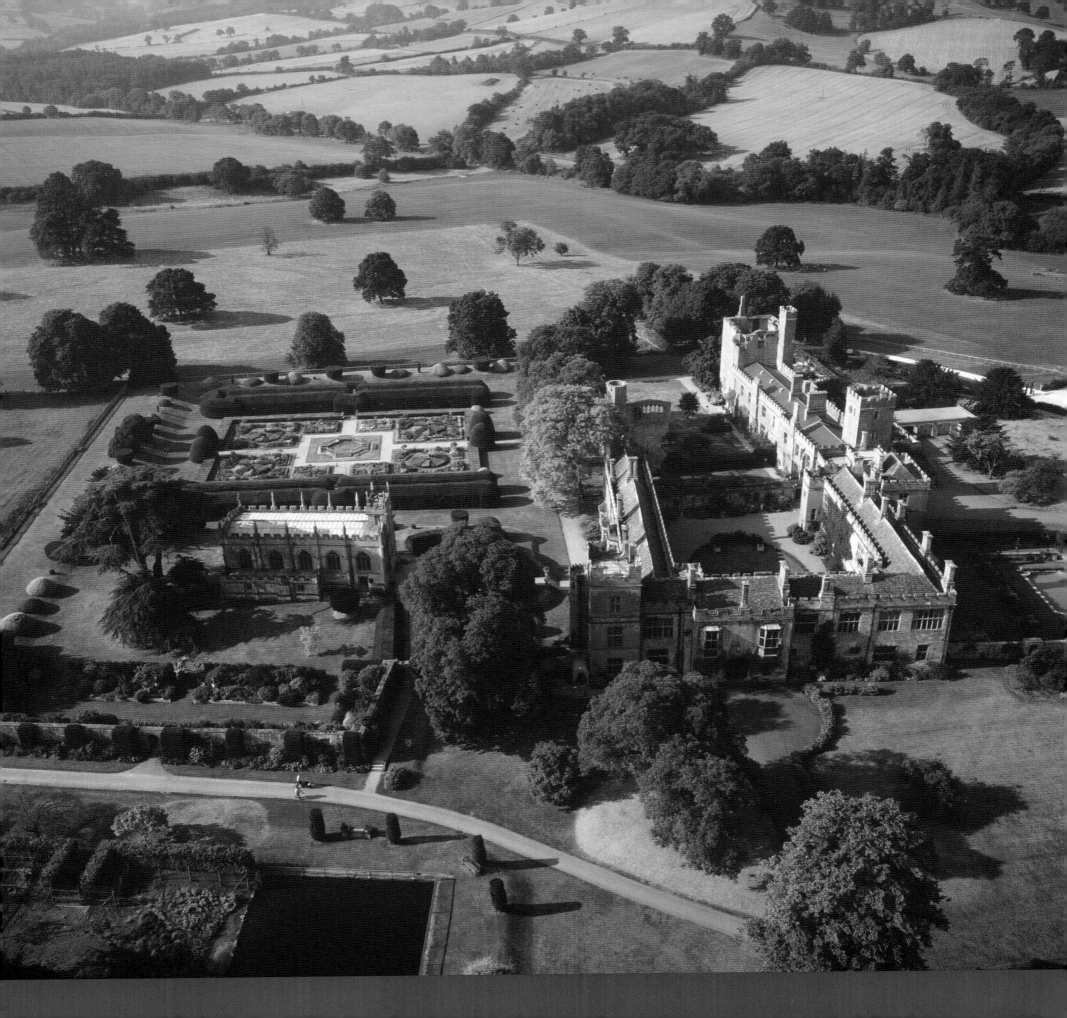

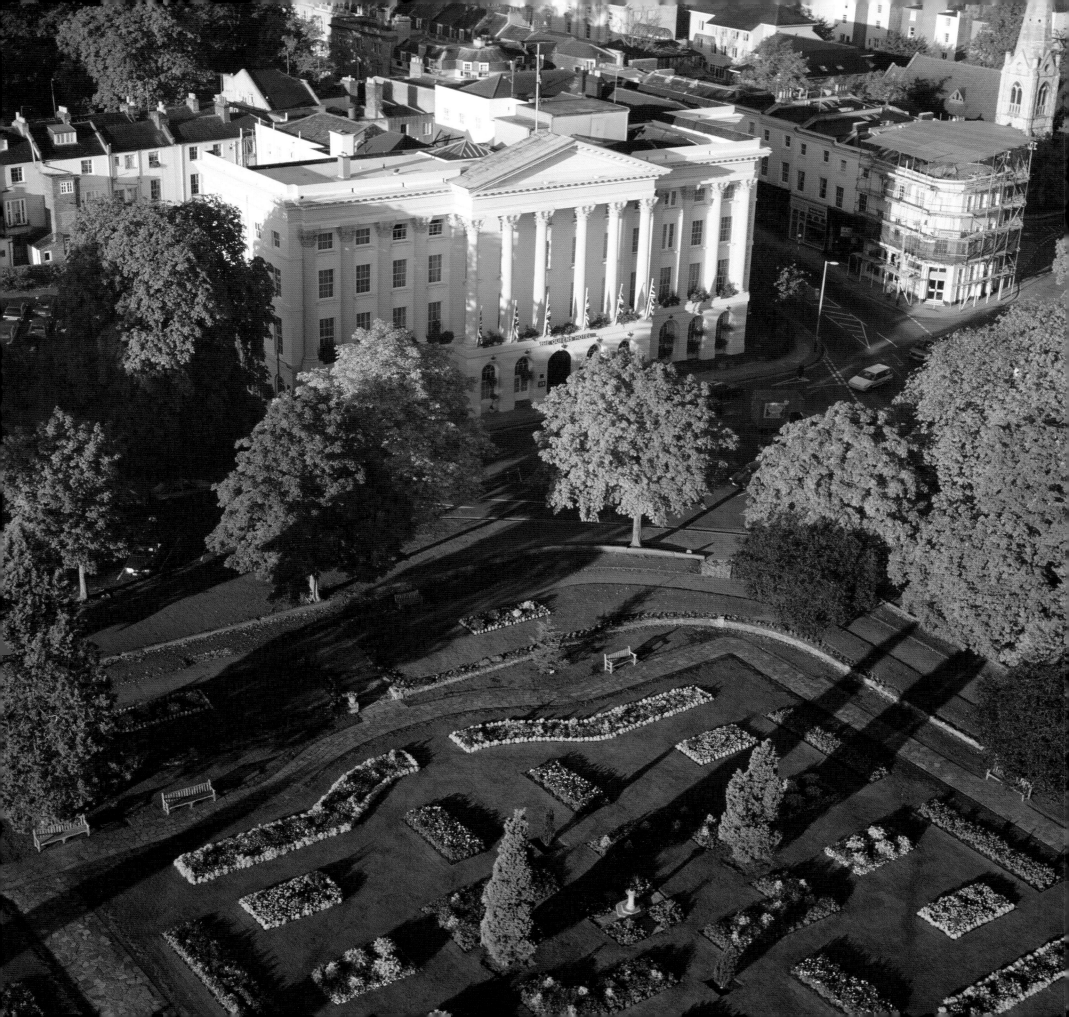

CHELTENHAM
Gloucestershire

Cheltenham was just another market town until healing waters were found nearby in 1716. In 1788 George III came to 'take the waters' and promptly made Cheltenham into the height of fashion. Over the next few decades several spas were set up and embellished with the fine architecture that now makes Cheltenham England's most complete Regency town. One of the finest is the Queen's Hotel, claimed to be the nation's first purpose-built hotel, seen here looking down Cheltenham's tree-lined promenade.

COTSWOLDS
Gloucestershire/Oxfordshire

The rolling hills of the Cotswolds lie south of Oxford and were formed from limestone that was once a seabed in the Jurassic age and is made from the bodies of untold billions of sea creatures. The stone is wonderfully easy to carve when freshly quarried, and weathers into a gentle range of brown and grey shades that make the Cotswold villages so charming. Despite its proximity to London and motorways, it remains a perfect piece of quintessential English countryside.

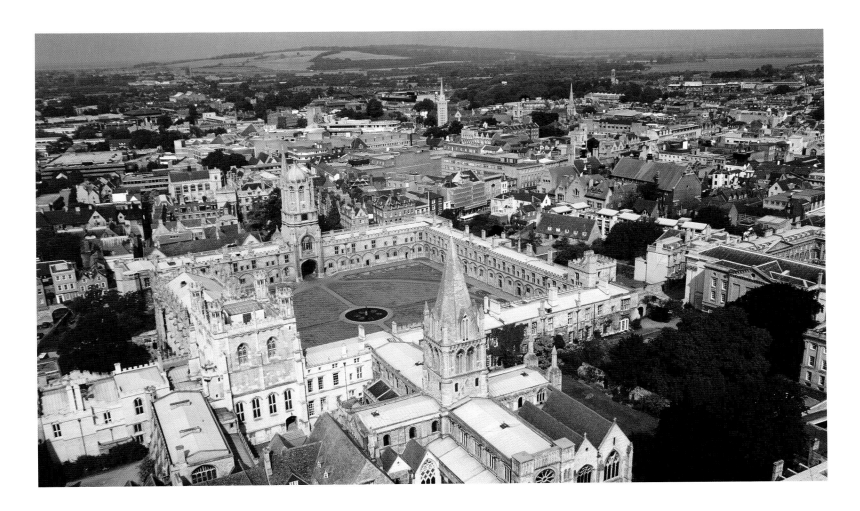

BLENHEIM PALACE
Oxfordshire

This breathtaking building near Woodstock in Oxfordshire was built on a site awarded to John Churchill, Duke of Marlborough, by Queen Anne as a gift for defeating the French at Blenheim in 1704. Designed by Sir John Vanbrugh and built from 1705–22, Blenheim is the only house known as a 'palace' that is neither a royal nor a bishop's residence. Blenheim has remained in the Churchill family. Sir Winston Churchill was born here in 1874 when his mother was attending a ball.

OXFORD
Oxfordshire

At the heart of this view of the city is Christ Church College, originally founded as Cardinal's College in 1524. Henry VIII re-founded the college as Christ Church in 1546. In 1682, Christopher Wren, an alumni, designed a tower to house the college's bell, 'Great Tom', from which the quadrangle and the tower get their names. The university so dominates the city that it is easy to forget that until the 1970s Oxford was also a major car-manufacturing centre.

UFFINGTON WHITE HORSE
Oxfordshire

No-one knows who created the White Horse by exposing the chalk beneath on the Ridgeway across the Lambourn Downs, or why – since the only place to see it properly is from the air. But the 110-m (360-ft)-wide figure dates back at least to 600 BC and possibly before, created by the prehistoric peoples who were responsible for so many monuments in this ancient part of Britain. On the ground the horse is best seen from the north, appropriately across the Vale of White Horse.

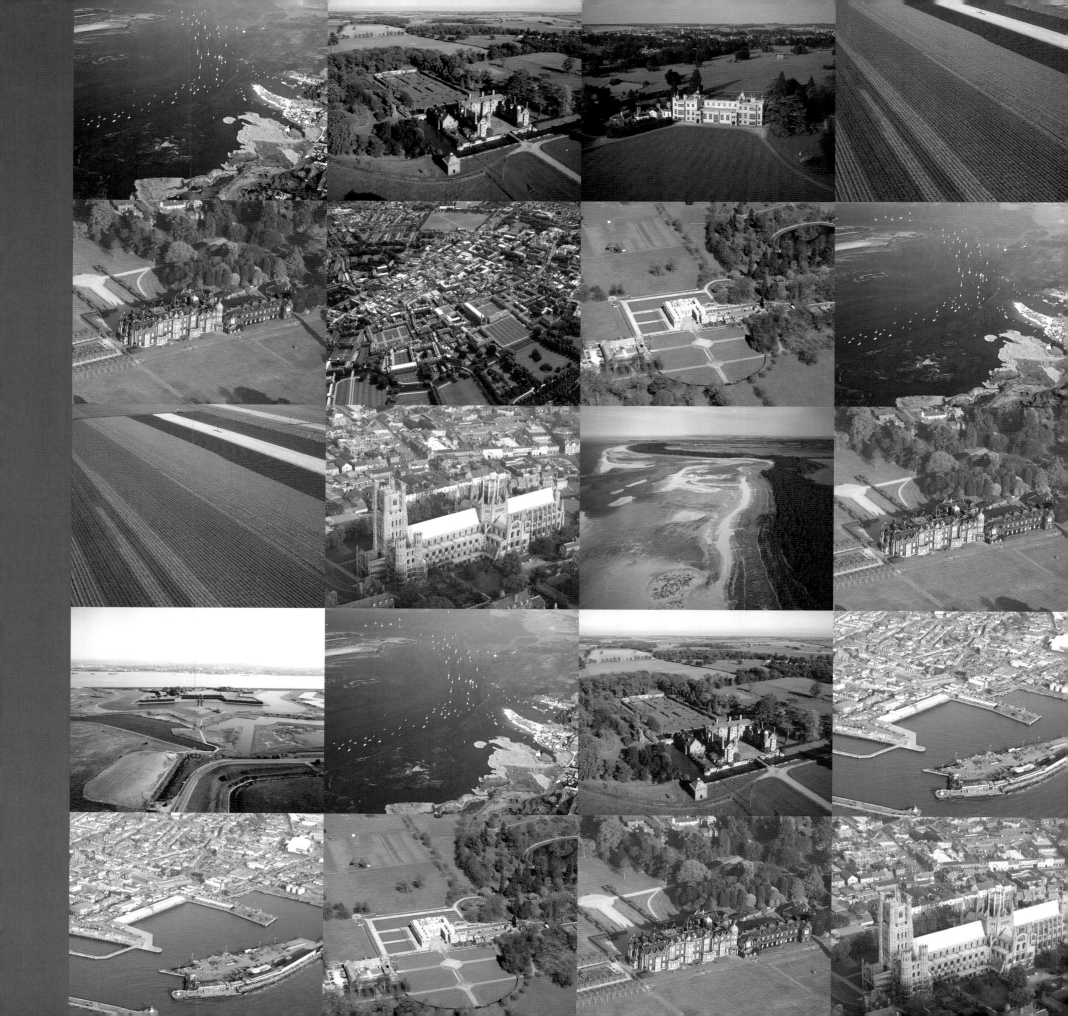

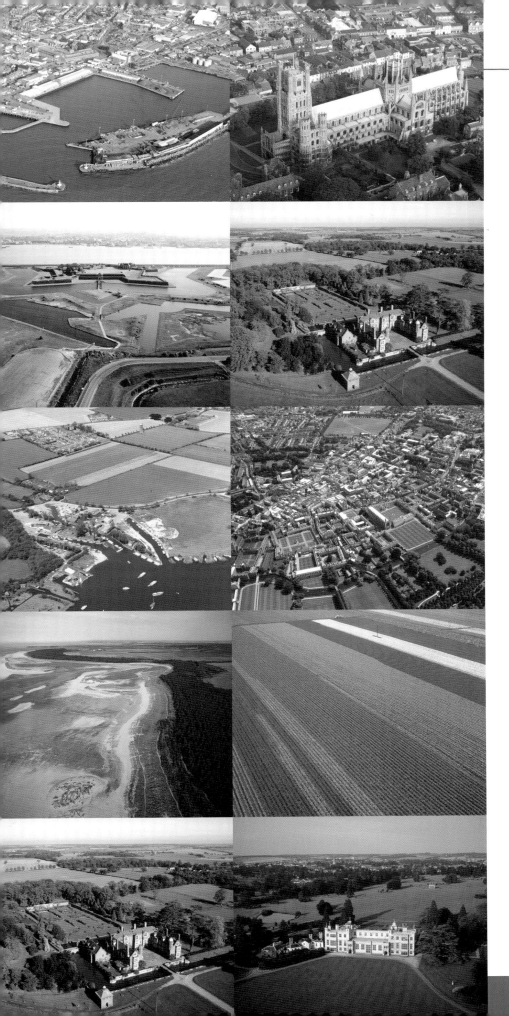

Eastern England

Eastern England is East Anglia, named after the Angles who arrived here from northern Europe in the fifth century.

As a landscape its most defining feature is the flatness creating a part of Britain where the 'big sky' is always in evidence, whether one is exploring Cambridge's ancient medieval streets or enjoying a gentle cruise down one of the Norfolk Broads.

East Anglia is not a region where heavy industry has ever really had much of a presence, and instead it retains much of its traditional character as a place of peaceful agriculture and where man is constantly challenged by the need to control water in all its forms. In the Middle Ages this was an exceptionally rich part of Britain, thanks to the trade in wool, and some of the finest architecture in the country can be seen here in cities that are today far less important than they once were, such as Ely.

But East Anglia features strongly in the romantic sensibilities of the English, epitomised by the poetry of John Clare and the paintings of John Constable. Its proximity to the south-east has guaranteed its popularity as a holiday and weekend destination for those desperate to escape London.

SANDRINGHAM HOUSE

Norfolk

Sandringham was built in the 1770s in the middle of 3,238 ha (8,000 acres) of Norfolk countryside, and bought in 1862 by Queen Victoria for her son, the future Edward VII. Edward found the house too small, so in the 1870s he replaced it with the present house. This was where King George V died in 1952, and today's royal family spend the first part of each year here to commemorate that, though at other times the house is open to the public.

BRANCASTER HARBOUR
Norfolk

Brancaster is one of the most remote and unspoiled parts of East Anglia. It lies on the north-west coast of Norfolk and enjoys a spectacular view across the North Sea and the entrance to the Wash, the vast marshy inlet that separates Norfolk from Lincolnshire. Once the site of the Roman fort of Branodunum, traces of which are still visible, Brancaster is now an important refuge for wildlife, especially birds. The wide sandy beaches attract holidaymakers, and the offshore wind sailing enthusiasts.

HOLKHAM BEACH
Norfolk

Holkham faces out towards the North Sea in this view looking east across the flat north Norfolk coastline between Wells-next-the-Sea and Burnham Market. The wide sandy beaches in this quiet and remote part of England make the region a popular holiday destination. Walkers also enjoy this part of the world because the Peddars Way and Norfolk Coast Path makes its way along the shoreline here, shielded from the weather by the prominent band of trees known as Holkham Pines.

LOWESTOFT HARBOUR
Norfolk

The view here is across the south pier and outer harbour; beyond are the docks and north Lowestoft, the town's commercial district. Lowestoft is one of Norfolk's two major east coast ports, the other (and Lowestoft's rival) being Great Yarmouth. Both grew in importance during the Middle Ages on the back of the fishing industry, but in recent times Lowestoft has benefited enormously from servicing the North Sea oil and gas rigs, as well as from tourism.

HICKLING BROAD
Norfolk

This is not the sea but one of the Norfolk Broads. Hickling is one of several broads between Norwich and the sea. The story of Eastern England has always been one about water and the battle to control it. The endless low-lying land is constantly susceptible to storms bringing high sea levels, and the rivers can easily flood. But the water also provides the region with a source of beauty, defining the landscape with the marshy fens and the Norfolk Broads.

ELY CATHEDRAL

Cambridgeshire

In the heart of the Cambridgeshire Fens by the River Great Ouse sits the small town of Ely, dwarfed by its magnificent cathedral, visible for miles across the flatlands of eastern England. A Saxon monastery was founded here in AD 673, but the present cathedral was begun in the late eleventh century. In 1322 the tower collapsed and in its place a unique octagonal Gothic dome was built. By the fifteenth century the north-west transept had collapsed, too, but has never been replaced.

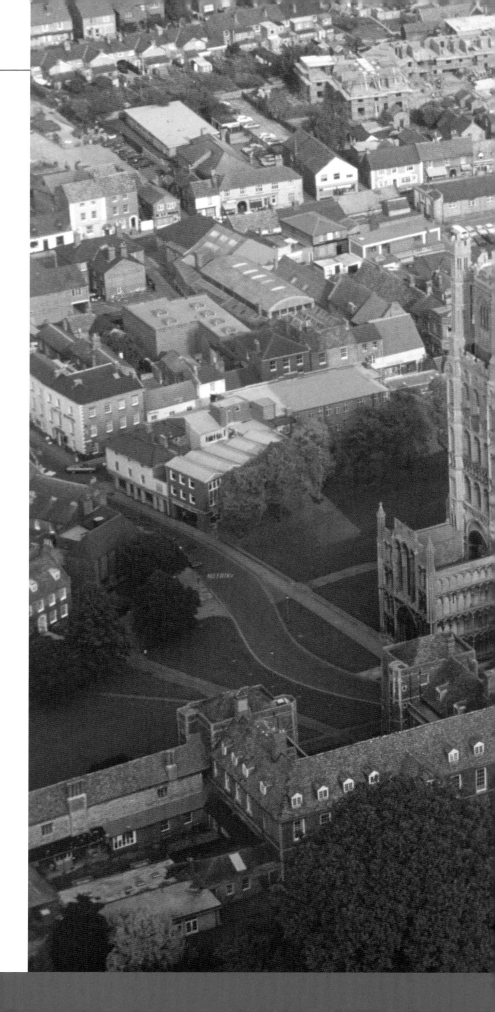

CAMBRIDGE
Cambridgeshire

Cambridge is England's 'other' ancient university city, the university being founded by students from Oxford who fled here in the early 1200s. Today Cambridge is still dominated by the colleges, and especially by the fifteenth-century King's College Chapel. But the university is only half the story today. Cambridge is a high-tech city with a thriving population and excellent transport links to London, just 80 km (50 miles) away. As a result it has become one of the most expensive places to live in England.

ALTHORP
Northamptonshire

Until 1981 it is unlikely that many people had ever heard of Althorp near Northampton, the family home of the earls of Spencer. It was the marriage of Lady Diana Spencer to the Prince of Wales which brought the house, pronounced 'All-trop', to wider attention. Althorp has been owned by the Spencers since the sixteenth century. Today the house can be visited by the public, many of whom come to see where Diana was buried on an island in the lake in 1997.

TULIPS
East Anglia

This looks almost like a colour test chart, though in fact it is a field of tulips in East Anglia. Tulips were brought to Europe, probably from Turkey, in the sixteenth century and soon became extremely popular, especially in the Netherlands where many new varieties were cultivated. The rich dark soils of East Anglia's fens are perfect for tulip-growing, and these days the region is the centre of Britain's flower-growing industry, celebrated with various festivals including the flower parade in Spalding, Lincolnshire.

SNAPE MUDFLATS
Suffolk

In this mid-morning view, Snape's mudflats look like polished bronze. This is where the River Alde winds its way east only to turn abruptly south just before it reaches the Suffolk coast, and carries on for another 17 km (10 miles) before finally flowing into the North Sea. These waters once carried Snape's malted barley by barge all the way to London where it was brewed into beer. The preserved buildings of the maltings now play host to part of the annual Aldeburgh Music Festival.

ORFORD CASTLE
Suffolk

This is Orford Ness, not far north of Felixstowe on the Suffolk coast, overlooked by Henry II's unusual castle and in the far distance the lighthouse. Orford Castle was built in the mid 1160s to give Henry a foothold in a land ruled by barons who he needed to control. This views shows off the castle's radical polygonal design that gave it 21 sides and three towers. Today the village clusters around the motte but once there were other castle buildings, now long demolished.

KENTWELL HALL
Suffolk

In the Middle Ages Suffolk's wealth came from wool, and the Clopton family did especially well out of it. The result was one of England's finest Tudor manor houses, close to the village of Long Melford, built in the early 1500s. Castles were really a thing of the past but old habits die hard and Kentwell was surrounded by a moat. Today Kentwell boasts a working Tudor kitchen and is a living history centre, hosting re-enactments of Tudor life and even Second World War events.

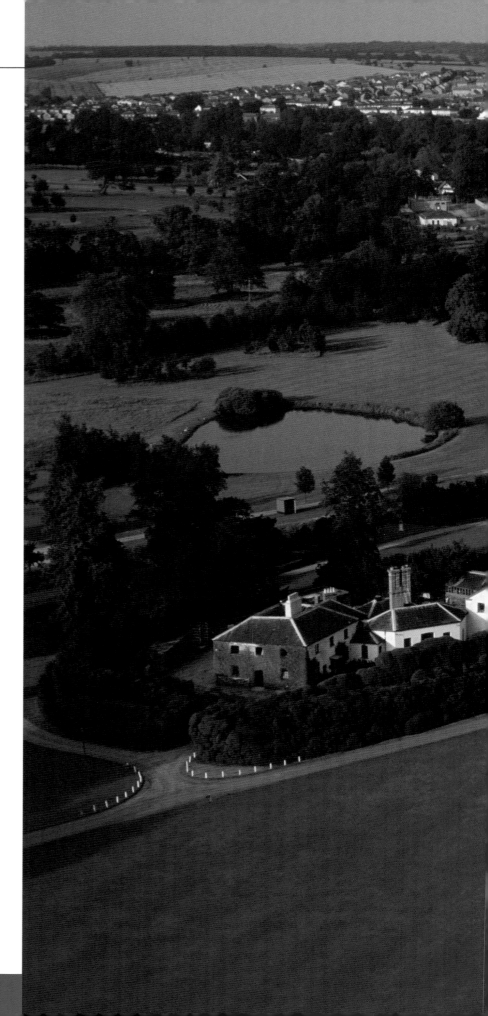

AUDLEY END HOUSE
Essex

This is Audley End House in the heart of Essex with Saffron Walden visible beyond. If the early seventeenth-century house, built on the site of a Benedictine monastery, looks impressive enough today it is remarkable to discover that it was once a very great deal larger. Thomas Howard, Earl of Suffolk, built Audley at colossal expense to impress King James I. But over the next two centuries various parts of the sprawling pile were demolished to make the place manageable.

COLCHESTER
Essex

Colchester can justly claim to be the oldest town in Britain. In the Iron Age this was Camulodunum, capital of the Catuvellauni from where Cunobelinus ruled most of Essex and Hertfordshire. The Romans arrived in AD 43, and Camulodunum became first a legionary fortress and then a proper Roman town with a senate house, theatre and a massive temple. Today Colchester has outgrown its Roman walls, but its ancient traditions are proudly displayed to visitors in the castle, which stands on top of the temple's foundations.

TILBURY FORT
Essex

The idea behind Tilbury's diamond-shaped projecting bastions was to make sure the fort's defenders could cover every possible angle against an artillery attack from enemy ships. The fort was a vital defence against a naval attack up the Thames to London, made all the more urgent because in 1667 the Dutch Navy had attacked the Medway and seized some of England's capital ships. Tilbury was begun 1672 by Charles II and it guarded the Thames until as recently as 1950.

South-East England

South-east England is the busiest and most crowded part of the whole British Isles. Inevitably it is dominated by the all-consuming sprawl of London, one of the world's greatest cities and certainly one of the most interesting.

With a history stretching back to Roman times, London became the largest medieval city in the country and by the seventeenth century dwarfed every other town in Britain and most of those in Europe. The Thames is the life-force of London and it deserves to be viewed from every angle, including during the annual London Marathon when tens of thousands of runners make their way through the middle of the capital.

But there is far more to the south-east than just London. Like so many other parts of Britain, castles stand as witness to the turbulent years of the Middle Ages and cathedrals like Chichester's to the genius of its medieval masons. Great houses were built here too, with Hampton Court and Hatfield two of the finest buildings from the 1500s and 1600s and then much later the astonishing Brighton Pavilion, built by the Prince Regent in the early nineteenth century. But it is back to London for that most modern of monuments, the London Eye, which anyone can ride in and experience an aerial view for themselves.

HATFIELD HOUSE
Hertfordshire

Hatfield House in Hertfordshire is one of England's most magnificent Jacobean houses. Elizabeth I grew up here in the royal palace. The estate was given by James I to his chief minister Robert, Earl of Salisbury, who demolished most of the palace and built the big house here in 1611. Hatfield remains in the family's hands though it escaped disaster in 1835 when the dowager duchess accidentally started a fire that killed her and destroyed one of the wings. It was later entirely restored.

WINDSOR CASTLE
Berkshire

Windsor Castle towers above the River Thames beside rolling parkland. Its history stretches all the way back to the Norman Conquest of 1066, when William the Conqueror built a keep to guard the western approaches to London. Later kings, especially Edward III and Charles II, enlarged and improved Windsor. Today it survives as not only the largest but also the oldest occupied castle in the world, restored after a major fire in 1992, and is one of the homes of the royal family.

ETON COLLEGE
Berkshire

Eton College, probably the most famous school in the world (and certainly one of the most expensive), is near Windsor in Berkshire. However, its prestige (which includes being able to boast 19 former British prime ministers) ensures there is no shortage of boys wishing to obtain one of the 1,300-odd places. Eton was founded by Henry VI in 1440 and one of its most important buildings is the fifteenth-century chapel, the most prominent building visible here and on the ground.

CITY OF LONDON
London

This is the very centre of the City of London, the traditional 'square mile', still bounded by the remains of the medieval city walls built themselves on top of Roman foundations. Today few people live in the City. This is the United Kingdom's international financial centre and the skyline is dominated by the massive commercial buildings, though here and there amongst them it is easy to pick out the churches built by Sir Christopher Wren after the Great Fire of 1666.

ST PAUL'S CATHEDRAL
London

On Sir Christopher Wren's tomb, deep beneath St Paul's, is a Latin motto: *Si requiris monumentum, circumspice*, meaning 'if you seek his monument, look around'. St Paul's of course was Wren's greatest gift to London. The old medieval cathedral was left in ruins after the Great Fire. Wren produced several controversial designs for a new cathedral and it was several years before the plan was finally agreed. Work was finished in 1709, leaving the result that triumphantly defied the Blitz of 1940–41.

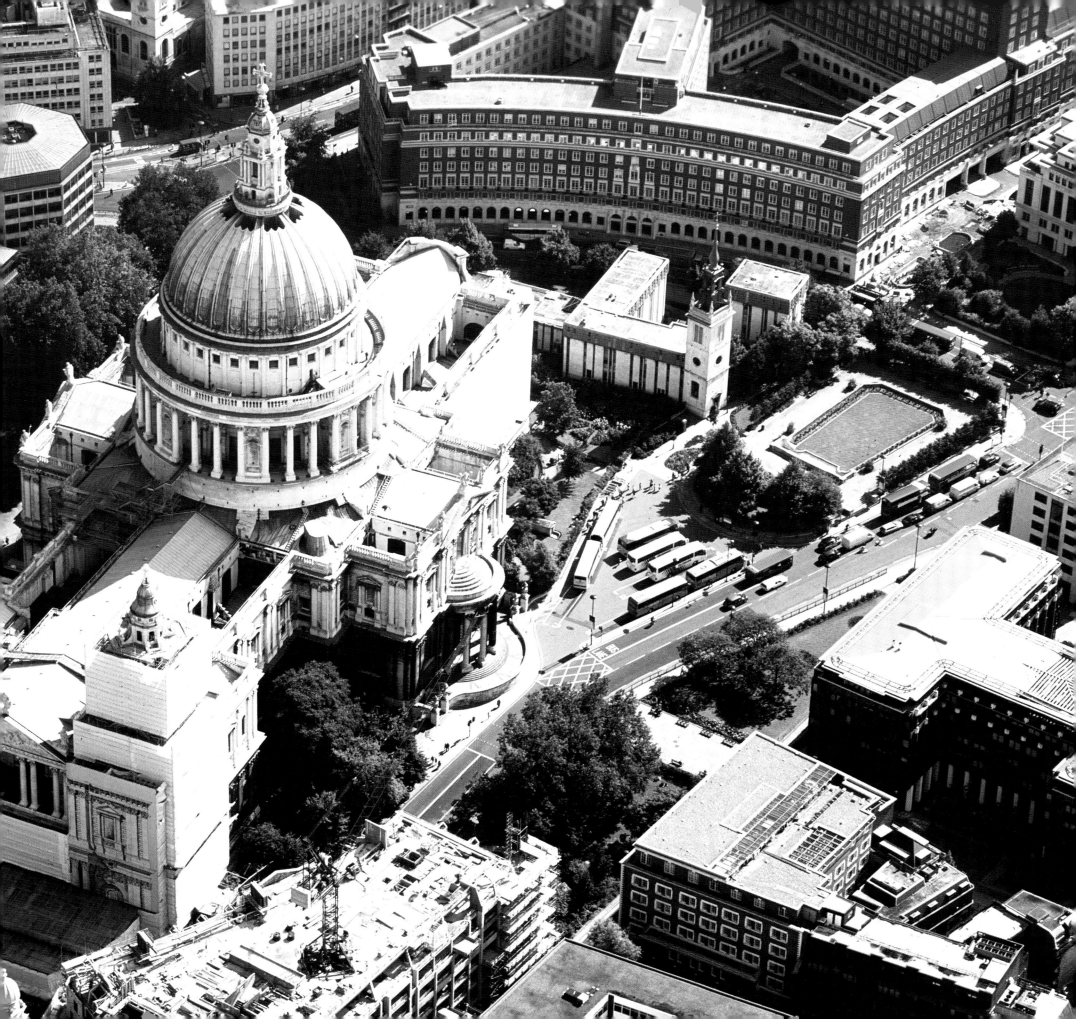

LONDON MARATHON

London

The legend of the marathon dates back to 490 BC when Pheidippides was said to have run from the Battle of Marathon to Athens to announce defeat of the Persians. Today's marathons are set at just over 41 km (26.22 miles). London's marathon was founded in 1981 and takes runners through one of the most stunning running routes in the world, starting at Greenwich in south-east London and ending up near Buckingham Palace. The fastest take just a little over two hours.

TATE MODERN

London

Almost directly opposite St Paul's Cathedral, and joined by the pedestrian Millennium Bridge over the Thames, the Tate Modern gallery is one of the most imaginative uses of an old building in Britain. Once the Bankside Power Station, this vast brick structure has a chimney almost 100 m (328 ft) tall and was finished in 1963. Less than 30 years later it was closed but instead of being demolished, the insides were stripped out and the modern art displays installed, opening to great acclaim in 2000.

LONDON EYE
London

Clinging to the south bank of the Thames, the London Eye has been carrying passengers up to 135 m (443 ft) above the river since 1999. This view is taken from almost at the top looking north-east across the Hungerford Railway Bridge and beyond is Waterloo Bridge. Each circuit of the wheel, the largest of its kind, with its 32 special observation cars takes about half an hour, with passengers hopping on and off as the cars slowly move past the boarding ramp.

HOUSES OF PARLIAMENT
London

The River Thames is the key to London's historical greatness, and there is no more appropriate place than the Palace of Westminster to appreciate that. Charles Barry's magnificent Houses of Parliament, finished in 1852, tower over the river on the north bank though Westminster Hall dates back to 1097. Beyond lie the modern government departments of Whitehall. Tourists today can fly above Parliament themselves by taking a ride on the London Eye, a great rotating wheel with observation cars on the south bank.

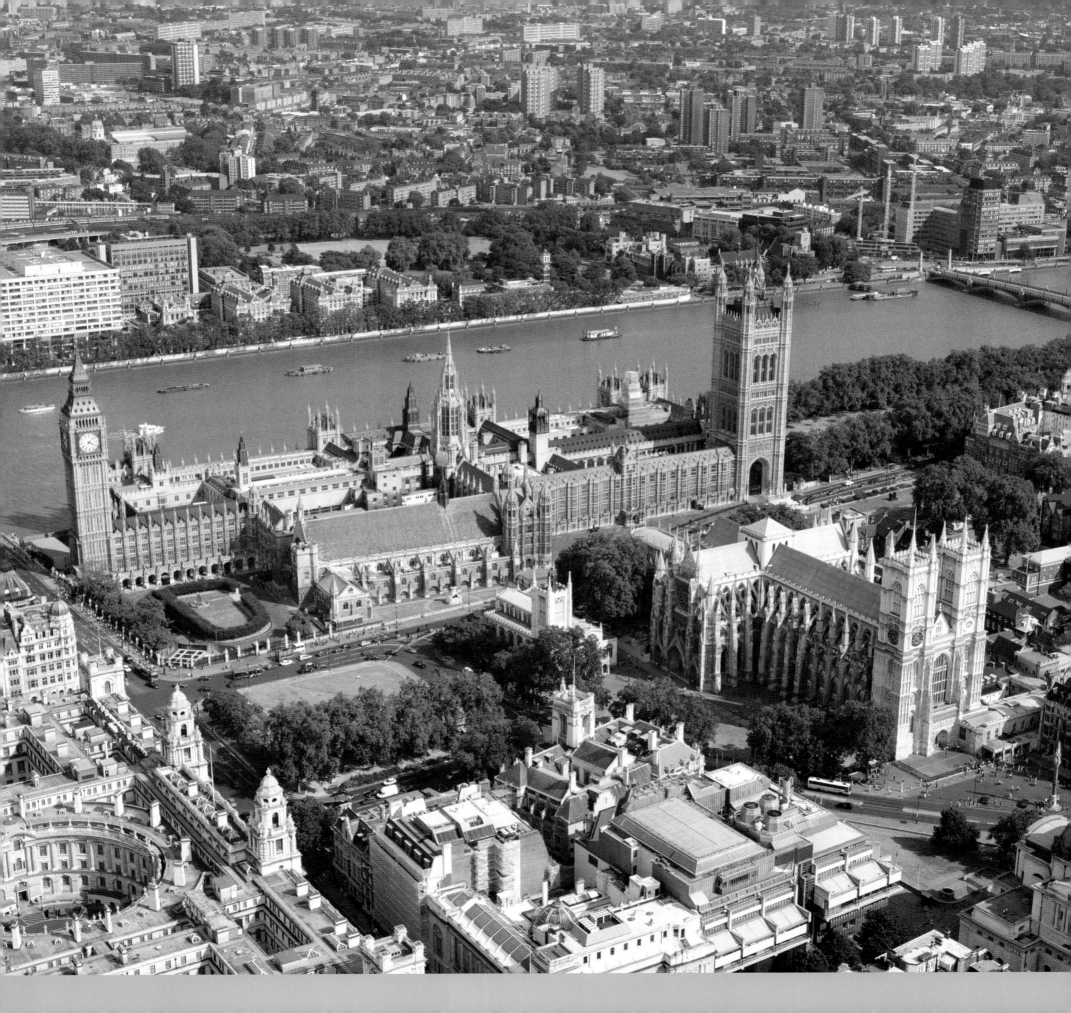

RIVER THAMES & BRIDGES

As the River Thames flows through London, it heads north past Westminster and then turns sharply to the east to make for the North Sea. This view shows the river with its regular flotilla of sightseeing boats coming up to that bend, flowing past the Houses of Parliament and then under Westminster Bridge. It begins to curve, past the London Eye, to the Hungerford Bridge that carries trains across the river to southern England. Next comes Waterloo Bridge, before it completes its turn and reaches the City of London.

WATERLOO STATION

Perhaps it is an irony that this great railway station, named after the Battle of Waterloo in 1815 that saw the end of Napoleon's ambitions, is now where trains leave for France from through the Channel Tunnel. But most of all Waterloo Station is a place where millions of commuters pass through every year on their way to work from the counties south-west of London, while others head for the nearby National Theatre and Royal Festival Hall on the south bank of the Thames.

BUCKINGHAM PALACE

The Duke of Buckingham built a house on this site in London in 1703. King George II took it over in 1762 and started the process of transforming it into a palace and creating the wings arranged around a central courtyard. It was not until 1837, when Victoria succeeded as queen, that Buckingham Palace became the official London residence of the monarch. Bombed in 1940, the Palace survived with little damage and remains today one of the most popular tourist destinations in the capital.

HAMPTON COURT

Thomas Wolsey, Henry VIII's Archbishop of York, rebuilt Hampton Court in the early 1500s before the King seized the palace. William III and Mary II (1689–94) added a new wing, but were especially keen on the gardens and it was then that the famous maze was planted in its present form (possibly replacing an earlier one). Anyone braving the maze without a map faces half a mile of paths winding throughout the 0.14 ha (⅓ acre) site, famously featured in *Three Men in a Boat* (1889).

CANTERBURY CATHEDRAL
Kent

There is no finer example of the sheer brilliance of the medieval church-builders than Canterbury Cathedral, one of the oldest and most famous Christian buildings in Britain. The seat of the Archbishop of Canterbury, head of the Church of England, the present structure dates back to Archbishop Lanfranc (1070–77) who rebuilt the ruined Saxon building. The most famous event here was the murder of Thomas à Becket in 1170, which turned Canterbury into a special place for pilgrims to his shrine.

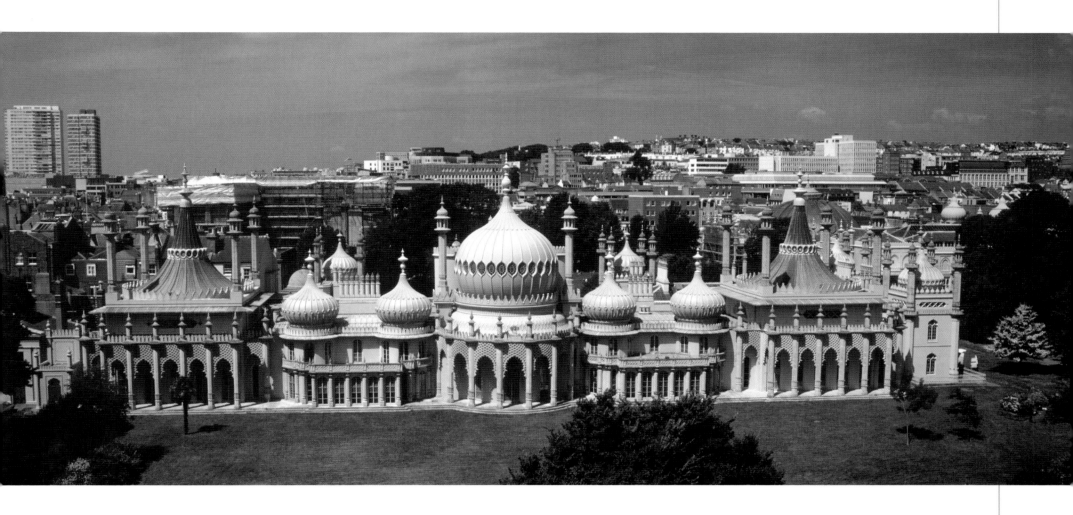

LEEDS CASTLE
Kent

Not to be confused with Leeds in Yorkshire, this is Leeds Castle in Kent just a few miles from Maidstone. The present building on the island in the lake dates back to 1119. Six queens lived here, including Catherine of Aragon for whom Henry VIII converted Leeds into a palace. Parliament spared Leeds in the Civil War because the Culpepper family who owned it then were Parliamentarians. Leeds is one of the most popular attractions in south-east England.

BRIGHTON PAVILION
East Sussex

This Regency extravaganza is the Brighton Pavilion, designed by John Nash for George, Prince of Wales, in 1815. During the illness of his father, George III, the prince acted as regent and is known to history as Prince Regent and was extremely interested in art, design and fashion, hence the term 'Regency' being applied to many buildings of this time. The Pavilion is unique in its use of various eastern styles from India, Mongolia and China to create a fantasy retreat for the prince.

BEACHY HEAD
East Sussex

What more evocative sight could there be of England's coast than the white cliffs of the south coast? Beachy Head is the most southerly point of Sussex, just a mile or two from the famous seaside resort of Eastbourne. At 162 m (532 ft), it is Britain's tallest chalk cliff, commanding magnificent views to east and west. Beachy Head has the unenviable reputation as a popular place for suicides. The present lighthouse was built in 1902 to protect shipping, replacing an earlier one built in 1831.

ARUNDEL CASTLE
West Sussex

Visitors to Arundel see the castle from a completely different angle. It towers over the little town beside the crossing of the Arun deep in the heart of West Sussex, and it is impossible to see within. The ancient eleventh-century motte with its twelfth-century keep is easily visible here, but it was the nineteenth-century fascination with all-things medieval that caused Henry Howard, fifteenth Duke of Norfolk, to rebuild Arundel as a huge Gothic castle, now one of the biggest in England.

CHICHESTER CATHEDRAL
West Sussex

This dramatic view shows Chichester Cathedral's west end and soaring spire to excellent effect. Although the church dates back to the late eleventh century and is itself built in the heart of the Roman city of Noviomagus, fires and other problems led to various bouts of rebuilding in succeeding centuries to create a unique combination of styles. The disasters continued to early modern times for the medieval spire, which was repaired in the late 1600s, totally collapsed in 1861 and had to be rebuilt from scratch.

THE NEEDLES
Isle of Wight

The Isle of Wight lies just off the Hampshire coast near Southampton. Famous today for its tourism and the annual Cowes regatta, it has a unique quality as a kind of miniature England. One of the most famous places to visit is the Needles, a series of chalk stacks at the most westerly point of the island, though the needle-shaped stack that gave the formation its name collapsed in 1764. Since 1859 a lighthouse has protected shipping creeping past into Southampton Water.

South-West England

England's south-west stretches from the vast ancient landscape of Salisbury Plain to the turbulent coastline of Cornwall.

The area boasts three of the most important prehistoric monuments in the whole world: Stonehenge, Avebury and Silbury Hill, which all date back to the time when the men and women of the Neolithic Stone Age started to clear the forests in order to farm. By the Middle Ages some parts of this region were wealthy and could afford the stunning cathedral church of Salisbury, one of the most stylistically coherent medieval churches in Europe, as well as the magnificent stately home at Longleat.

The Industrial Revolution brought the railways to this region, and other great achievements like the Clifton Suspension Bridge. But the south-west stretches a long way from here into Cornwall where the land is wilder and remote. The coastline includes Torquay's elegant seafront, the curious formation of Chesil Beach, and an endless parade of rocky cliffs and dramatic views, broken up here and there by fishing villages like Clovelly and Mousehole. Exmoor and Dartmoor are two of the nation's most important national parks and are as popular with holidaymakers and walkers as the coastal sights of Land's End and St Michael's Mount.

CLIFTON SUSPENSION BRIDGE

Bristol

Clifton Suspension Bridge joins Bristol to North Somerset by spanning the Avon Gorge triumphantly. Work started on Isambard Kingdom Brunel's design in 1831 but was unfinished when he died in 1859, delayed by the Bristol riots and money problems. It was only completed in 1864 using chains from Brunel's Hungerford Bridge in London, demolished in 1860, and has remained in use ever since. Famously, in 1885, a lady tried to commit suicide by jumping off, but was saved when her skirts acted as a parachute.

ROYAL CRESCENT
Bath

Bath's fame lies in its celebrated hot water spring. The Romans turned this place into a healing complex, visited by the sick from across the Roman Empire. The remains of their baths and temple are one of Bath's greatest sights. But the glory of Bath today is its streets, squares and houses built with honey-coloured Bath stone, of its Regency heyday when it became the most fashionable place in Georgian England, immortalised by Jane Austen in *Northanger Abbey* (written in 1798).

KENNET AND AVON CANAL
Wiltshire

This is just part of the 140-km (87-mile)-long Kennet and Avon canal which links the rivers Kennet and Thames in the east at Reading to the Avon at Bristol in the west. Construction started in 1794 and took 16 years. This section is the Caen Hill series of 16 locks out of the 29 that make up the Devizes Flight. The canal gradually fell into disuse after the railways arrived but the canal was restored by a dedicated Trust and reopened in 1990.

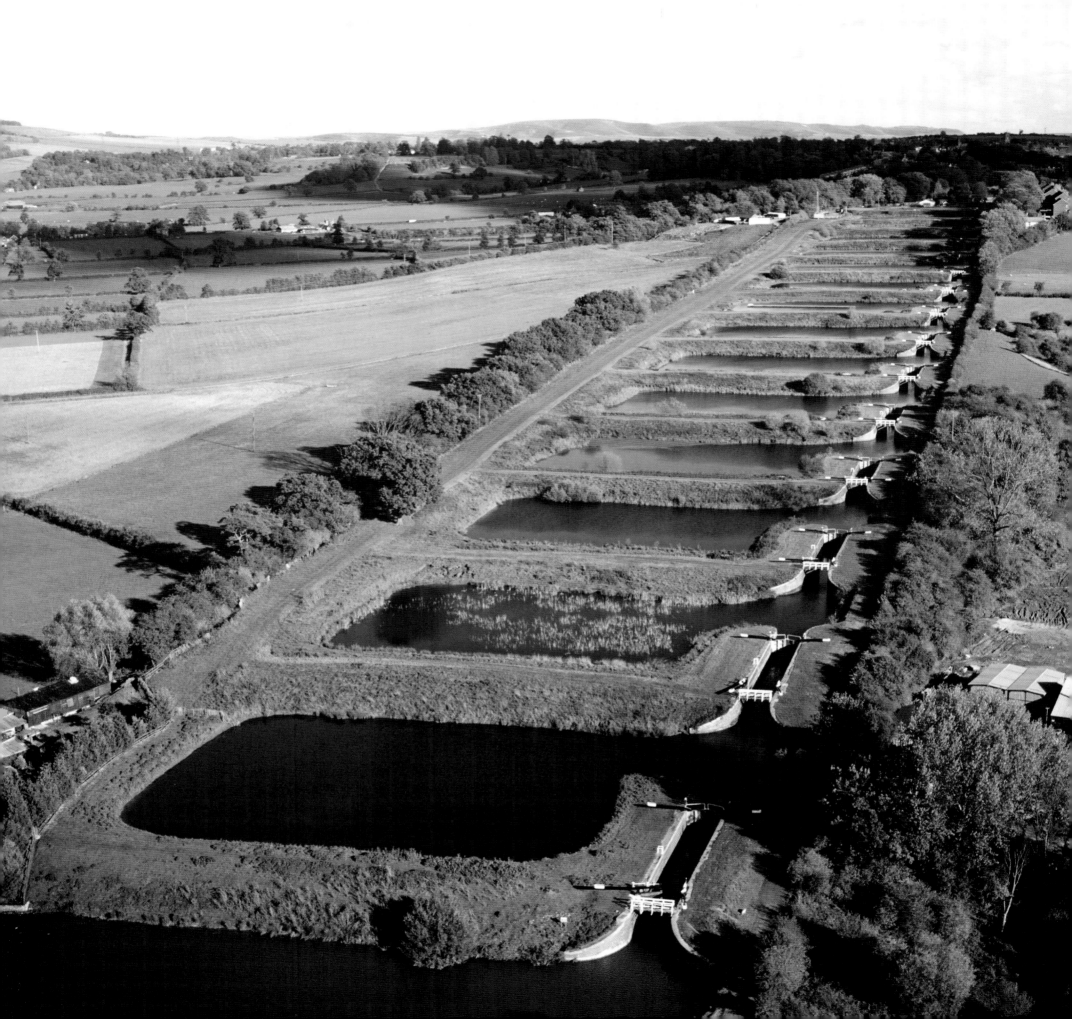

SILBURY HILL
Wiltshire

From a distance this looks like a Norman castle motte, but Silbury Hill is not only prehistoric in date but also Europe's largest man-made hill. It was begun nearly 5,000 years ago in the Neolithic period by digging out a 250,000 cubic m (326,988 cubic yds) of chalk to create a circular mound that eventually rose to 40 m (131 ft) in height. Despite various excavations, no-one has ever worked out why Silbury Hill was built, though it lies in an area rich in prehistoric monuments.

AVEBURY
Wiltshire

Far bigger than the more famous Stonehenge, the Neolithic henge monument at Avebury is more than 420 m (1,378 ft) wide and dates back some 5,000 years to when the circular ditch and outer mound was dug. Not long afterwards about 98 standing stones were laid out in a circle within the ditch, making the biggest prehistoric stone circle known, with two smaller stone circles within. By the late Middle Ages locals started demolishing the circle for the stone, but these days Avebury is protected.

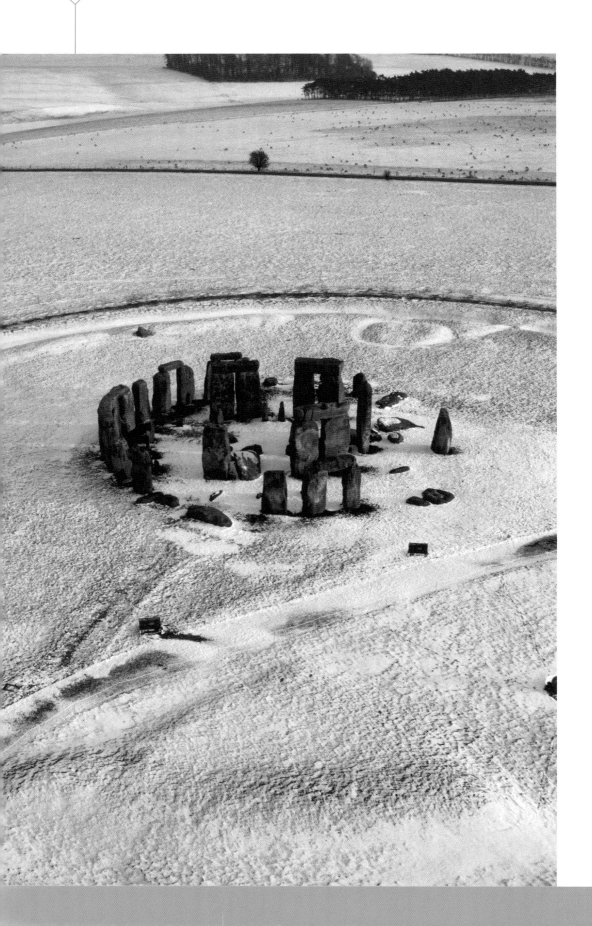

STONEHENGE
Wiltshire

Photographed at sunset in mid-winter, this is unmistakeably the most famous prehistoric monument in Europe and perhaps the world. Stonehenge was a temple and astronomical instrument built in its present form by 2000 BC in the heart of Salisbury Plain, but started life a thousand years earlier. Some of the stones were brought here from the Presely Mountains in Wales but no-one knows how the ancient peoples did this. Every year pilgrims gather on midsummer's day to greet the sunrise.

SALISBURY & CATHEDRAL
Wiltshire

The local centre was once nearby at Old Sarum but in 1220 the bishopric was moved to Salisbury and a new cathedral was begun. What makes Salisbury extremely unusual is that it was built entirely in the Early English Gothic style and was largely completed by 1280 with the spire finished by 1320. The result was an enormous building with England's highest spire and largest cloisters. The tower is 123 m (404 ft) high, with the colossal downward thrust resisted by massive buttresses.

LONGLEAT

Wiltshire

Today Longleat is best-known for its wildlife safari park and the personality of the current owner Alexander Thynn, the seventh Marquess of Bath. He is a direct descendant of the first owner, Sir John Thynne, who began the house in 1572 following a major fire. Designed to be outward-looking and to combine the French love of symmetry with the English courtyard house, it remains one of the most innovative, best-preserved and complete examples of Elizabethan country house architecture in England.

MAIDEN CASTLE

Dorset

Near Dorchester in Dorset, Maiden Castle dates back around 6,000 years but it was only around 2,500 years ago that the place was developed into the largest Iron Age hillfort in Britain with gigantic fortifications. Many others survive, showing that this was how Britain's ancient tribal leaders showed their power and protected their people. When the Roman army arrived here in the late summer of AD 43 it made short work of the defenders. Archaeologists have found the defenders' skeletons where they fell.

CERNE GIANT

Dorset

Leaving nothing to the imagination and casting modesty aside, the Cerne Abbas Giant is a prehistoric figure cut into the hills of central Dorset. One theory is that he dates back 2,000 years to the Iron Age or possibly even earlier, perhaps representing a warrior fertility god, though the style and the club suggest perhaps a Roman representation of Hercules. But with no record of the figure before the seventeenth century at the earliest, no-one knows, and the Giant is saying nothing.

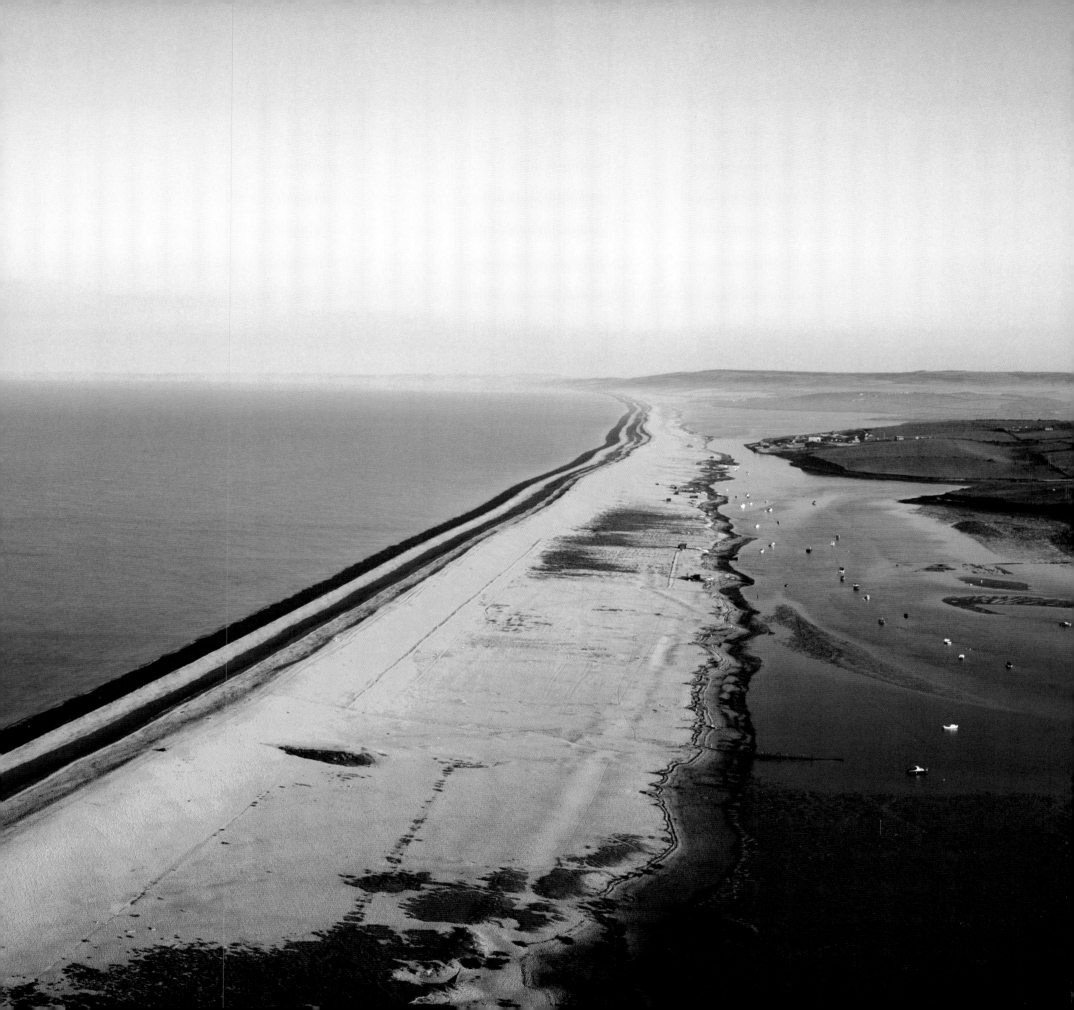

CHESIL BEACH

This huge bank of sand and shingle is Chesil Beach in Dorset, which joins the Isle of Portland to the mainland near Weymouth and shelters the coastline from the choppy waters of the English Channel, creating a safe lagoon haven for holidaymakers and small boats. The natural phenomenon is known as a 'tombolo', caused by waves meeting longshore drift and causing sediment to accumulate in one stretch. The result here is 29 km (18 miles) in length and 18 m (59 ft) in height.

CORFE CASTLE

One of the most dramatic ruined castles in the British Isles, Corfe was built by the Norman invaders to guard the pass through Dorset's Isle of Purbeck, which overlooks the strategically vital entrance to Poole Harbour. King John (1199–1216) liked Corfe and had the castle enlarged to create something so impregnable that it withstood two sieges in the English Civil War of the 1640s. Efforts to demolish it after the war were abandoned, leaving the stunning ruin clinging to the hill today.

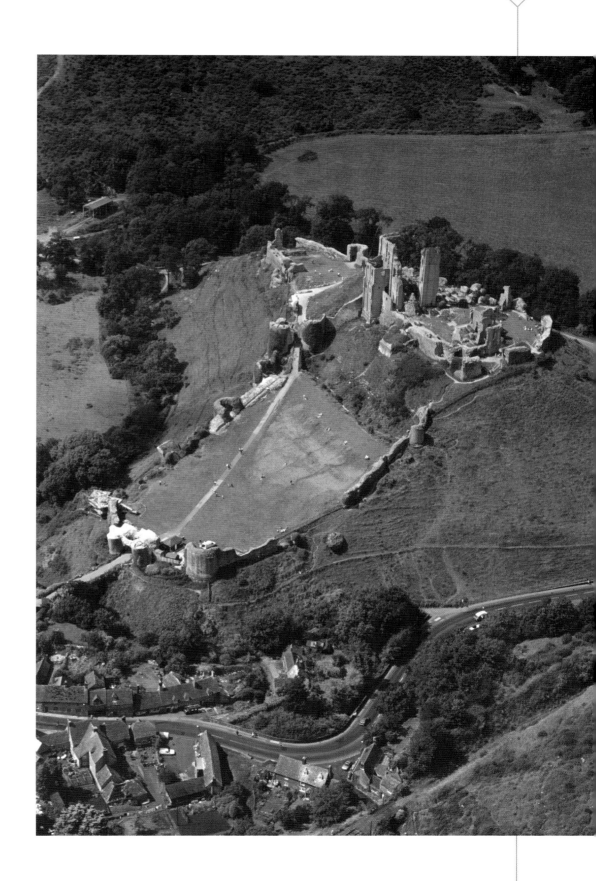

TILLY WHIM CAVES

Dorset

It is hard to believe that this picture has anything to do with St Paul's Cathedral but these limestone quarries on the south-east point of the Isle of Purbeck at Durlston Head produced the stone for the cathedral and many other buildings. The stone was hacked out, creating the caves, and lowered to waiting barges. The coastal quarries have not been worked since the early nineteenth century and are closed to public access for safety reasons. These days Purbeck stone is quarried further inland.

OLD HARRY ROCKS

Dorset

The most easterly point of the Isle of Purbeck is the Foreland. Just below is a series of chalk stacks known as the Old Harry Rocks. The whole area is an extremely dangerous place with sheer cliffs, though a clifftop path does wind its way around the headland from Swanage to Studland. Old Harry was created some two centuries ago when erosion cut him off from the mainland. Beyond him once was 'Old Harry's Wife' but she collapsed many years ago.

GLASTONBURY & TOR
Somerset

Tor is an ancient word that means 'conical hill'. It could not be more apt for this curious piece of high ground in the Somerset Levels, with the tower of the long-vanished St Michael's church on top where the last Abbot of Glastonbury Abbey was hung in 1539 during the Dissolution of the Monasteries. The terraced sides were created by medieval farmers, and archaeology has shown that Glastonbury was home to a prehistoric lakeside village long before when the levels were flooded.

EXMOOR
Devon/Somerset

Exmoor hugs Devon and Somerset's north coast and is where the River Exe rises to flow south across the county to Exeter, helped by the heavy rainfall that sometimes exceeds 2 m (80 in) a year. The view is west to Foreland Point in the distance past hills that rise over 400 m (1,312 ft) above the shore, and many of the clifftops themselves are still more than 200 m (656 ft) high. There are many areas of distinctive coastal woodland, some of which can be seen here.

CLOVELLY

Devon

Tiny Clovelly village is tightly packed into a narrow valley on Devon's north coast at the top of a 122-m (400-ft)-high cliff in Bideford Bay. No cars are allowed here, and visitors must make their way through the cobbled streets on foot. Although today the village depends on tourism, it still looks very much as it did when the main activity was herring fishing in the eighteenth century.

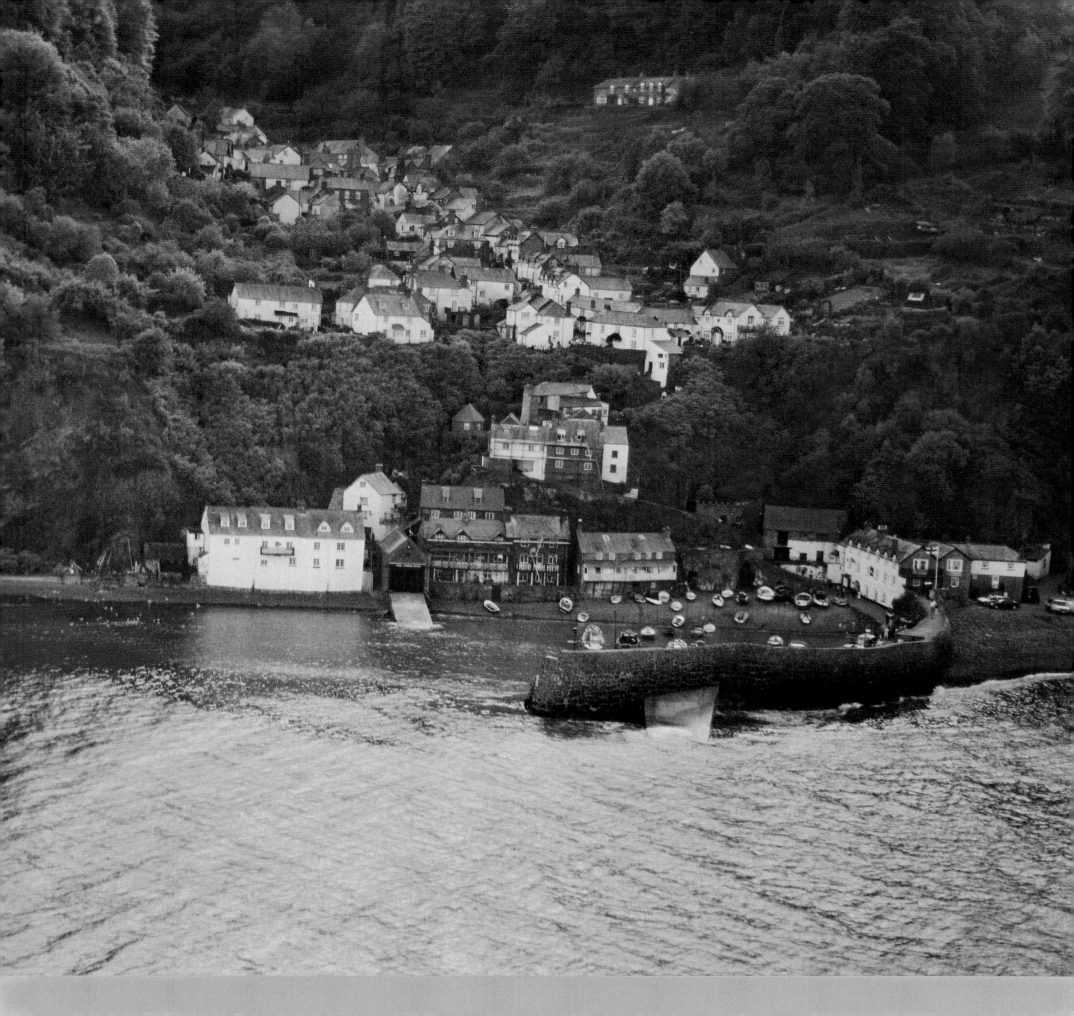

DARTMOOR

Dartmoor National Park occupies a large part of south Devon to the west of Exeter, covering around 958 sq km (370 sq miles). Its distinctive appearance is the result of weathering which has exposed the hard granite hilltops known as 'tors'. It is an extremely popular place for walking and camping, and is still also used for military training. But Dartmoor can also be dangerous and bleak, the cause of many legends due in no small part to the prehistoric monuments scattered across its hills.

TORQUAY

Bathed in the mild air flowing across the Atlantic Ocean, Torquay on Devon's south coast enjoys one of the pleasantest climates in the British Isles. No wonder it has been a fashionable resort for a very long time, mainly since the days of the Napoleonic Wars when those desperate for a healthy climate, or rich English families in search of a Riviera holiday, had to look closer to home. This view is Hope's Nose, a promontory on the south side of Babbacombe Bay.

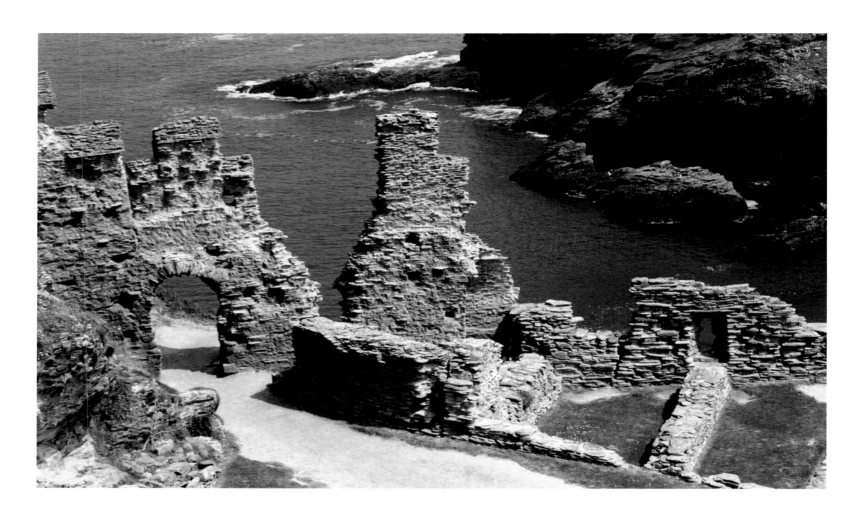

TINTAGEL

This is all that remains of the Great Hall of Tintagel Castle, which clings to a rocky headland on the north coast of Cornwall. A bleak and romantic setting, often lashed by Atlantic storms, Tintagel has a truly ancient history that goes back to the days of the Roman Empire and beyond. Its fame comes from its mythical association with the legend of King Arthur, but the ruins mostly belong to the time of Richard, Earl of Cornwall, in the thirteenth century.

EDEN PROJECT

From up here the Eden Project, near St Austell in Cornwall, looks like a giant grub emerging from the soil. In reality this is a major experiment built in an old china clay quarry. Eden is designed to recreate a tropical environment in one dome, and a Mediterranean environment in the other, to see how animals and plants adapt themselves to the local soil and environmental conditions. Although Eden is now a major visitor attraction it is also dedicated to education.

THE LIZARD

Cornwall

Lizard Point is the most southerly part of Cornwall, and therefore the whole British Isles. A vital landmark in the days when navigation relied on the sun and stars, mariners headed for home from voyages to the Mediterranean or across the Atlantic knew that once they saw the Lizard then Plymouth or Portsmouth were within reach. But the Lizard was also extremely dangerous and hundreds of ships whose captains miscalculated were wrecked on the rocky coast.

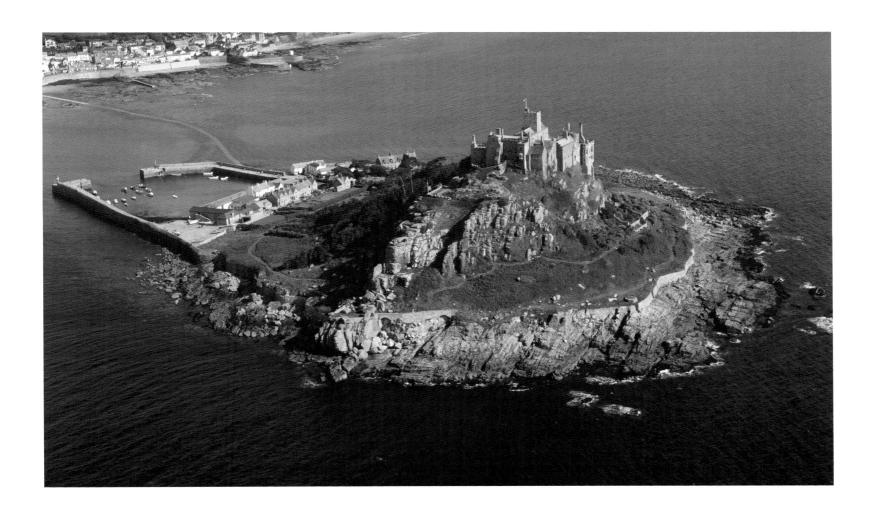

ST IVES

Cornwall

There are three St Ives in England, and this is Cornwall's. The view here is of 'The Island', a peninsula jutting out from the main town into St Ives Bay on the north Cornish coast. The huge sandy beach means it is hardly necessary to say this is a popular holiday destination, a habit the Victorians started in the late 1870s when the railway, which still runs here, was built. It meant an end to St Ives' dependence on the fishing industry.

ST MICHAEL'S MOUNT

Cornwall

Our aerial vantage point takes us out to sea here, high above Mount's Bay in Cornwall and above St Michael's Mount close to Penzance. The natural causeway from Marazion some 400 m (1,312 ft) away on the mainland is submerged during high tide, making this a tidal island. St Michael's church dates back to the fifteenth century, since when it has played an important role as a landmark for shipping, some of which makes its way into the small harbour on the north side.

MOUSEHOLE

Cornwall

Mousehole lies on the west side of Mount's Bay in Cornwall. These days Mousehole is a small place, mainly concerned with the tourist trade. But once it was an important port on the Cornish coast, indeed important enough for the Spanish to attack Mousehole in 1595 and raze it to the ground. Since those times, other places like nearby Penzance and Newlyn have grown much larger but Mousehole is famous for its beautiful harbour, seen to its best advantage from this overhead view.

LAND'S END

Cornwall

The name says it all. Here we are facing due west looking out over Land's End towards the lighthouse on the Longships Rocks a mile or so out to sea and the Scilly Isles beyond. This is not the most westerly point of Britain (parts of Scotland beat it), but it makes no difference to the thousands of people who make their way across Cornwall to the far end of the Penwith peninsula, and those who start their treks to John O' Groats from here.

Index

Page references in *italics* indicate illustrations